HERALDRY
FOR DESIGNERS
AND CRAFTSPEOPLE

W. H. ST. JOHN HOPE

DOVER PUBLICATIONS, INC.
MINEOLA, NEW YORK

Bibliographical Note

This Dover edition, first published in 1999, is an unabridged
reprint of *Heraldry for Craftsmen and Designers* first published by Sir
Isaac Pitman & Sons, Ltd., London, in 1913. A new Introduction
by Dr. Helmut Nickel has been added. The eight color plates scat-
tered throughout the original British edition have been grouped in
one signature, and the 24 collotype plates have been reproduced
and placed in the text in accordance with contemporary printing
standards.

Library of Congress Cataloging-in-Publication Data

Hope, W. H. St. John (William Henry St. John), Sir, 1854–1919.
 [Heraldry for craftsmen & designers]
 Heraldry for designers and craftspeople / W. H. St. John
Hope ; diagrams by the author ; introduction by Helmut Nickel.
 p. cm.
 Originally published: Heraldry for craftsmen & designers.
London ; New York : Sir I. Pitman, [1913]. With new introd. and
minor changes.
 Includes index.
 ISBN 0-486-40475-7 (pbk.)
 1. Heraldry—Great Britain. 2. Heraldry, Ornamental. 3.
Heraldry in art. I. Title.
CR492.H66 1999
929.6'0941—dc21 98-43892
 CIP

Manufactured in the United States of America
Dover Publications, Inc., 31 East 2nd Street, Mineola, N.Y. 11501

INTRODUCTION TO THE DOVER EDITION

HELMUT NICKEL

The three art forms created by the Age of Chivalry were the poetry of the troubadours and minnesingers, in the field of literature; the pageantry of the tournament, in the performing arts; and heraldry, in the graphic arts. Of these three, only heraldry is still alive, even though it is regarded by many as an idle vanity, a quaint snobbery for decadent elitists, or at best an esoteric field of study for ivory-tower scholars.

The Age of Reason and Enlightenment regarded heraldry as a product of the benighted Middle Ages and as the trappings of feudalism, an institution abhorred by the zealous promoters of egalitarian and republican ideas and ideals. In the French Revolution the royal arms of France and the fleur-de-lys, which for most laymen is still the heraldic figure *par excellence*, were banned, and as a consequence, none of the French republics that intermittently followed in the nineteenth and twentieth centuries adopted and used true heraldic arms. The fervor of the French revolutionaries even went so far as to abolish heraldry as such, although the art had originated in the geographical area that is now France. A side effect of this abolition of heraldry was that myriads of armorial shields were erased from prerevolutionary French works of art, to the despair and frustration of generations of art historians.

The same aversion toward suspected trappings of nobility or royalty, coupled with the need of identifying political symbols of sovereignty, led the republics of the Americas to design seals and flags that in most cases are deliberately nonheraldic. The unfortunate result was that these surrogates became cluttered with supposedly significant elements that are depressingly monotonous. In the United States, twenty-five state seals display entire landscapes, fifteen of them with a rising sun. Thirty-one state flags display their state seal, and fourteen

show the seal on a blue field. This way, the original purpose of arms and flags, to be unmistakably distinguishable at a distance, is totally defeated. In some state flags this need for clearly recognizable charges has led to compromises. One of them is the flag of Florida, where a medallion of the state seal—the ubiquitous landscape, with an Indian maiden under a palm tree looking toward the obligatory rising sun—is put on the center of a red St. Andrew's cross on a white field, a design adapted from eighteenth-century Spanish regimental colors.

The elegant St. Andrew's cross appears in the flags of several states that were former Spanish possessions, and it reappears as the distinctive charge on the battle flag of the Confederacy, which is still a stubbornly treasured symbol of the South, hotly challenged by the politically correct.

Heraldic charges, originally painted on a shield as marks of identification to tell friend from foe, were literally a matter of life and death. Far from being irrelevant today, they have retained their power as symbols, and as a consequence, heraldic charges reappear in contexts where formerly they had been treated only with contempt.

This was demonstrated when, after the Berlin Wall fell, the liberated East German provinces reintroduced their traditional arms and flags, which had been *verboten* during four decades of Communist rule. The same happened in Russia, where the tsarist double-eagle has been resurrected, as well as in Serbia, where after the breakup of Yugoslavia a version of the double-eagle of Byzantium was eagerly adopted. The political strife triggered by the readoption of these cherished symbols shows only too clearly their irrepressible power. In much the same way, the inclusion of the French fleur-de-lys in the English royal arms became a spark that ignited the Hundred Years' War. Today, the fleurs-de-lys in the flag of Quebec have a similar political appeal. It remains to be seen whether or not there will be political consequences.

Heraldic differences, such as the colors of the lions in the arms of Belgian provinces—*sable on Or* for the Flemish-speaking north, *Or on sable* for the French-speaking south—are fiercely upheld by Flemings and Walloons, respectively, and are of the same importance as the placing of the Scottish lion in the arms of the United Kingdom as used in Scotland.

The same goes for the many new flags and civic arms all over the world, spontaneously created to establish an outward token of national identity as soon as a country achieved independence. For many of these, though, it would have been better if their creators had been familiar with the basic rules of heraldry.

4

In spite of the ambivalent attitude of the general public toward heraldry, books on the subject have continued to be published, at a rate of least one or two in each decade over the last two centuries. However, practically all of these works have been encyclopedias or manuals concerned with terminology, rules and regulations, and the niceties thereof, such as the use of arms by ladies; the authors usually have paid no attention whatsoever to the aesthetics of this art form.

St. John Hope's *Heraldry for Craftsmen and Designers* (1913), on the other hand, was, as its title says, created with the intention to supply models of good heraldic design. It was for this reason that the author selected examples of original works of art from English sources "from the thirteenth to the seventeenth century, beyond which it is hardly necessary to go."

The specimens chosen are in many different media, from tiles and seals to Garter stall-plates; the preferred times are the fourteenth and fifteenth centuries, when, according to the eminent Viennese collector Albert Figdor, there was a period of refinement and instinctive surety in style in Northern Europe that never has been surpassed.

St. John Hope's *Heraldry for Craftsmen and Designers* was not the first work of its kind dedicated to the express purpose of educating artists and designers—there were earlier attempts by German heraldists, such as A. Hildebrandt (1872), F. Warnecke (1876), and E. Doepler (1898)—but it appears to have had a noticeable influence on the style of English armorial design in the twentieth century. Among the successes in this area are the reverses of British shillings and half crowns, which are such an aesthetic delight for the heraldic connoisseur. On the other side of the coin, so to speak, is the lion on the new ten pence piece, which looks just like one of the scorned examples of the post-seventeenth-century period.

The republishing of Hope's classic work, it is to be hoped, should help to continue the noble tradition of heraldic design at its best.

EDITOR'S PREFACE

In issuing this volume of a series of Handbooks on the Artistic Crafts, it will be well to state what are our general aims.

In the first place, we wish to provide trustworthy text-books of workshop practice, from the points of view of experts who have critically examined the methods current in the shops, and, putting aside vain survivals, are prepared to say what is good workmanship and to set up a standard of quality in the crafts which are more especially associated with design. Secondly, in doing this, we hope to treat design itself as an essential part of good workmanship. During the last century most of the arts, save painting and sculpture of an academic kind, were little considered, and there was a tendency to look on 'design' as a mere matter of *appearance*. Such 'ornamentation' as there was was usually obtained by following in a mechanical way a drawing provided by an artist who often knew little of the technical processes involved in production. With the critical attention given to the crafts by Ruskin and Morris, it came to be seen that it was impossible to detach design from craft in this way, and that, in the widest sense, true design is an inseparable element of good quality, involving as it does the selection of good and suitable material, contrivance for special purpose, expert workmanship,

proper finish and so on, far more than mere orna-
ment, and, indeed, that ornamentation itself was
rather an exuberance of fine workmanship than a
matter of merely abstract lines. Workmanship
when separated by too wide a gulf from fresh
thought—that is, from design—inevitably decays,
and, on the other hand, ornamentation, divorced
from workmanship, is necessarily unreal, and quickly
falls into affectation. Proper ornamentation may be
defined as a language addressed to the eye ; it is
pleasant thought expressed in the speech of the tool.

In the third place, we would have this series put
artistic craftsmanship before people as furnishing
reasonable occupations for those who would gain
a livelihood. Although within the bounds of
academic art the competition, of its kind, is so
acute that only a very few per cent. can fairly hope
to succeed as painters and sculptors, yet as artistic
craftsmen there is some probability that nearly
every one who would pass through a sufficient
period of apprenticeship to workmanship and design
would reach a measure of success.

In the blending of handwork and thought in such
arts as we propose to deal with, happy careers may
be found as far removed from the dreary routine
of hack labour as from the terrible uncertainty of
academic art. It is desirable in every way that
men of good education should be brought back into
the productive crafts : there are more than enough
of us ' in the City,' and it is probable that more
consideration will be given in this century than in
the last to Design and Workmanship.

8

Designers have at times to deal with some matters which are almost common to all the arts, matters which they either know or do not know, and in which the genius they are apt to trust in goes for little apart from knowledge. They must learn lettering for inscriptions much like they once learnt the multiplication table, and they should learn the elements of heraldry in the same way. This it has been difficult to do, as most of the books on heraldry, in seeking to be complete, so effectually muddle up the few important points with the vast number of things unimportant, or worse, that the art student is likely to give it up in despair. Many books on heraldry, which in itself is surely a gay thing, have been made to resemble grammars and dictionaries of a meaningless jargon.

Any student, however, who has become interested in a single shield, or in the look of the thing as seen in a collection of fine examples of heraldry such as are illustrated in this volume, should be able to master the main principles in an hour or two. The curious terms are only old-fashioned ; they are used, so far as they are necessary, not of malice, but because it is of the essence of heraldry that everything shall be so strictly defined that a few words may represent a shield of arms as surely as a picture. Hence everything has a name, everything is clear, sharp, and bright, the colours are few, the forms must be large and simple. Even the seemingly arbitrary dictum that 'no colour must be put on colour or metal on metal' may probably have arisen from the fact that when gilding or silvering was used on a shield it would form a perfect foil for

9

colours, but as they reflected light in the same way, they could not be distinguished if used one on the other. Even yellow pigment on white would not tell clearly at any distance ; the maxim is merely a rule for the sake of distinctness. Again, the curious vigorous drawing of beasts and birds with the eyes staring and the feet spread out was not the result of a desire to be quaint, but arose naturally from the same need of being clear. A good naturalistic drawing of a lion would be useless on a flag. Granted the special needs of heraldry, it developed in a perfectly understandable way.

On the question of heraldic drawing I should like to caution the student against thinking that it is so easy as it looks. Elementary and exaggerated, it may seem as if any child might do it, but in truth it is terribly difficult. The old shields were designed by experts with great experience ; they placed the charge perfectly on the field and so distributed the parts that they were balanced in 'weight' ; there were no weak lines and nothing was crowded for lack of room. Much practice made them perfect, and perfection is still difficult.

The present volume seems to me exactly what artists have wanted.

<div align="right">W. R. LETHABY</div>

March 1913

AUTHOR'S PREFACE

THIS book is an attempt to place before designers and craftsmen such an account of the principles of the art of Heraldry as will enable them to work out for themselves the many and various applications of it that are possible to-day.

To that end the different usages which have prevailed from time to time are dealt with in detail, and are illustrated as far as may be from ancient sources.

Should it be thought that undue stress has been laid upon the pre-Tudor heraldry, to the comparative exclusion of that of later times, it may be pointed out that until the principles of the earlier heraldry have been grasped and appreciated, it is impossible to get rid of the cast-iron uniformity and stupid rules that bound the heraldry of to-day, and tend to strangle all attempts to raise it to a higher level.

To what extent these chilling ideas prevail, and how necessary it is to get rid of them, cannot better be illustrated than by two letters written to the author, after most of the following chapters were in type, by a critical friend who has not read any of them.

He points out in his first letter that on the very day of his writing there had been brought to his

notice, not for the first time, the great need that
exists for a book in which sculptors and painters
may find out what they legitimately may and what
they may not do as regards heraldry. What, for
example, may be left out from an achievement of
arms, and how the different elements composing it
may be varied, or even rearranged.

He instances the case of a sculptor who had been
supplied with a drawing, 'brilliant in emerald green
and powder blue,' of the arms that had been granted
to a famous Englishman whose memory was about
to be honoured by the setting up of a statue with
his arms, etc. carved upon the pedestal.

The arms in the drawing did not present any
difficulties, but the crest was not shown upon the
helm, and the whole was surrounded by a series of
trophies which to this unenlightened sculptor were
as heraldic as the arms and crest. Out of all this,
asked the sculptor, what could lawfully be omitted ?
If any of the trophies were supporters, must they be
shown ? And must the crest be used ? Ought
the crest to be on a helm ? And should the helm
be shown in profile or full-faced ?

The contents of the drawing, if all were sculp-
tured, would, in my friend's opinion, 'either come
so small as to be unmonumental, or so large as to
dwarf the statue into a doll.'

It will be seen from the principles enunciated in
the present work that the answers to the foregoing
questions were obviously as follows :

I. That the sculptor might use the arms alone
if he thought fit, and he might vary the shape
and size of the shield according to his fancy.

II. That he could omit the crest if he wished,
but if he elected to use it, the crest ought certainly
to be set upon a helm, which should face the same
way as the crest; the crested helm might also
be flourished about with such mantling as the
sculptor thought proper.

III. That in the particular drawing none of the
trophies was heraldic. The sculptor accordingly
could omit the whole, if he were so minded, or
could dispose about the arms and crested helm any
such other trophies of like character as would in his
judgment look well or be appropriate.

In a further letter my friend enumerates other
difficulties that vex poor artists. Must a shield
always be surmounted by a crested helm? Should
the helm face any special way according to the degree
of the bearer thereof? What are the ordinary
relative proportions which helm and crest should
bear to the shield? May a shield be set aslant as
well as upright? Should a torse be drawn with a
curved or a straight line? Is it necessary to represent
the engraved dots and lines indicative of the
tinctures? What are supporters to stand upon?
Are they to plant their feet on a ribbon or scroll, or
on a flowering mound, or what? May arms
entitled to have supporters be represented without
them? What are the simplest elements to which
a shield of arms may be reduced?—as, for example,
in a panel some 60 or 70 feet above the eye, and
when but a small space is available.

To a craftsman or designer who has grasped the
principles of heraldry these further questions will
present no difficulty, and most of them can be

13

answered by that appeal to medieval usage which the nature of the illustràtions renders possible.

These illustrations, it will be seen, are largely selected from heraldic seals, and for the particular reason that seals illustrate so admirably and in a small compass such a number of those usages to which appeal may confidently be made. Examples of heraldry in conjunction with buildings, monuments, and architectural features generally, have also been given, and its application to the minor arts has not been overlooked.

In order, too, to enable full advantage to be taken of the long period covered by the illustrations, the most typical of these have been collected into a chronological series at the end of the book. It is thus possible to show the gradual rise and decline of heraldic art from the thirteenth to the seventeenth century, beyond which it is hardly necessary to go.

The only modern illustrations that have been tolerated are those showing the formation or the Union Jack, and the degraded condition of the so-called Royal Standard. The coloured frontispiece is an attempt to show a more effective way of displaying with equal heraldic ' correctness ' the arms ot our Sovereign Lord King George the Fifth.

<div align="center">W. H. ST. JOHN HOPE</div>

My thanks are due to the Society of Antiquaries of London for leave to reproduce the coloured illustrations in pls. I and II, for the loan of blocks or drawings ot figs. 7, 13, 33, 64, 65, 101, 129, 153, 186, 187, 190, and 193, and for leave to photograph the

numerous casts of seals figured in pls. v–xiv and
xvii–xxx and throughout the book; to the Royal
Archæological Institute for loan of figs. 20 and 107;
to the Sussex Archæological Society for the loan of
fig. 142 ; to the Society of Arts for figs. 6, 15, 17, 28, 30, 41,
45, 46, 48, 51, 55, 73, 74, 86, 92, 114, 126, 127, 150, 154,
155, and 199; to the Royal Institute of British Archi-
tects for figs. 8, 93, and 199 ; to Messrs. Cassell & Co. for
figs. 21, 53, 54, 56, 63, 81, 84, 85, 91, 108, 109, 117, 118,
124, 132, 133, 139, 151 ; to Messrs. Constable & Co. for
figs. 9, 14, 43, 67, 68, 72, 75, 76, 77, 78, 83, 136, 137,
138 ; to Messrs. Parker & Co. for fig. 143 ; and to Messrs.
Longmans & Co. for figs. 177, 183. Also to Mr. T. W.
Rutter for lending the drawings reproduced in pls. ii
and iii ; to Mr. R. W. Paul for the drawing of fig. 184 ;
to Mr. Mill Stephenson for the loan of the brass rub-
bings reproduced in figs. 19, 26, 27, 29, 31, 32, 35–39,
42, 146–148 ; to the Rev. T. W. Galpin, Mr. E. M.
Beloe, and Mr. Aymer Vallance for the photographs
of figs. 47, 149, and 191 respectively ; and to the Rev.
Severne Majendie for leave to photograph the effigies
of the Duke and Duchess of Exeter (figs. 167, 168) in
St. Katharine's chapel in Regent's Park.

I wish also to thank, among others, Mr. David Weller,
head verger of Westminster Abbey, for leave to repro-
duce the photographs shown in figs. 1, 2, 4, 34, 40, 87,
104, 110, 134, 156, 176, 194, 195 ; Mr. T. W. Phillips, of
Wells, for those forming figs. 23 and 111 ; Mr. Charles
Goulding, of Beverley, for those forming figs. 49, 50;
Mr. T. Palmer Clarke, of Cambridge, for those forming
figs. 88, 96, 128, 170, 171, and 172 ; and Mr. Fred
Spalding, of Chelmsford, for the photograph of the New
Hall panel in fig. 189.

CONTENTS

16

LIST OF ILLUSTRATIONS
Color Plates
(Between pages 64 and 65)

Black-and-White Plates
(in text)

19

List of Illustrations

ILLUSTRATIONS IN TEXT

31

CHRONOLOGICAL SERIES OF ILLUSTRATIONS

CHAPTER I

INTRODUCTION

Defects of Modern Heraldic Decoration ; Appeal
to First Principles ; English *versus* Foreign
Sources ; Definition of Heraldry ; Modes of
Display ; Colours and Furs ; Formation of Arms ;
Divisions of the Shield ; Early Authorities :
Seals, Monuments, Buildings, Wills and Inventories, Rolls of Arms.

To those who have given attention to the
study of ancient heraldry few things are
more surprising than the imperfect understanding of its true principles displayed in
their works by so many artists and craftsmen of every degree. Year after year, in
paintings and sculpture at the Royal
Academy and other exhibitions, in the
architecture and decorations of our
churches and public buildings, on monuments, on plate, jewellery, and ornaments
of all kinds, the attempt to introduce
armorial accessories, even by some of our
best artists, is almost always a failure.

In so recent a work as the national
memorial to Queen Victoria before

33

Buckingham Palace, the shields for Scotland in the frieze of the pedestal bear the rampant lion only, and the distinctive double tressure is again omitted in the Scottish quarter of the royal arms behind the figure of Victory. The sides of the pedestal also bear fanciful shields of arms, in the one case with three lamps, in the other with some allegorical device, charged on bends sinister!

It is only fair to say that the fault appears to be not altogether that of the artist or craftsman, but should rather be ascribed to the disregard of the principles and usages of true armory that pervades so much of the printed literature to which men naturally turn for information.

He, however, who would know something about heraldic art must go behind the books to better sources of information, and rid himself once and for all of the modern cast-iron rules that cramp all attempts to improve matters. He will then soon find himself revelling in the delightful freedom and playful common-sense of medieval armory when it was still a living art, and a science too, utilized for artistic purposes by every class of worker and unencumbered by the ridiculous conceits of Tudor and later times.

34

The appeal, moreover, should largely be
confined, if one would have what is best,
to our own land. In the beginning
heraldry was much the same in most
European countries, but in course of time
foreign armory became complicated by
needless subdivisions and new methods ot
expression and combination. It would
indeed be foolish to maintain that nothing
can be learnt from foreign sources, but in
the earlier stages of study English heraldry
should come first. Not only is it charac-
terized by a beautiful simplicity which
continued practically unchanged until the
beginning of the sixteenth century, but no
other country outside England possesses
such a wealth of examples of its various
applications, and they lie immediately to
hand for purposes of study and comparison.
Moreover, English heraldry so fully illus-
trates the general principles followed in
other countries that it is unnecessary at
first to go further afield.

Heraldry, or armory as it was anciently
called, is a symbolical and pictorial language
of uncertain and disputed origin, which,
by the beginning of the thirteenth century,
had already been reduced to a science with
a system, classification, and nomenclature

35

Introduction of its own. The artistic devices known as
arms, which may be formed by proper com-
binations of the colours, ordinaries, and
figures that represent the letters of this

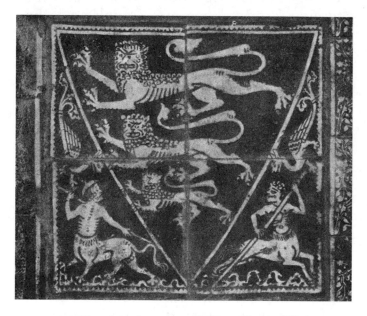

Fig. 1. Tile with the arms of King Henry III, *c.* 1255,
from the chapter-house of Westminster abbey.

language, had each their significance, and
soon came to be regarded as the hereditary
possession of some person, family, dignity,
or office.

The display of arms was restricted

36

primarily to shields and banners, but occa-
sionally to horse-trappers (pls. XI B and
XII B) and such garments as jupes, gowns,
and mantles. Later on heraldry came also

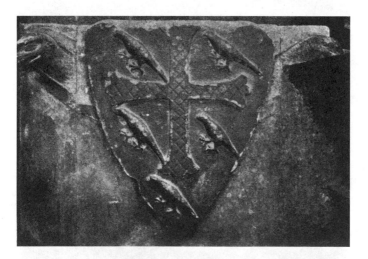

FIG. 2. Shield of the arms of St. Edward, *c.* 1259, in
the quire of Westminster abbey church. An early
instance of the use of heraldry in architecture.

to be used ornamentally, either upon shields
or without them, in all kinds of ways, in
architecture and on monuments, on tiles
and in glazing, in woodcarvings and in
paintings, in woven stuffs and embroideries,
in jewellery and on seals.

The colours used in heraldry are red,
blue, green, purple, and black, or, to

37

give them their old names, gules, azure, vert, purpure, and sable ; combined with the yellow of gold and the whiteness of silver. Orange was never used, prob-

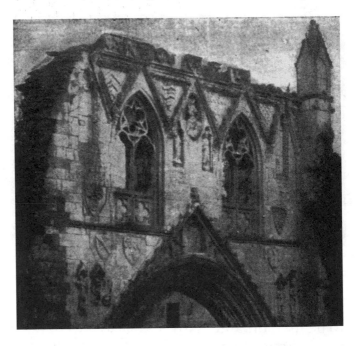

Fig. 3. Heraldry on the gatehouse of Kirkham priory, Yorkshire, built between 1289 and 1296.

ably on account of the difficulty of finding a stable pigment. It was soon found that for brilliancy of effect the use of gold or silver with a colour was preferable to that

38

of colour with colour or metal with metal ;
two colours are therefore found together
or superposed only under certain con-
ditions, and the same applies to the two
metals.

Imitations of two furs, ermine and vair,
were also used : the one of white flecked
with little black tails ; the other of alterna-
ting oblong patches of white and blue,
square at the top and rounded at the
bottom, to represent grey squirrels' skins.
(See figs. 151, 152.) If vair were
coloured other than white and blue, the
resultant was called vairy. There is also
known a black fur with silver ermine-tails.

There were never any exact rules as to
the particular tint of the colour employed,
that being simply a matter of taste. Thus
blue may range from a full indigo almost
to Cambridge-blue, and red from a bright
scarlet, through vermilion, to a dull
brick colour, and so on ; and it is sur-
prising to find how well quiet colours blend
together.

In the formation of arms the mere com-
binations of colours and metals produced
by vertical, horizontal, or other divisions
of the shield were soon exhausted, as were
quarters, checkers, etc. There accordingly

39

Introduction grew quite naturally the further use of applied strips or bands based upon such divisions.

Thus the vertical parting of a metal and

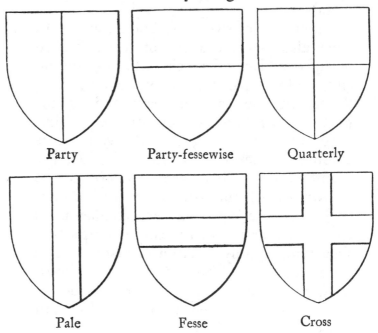

Party Party-fessewise Quarterly

Pale Fesse Cross

a colour known as party produced the pale, and a horizontal division the fesse or bar, and these combined to form the cross suggested by the quarterly lines. An oblique or slanting parting gave rise to the bend, and the crossing of two such produced the St. Andrew's cross or saltire. A combination

40

of the lines of a saltire with a quarterly division produced the varied field called gyronny. The border almost suggested itself. A cutting off of the upper half or

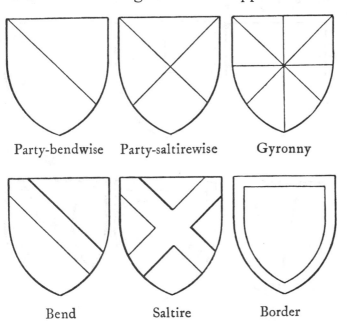

Party-bendwise Party-saltirewise Gyronny

Bend Saltire Border

head of the shield yielded the chief, and of a fourth part the quarter. One other of these applied pieces, or ordinaries as they were called, was the cheveron, formed of two strips issuing from the lower edges of the shield and meeting in a point in the middle, like the cheverons forming the roof

41

timbers of a house. Another ordinary was the pile, which was often threefold with lines converging towards the base as in fig. 72. Sometimes a shield was charged

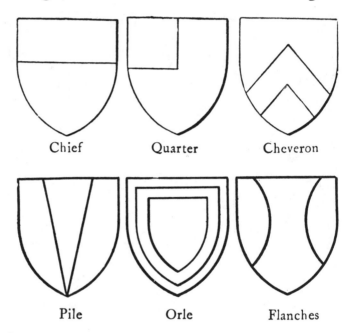

Chief Quarter Cheveron

Pile Orle Flanches

with one of smaller size called a scutcheon, and the middle of this was occasionally cut out to form a voided scutcheon or orle. Flanches, as they are called, are very rarely found ; they are formed by drawing in- curving lines within each side of the shield. An even series of pales yielded a vertical

striping called paly, and of piles, pily, while
an even number of bars became barry.
Undulated or waved bars formed wavy, and
sometimes paly and pily stripes were also

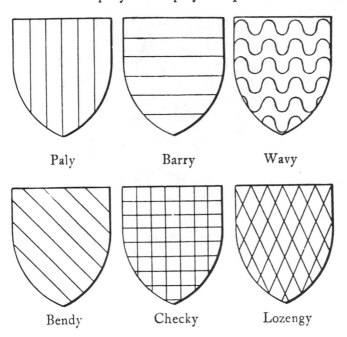

| Paly | Barry | Wavy |

| Bendy | Checky | Lozengy |

waved (fig. 19). In early examples the
bend was often bended or curved. Bends
are so represented in one of the shields in
Westminster abbey (fig. 4), in some of the
shields over the nave arcades in York
minster, and on a number of monumental
effigies. A narrower bend which overlaid

43

everything was known as a baston (see fig. 60). A number of narrow bends produced bendy, but the lines were then straight. A field divided into squares or checkers

Fig. 4. Shield with curved bend or baston of Henry de Laci earl of Lincoln, *c.* 1259, in the quire of Westminster abbey church.

formed checky, and when divided into what are now called lozenges it became lozengy. Pales, fesses, crosses, saltires, borders, and cheverons sometimes had their edges engrailed by taking out of them, as it were, a continuous series of bites separated by sharp points, and the lower edge of a

44

chief or the inner margin of a border was often indented like the edge of a saw ; but in early heraldry engrailing and indenting were interchangeable terms. An indented fesse was anciently called a daunce. Cheverons, fesses, bars, etc. were occasionally battled, through the upper line being formed into battlements. A fesse was often placed between two cheverons, as in the well-known arms of FitzWalter ; or between two very narrow bars called cotises, or pairs of cotises called gemell bars. Cheverons, bends, and pales were also sometimes cotised. Cotises were often of a tincture different from that of the ordinary which they accompanied, and sometimes indented or dancetty as in the arms of Clopton (fig. 5) and Gonvile. The ground or field could be relieved by the use of vair or ermine, or by the addition of fretting or trellis-work or other simple means. It was also not unfrequently powdered with small crosses, fleurs-de-lis, or billets ; often in conjunction with a larger charge like a cinqfoil or a lion.

Almost from the beginning every kind of device was charged or painted upon shields, either singly or in multiple, and upon or about such ordinaries as crosses,

45

cheverons, and fesses. Birds, beasts, and fishes, and parts of them like heads, or feet, or wings; flowers, fruits, and leaves; suns, moons or crescents, and stars; fleurs-de-lis, crosses, billets, roundels, rings, etc. —all were pressed into the service. The

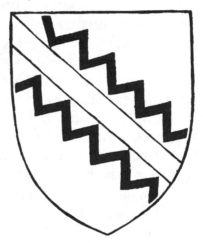

FIG. 5. Arms of Clopton, *sable a bend silver and two cotises dancetty gold,* from a brass *c.* 1420 at Long Melford in Suffolk.

great rule as to colour held good as regards charges, and it was not permissible to paint a red rose upon blue or a gold star upon silver; but a red rose upon gold or a silver star upon blue was quite right.

It has however been lawful at all times to place an ordinary, such as a fesse or a

46

cheveron, and whether charged or not,
upon a parti-coloured field like quarterly,
checky, paly, or barry, or upon vair or
vairy. A quarter, or a chief, or a border,
without reference to its colour, can also be
added to any such field.

Conversely, a parti-coloured cross, fesse,
or charge of any kind is allowable upon a
plain field.

In the Great Roll of arms, *temp*. Edward
II, are instances of two shields, in the one
case of a red lion, and in the other of
a red *fer-de-moline*, on fields party gold
and vert ; also of a silver leopard upon
a field party gold and gules, and of three
red lions upon party gold and azure. Like-
wise of a shield with three lions ermine
upon party azure and gules, and of another
with wavy red bars upon a field party
gold and silver.

In the arms, too, of Eton College
granted by King Henry VI in 1448-9
three silver lilies on a black field are com-
bined with a chief party azure and gules,
with a gold leopard on the red half and a
gold fleur-de-lis on the blue half. King
Henry also granted in 1449 these arms,
*party cheveronwise gules and sable three gold
keys*, to Roger Keys, clerk, for his services

47

in connexion with the building of Eton College, and to his brother Thomas Keys and his descendants.

Shields with quarterly fields often had a single charge in the quarter, like the well-known molet of the Veres, or the eagle of Phelip.

Arms were sometimes counter-coloured, by interchanging the tinctures of the whole or parts of an ordinary or charge or charges overlying a parti-coloured field. This often has a very striking effect, as in the arms of St. Bartholomew's Hospital, which are *party silver and sable a cheveron counter-coloured*, or those of Geoffrey Chaucer, who bore *party silver and gules a bend counter-coloured*. Sir Robert Farnham bore *quarterly silver and azure four crescents counter-coloured*, or, as the Great Roll describes them, 'de l'un en l'autre.' The town of Southampton likewise bears for its arms *gules a chief silver with three roses counter-coloured*.

In drawing parti-coloured fields it is as well to consider what are the old rules with regard to them. In the early rolls a field barry of silver and azure, or of gold and sable, is often described as of six pieces, that is, with three coloured bars alternating with three of the metal, though barry

48

of eight and even ten pieces is found. Paly of six pieces is also a normal number. But the number of pieces must always be even, or the alternate pieces will become bars or pales. The number of squares in each line of a checkered field or ordinary is also another important matter. Six or eight form the usual basis for the division of a field, but the seven on the seal of the earl of Warenne and Surrey attached to the Barons' Letter of 1300-1 is not without its artistic advantages. On an ordinary, such as a fesse or cross, there should be at least two rows of checkers. Here, however, as in other cases, much depends upon the size of the shield, and a large one could obviously carry with advantage either on field or ordinary more squares than a small one without infringing any heraldic law.

Besides the plain cross familiar to most of us in the arms of St. George, and the similar form with engrailed edges, there is a variety known as the ragged cross, derived from two crossed pieces of a tree with lopped branches. This is often used in the so-called arms of Our Lord, showing the instruments of His Passion, or in compositions associated therewith, as in the

49

cross with the three crowned nails forming the arms of the town of Colchester.

Several other forms of cross have also been used. The most popular of these is that with splayed or spreading ends, often split into three divisions, called the cross paty, which appears in the arms of St. Edward (see figs. 2 and 43). It is practically the same as the cross called patonce, flory, or fleury, these being names applied to mere variations of drawing. The cross with *les chefs flurettes* of the Great Roll seems to have been one flowered, or with fleurs-de-lis, at the ends.

Another favourite cross was that with forked or split ends, formed of a *fer-de-moline* or mill-rind, sometimes called a cross *fourchée*, or, when the split ends were coiled, a cross *recercelée*. The arms of Antony Bek bishop of Durham (1284-1310) and patriarch of Jerusalem were *gules a fer-de-moline ermine*, and certain vestments ' woven with a cross of his arms which are called *ferrum molendini* ' passed to his cathedral church at his death. On his seal of dignity the bishop is shown actually wearing such a vestment of his arms.

The tau or St. Anthony's cross also occurs in some late fifteenth century arms.

50

The small crosses with which the field
of a shield was sometimes powdered were
usually what are now called crosslets, but
with rounded instead of the modern squared
angles, as in the Beauchamp arms (fig. 14),
and a field powdered with these was simply
called crusily. But the powdering some-
times consisted of crosses paty, or formy
as they were also styled, as in the arms of
Berkeley, or of the cross with crutched
ends called a cross potent, like that in the
arms of the Kingdom of Jerusalem. These
crosses often had a spiked foot, as if for
fixing them in the ground, and were then
further described as fitchy or crosses
fixable.

Since the elucidation of the artistic rather
than the scientific side of heraldry is the
object of this present work, it is advisable
to show how it may best be studied.

The artistic treatment of heraldry can
only be taught imperfectly by means of
books, and it is far better that the student
should be his own teacher by consulting
such good examples of heraldic art as may
commonly be found nigh at hand. He
may, however, first equip himself to ad-
vantage with a proper grasp of the subject
by reading carefully the admirable article

Introduction on Heraldry, by Mr. Oswald Barron, in the new (eleventh) edition of the *Encyclopædia Britannica.*

The earliest and best of artistic authorities are heraldic seals. These came into common use towards the end of the twelfth century, much at the same time that armory itself became a thing of life, and they were constantly being engraved for men, and even for women, who bore and used arms, and for corporate bodies entitled to have seals.

Moreover, since every seal was produced under the direction of its owner and continually used by him, the heraldry displayed on seals has a personal interest of the greatest value, as showing not only what arms the owner bore, but how they were intended to be seen.

From seals may be learnt the different shapes of shields, and the times of their changes of fashion ; the methods of depicting crests ; the origin and use of supporters ; the treatment of the 'words' and 'reasons' now called mottoes ; the various ways of combining arms to indicate alliances, kinships, and official connexions ; and the many other effective ways in which heraldry may be treated artistically without breaking the rigid rules of its scientific side.

52

Seals, unfortunately, owing to their in-
accessibility, are not so generally available
for purposes of study as some other
authorities. They are consequently com-
paratively little known. Fine series, both
of original impressions and casts, are on
exhibition in the British and the Victoria
and Albert Museums, and in not a few
local museums also,* but the great collec-
tion in the British Museum is practically the
only public one that can be utilized to any
extent by the heraldic student, and then
under the limitation of applying for each
seal by a separate ticket.

The many examples of armorial seals
illustrated in the present work will give
the student a good idea of their importance
and high artistic excellence.

Next to the heraldry on seals, that dis-
played on tombs and monuments, and in
combination with architecture, may be
studied, and, of course, with greater ease,
since such a number of examples is avail-
able. Many a village church is compara-
tively as rich in heraldry as the abbey

* It would surely not be a matter of much diffi-
culty or expense to equip the leading schools of art
in this country with sets of casts of these beautiful
objects.

churches of Westminster and St. Albans, or the minsters of Lincoln and York and Beverley.

It is to the country church, too, that we may often look for lovely examples of old heraldic glass, which has escaped the destruction of other subjects that were deemed more superstitious (pls. i, ii, and iii).

But the student is not restricted to ecclesiastical buildings in his search for good examples of heraldry.

Inasmuch as there never was such a thing as an ecclesiastical style, it was quite immaterial to the medieval master masons whether they were called in to build a church or a gatehouse, a castle or a mansion, a barn or a bridge. The master carpenter worked in the same way upon a rood loft or a pew end as upon the screen or the coffer in the house of the lord ; the glazier filled alike with his coloured transparencies the bay of the hall, the window of the chapel, or that of the minster or the abbey ; and the tiler sold his wares to sacrist, churchwarden, or squire alike.

The applications of heraldry to architecture are so numerous that it is not easy to deal with them in any degree of connexion.

Shields of arms, badges, crests, and

supporters are freely used in every con- Introduction
ceivable way, and on every reasonable place :

Fig. 6. Heraldic candle-holder, etc. from the latten grate
about the tomb of King Henry VII at Westminster.

on gatehouses (figs. 3, 95, 96) and towers,
on porches and doorways, in windows and

55

on walls, on plinths, buttresses, and pinnacles, on cornice, frieze, and parapet, on

FIG. 7. Firedog with armorial bearings.

chimney-pieces (figs. 8, 94) and spandrels, on vaults and roofs, on woodwork, metalwork (figs. 6, 7), and furniture of all kinds, on tombs, fonts, pulpits, screens, and

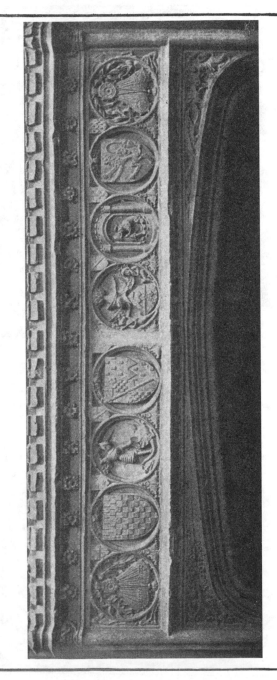

Fig. 8. Chimney-piece in Tattershall castle, Lincolnshire, built by Ralph lord Cromwell between 1433 and 1455, with shields of arms and treasurer's purse and motto.

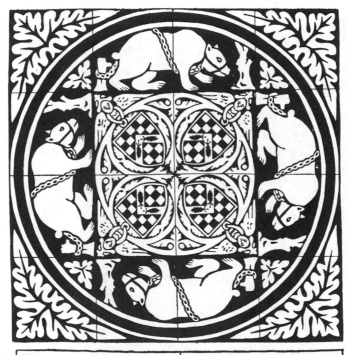

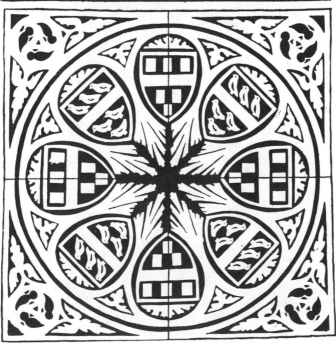

Fig. 9. Paving tiles with arms and badges of the Beauchamps, from Tewkesbury abbey church.

coffers, in painting, in glass, and on the tiles of the floor (figs. 1, 9, 14).

Though actual examples are now rare,

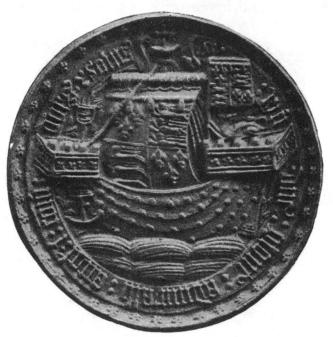

Fig. 10. Seal of Richard duke of Gloucester, as admiral of England in Dorset and Somerset (1462), with arms on the mainsail of the ship.

we know from pictures and monuments, and the tantalizing descriptions in inventories, to how large an extent heraldry was used in embroidery and woven work, on carpets and hangings, on copes and

Introduction frontals, on gowns, mantles, and jupes, on trappers and in banners, and even on the sails of ships (fig. 10).

Wills and inventories also tell us that in

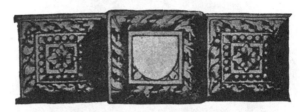

FIG. 11. Heraldic buckle from the effigy of Robert lord Hungerford (*ob.* 1459) in Salisbury cathedral church.

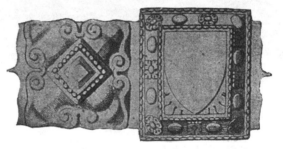

Fig. 12. Heraldic buckle from the effigy of William lord Bardolf (*ob.* 1441) in Dennington church, Suffolk.

jewellery and goldsmiths' work (see figs. 11 and 12) heraldry played a prominent part, and by the aid of enamel it appeared in its proper colours, an ad-
60

vantage not always attainable otherwise
(fig. 13). Beautiful examples of heraldic
shields bright with enamel occur in the

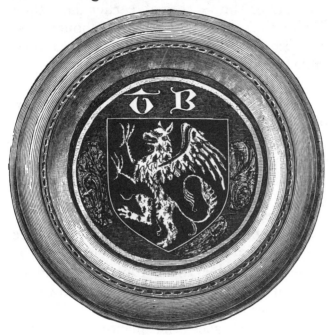

FIG. 13. Enamelled shield with the arms of
Ballard on the print of a mazer (*c.* 1445)
at All Souls college, Oxford.

abbey church of Westminster on the tombs
of King Edward III and of William of
Valence, and on the tombs at Canterbury
and Warwick respectively of Edward
prince of Wales and Richard Beauchamp

61

earl of Warwick ; while in St. George's chapel in Windsor castle there are actually nearly ninety enamelled stall-plates of Knights of the Garter of earlier date than Tudor times, extending from about 1390 to 1485, and forming in themselves a veritable heraldic storehouse of the highest artistic excellence. (See pls. xv, xvi.)

Another source of coloured heraldry is to be found in the so-called rolls of arms.

While heraldry was a living art, it obviously became necessary to keep some record of the numerous armorial bearings which were already in use, as well as of those that were constantly being invented. This seems to have been done by entering the arms on long rolls of parchment. In the earliest examples these took the form of rows of painted shields, with the owners' names written over (pl. iv) ; but in a few rare cases the blazon or written description of the arms is also given, while other rolls consist wholly of such descriptions, as in the well-known Great and Boroughbridge Rolls. These have a special value in supplying the terminology of the old heraldry, but this belongs to the science or grammar and not the art of it. The pictured rolls, on the other hand, clearly

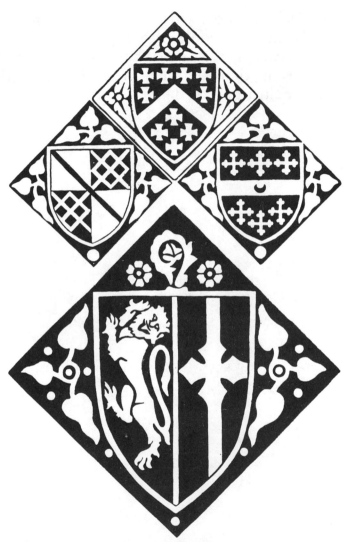

Fig. 14. Heraldic paving tiles from Tewkesbury abbey. The three uppermost bear the arms of Despenser, Berkeley, and Beauchamp, and the large one the arms of Robert Fitz-Hamon, the founder, impaled with the singular cross of the abbey.

belong to the artistic side, and as they date from the middle of the thirteenth century onwards, they show how the early heralds from time to time drew the arms they wished to record.

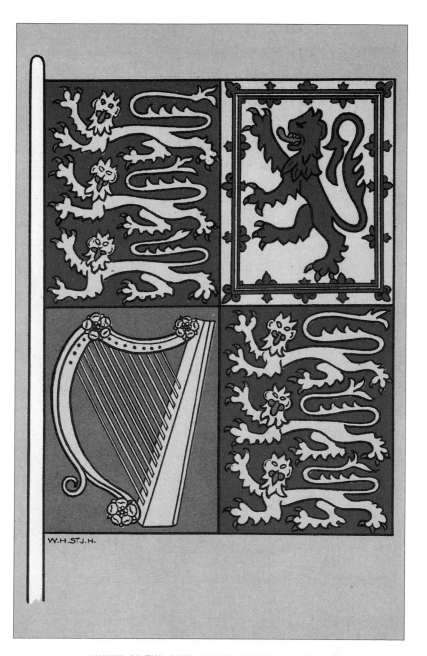

BANNER OF THE ARMS OF KING GEORGE THE FIFTH.

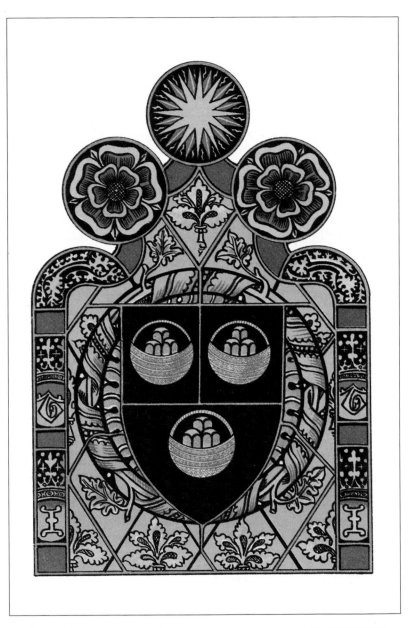

PLATE I. ARMS OF MILTON ABBEY FROM A WINDOW IN IBBERTON CHURCH, DORSET, C. 1475 (FROM ARCHAEOLOGIA, VOL. XLVII.)

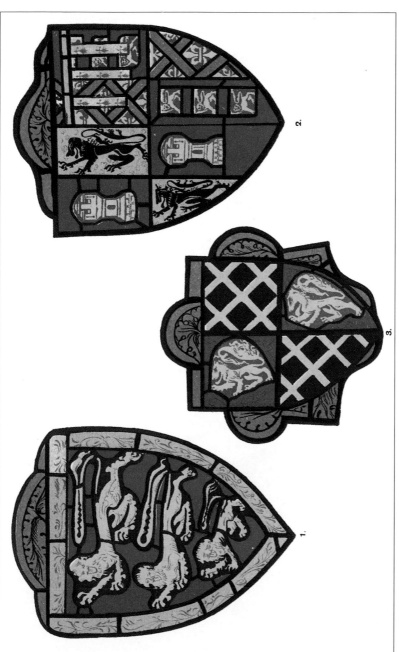

PLATE II. SHIELDS IN STAINED GLASS OF THE 14TH CENTURY WITH THE ARMS OF (1) JOHN, EARL OF KENT, (2) JOHN OF GAUNT AS KING OF CASTILE, AND (3) SIR WILLIAM ARUNDEL, K.G.: IN THE VICTORIA AND ALBERT MUSEUM.

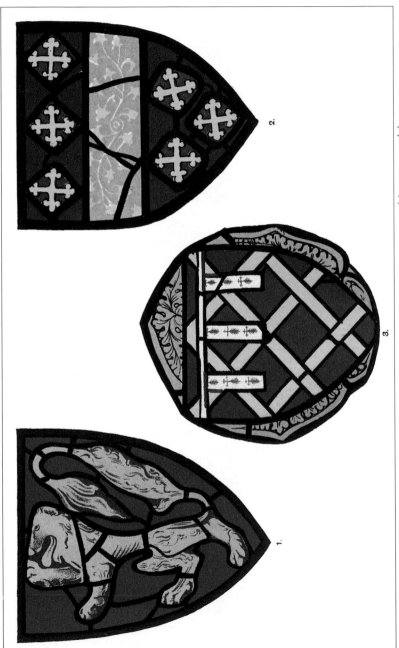

PLATE III. SHIELDS IN STAINED GLASS OF THE 14TH CENTURY WITH THE ARMS OF (1) MOWBRAY (2) BEAUCHAMP, AND (3) AUDLEY: IN THE VICTORIA AND ALBERT MUSEUM.

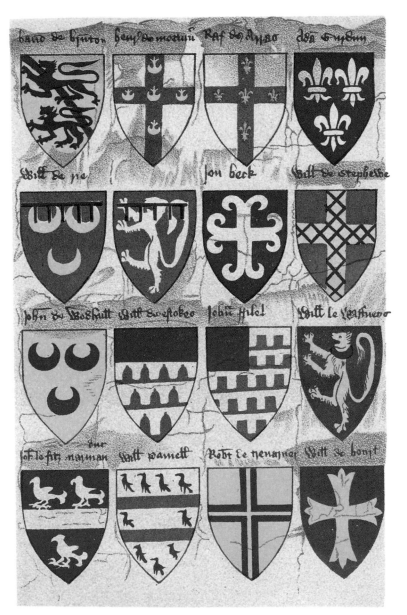

PLATE IV. PART (REDUCED) OF AN EARLY ROLL OF ARMS BELONGING
TO THE SOCIETY OF ANTIQUARIES OF LONDON.

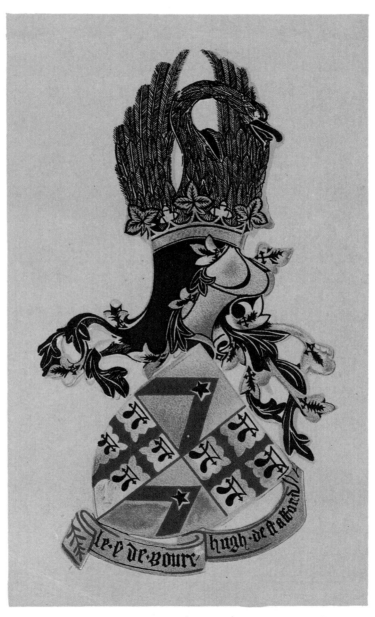

PLATE XV. STALL-PLATE (REDUCED) OF HUGH STAFFORD
LORD BOURCHIER, C. 1421.

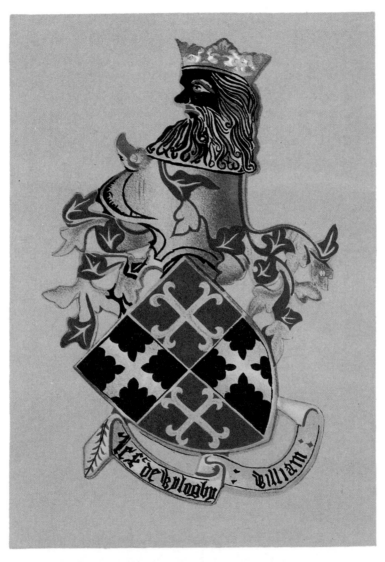

PLATE XVI. STALL-PLATE OF WILLIAM LORD WILLOUGHBY,
C. 1421.

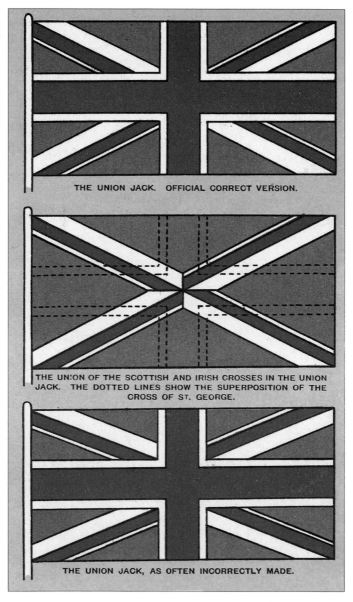

THE UNION JACK. OFFICIAL CORRECT VERSION.

THE UNION OF THE SCOTTISH AND IRISH CROSSES IN THE UNION
JACK. THE DOTTED LINES SHOW THE SUPERPOSITION OF THE
CROSS OF ST. GEORGE.

THE UNION JACK, AS OFTEN INCORRECTLY MADE.

PLATE XXXI. RIGHT AND WRONG VERSIONS OF THE UNION JACK.

CHAPTER II

THE SHIELD AND ITS TREATMENT

Early Forms of Shields ; Later Forms ; Shields of Irregular Outline and Surface ; The Filling of a Shield ; Apparent *versus* Absolute Uniformity ; Modern Rules as to Proportion ; The Use and Abuse of Quartering : its Origin and Growth ; Differencing of Arms ; The Scutcheon of Ulster ; Diapering.

FROM these preliminary remarks we may pass to the practical consideration of the principles of heraldic art.

And first as to shields and their treatment.

The form of a shield is in itself entirely arbitrary and void of meaning. Although it varied from time to time, this was simply a matter of fashion, like the shape of an arch or the pattern of a window. Such changes must not, however, be overlooked, or it would be absurd in actual practice to use an ornate shield of the style of the fifteenth or sixteenth century for a lion of (say) the thirteenth century type, or to fill a shield of early form with charges characteristic of a later date.

During the twelfth century shields were more or less kite-shaped, like those that were actually used, but in the thirteenth century they began to be shorter and straighter across the top. Good examples

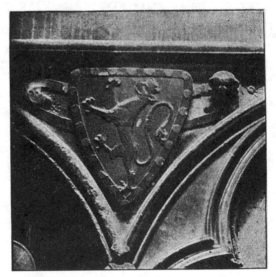

Fig. 15. Shield with rounded corners (*c.* 1259) of Richard earl of Cornwall in the quire of Westminster abbey church.

of this type may be found on seals. In the aisles behind the quire of Westminster abbey church, the beautiful shields in the spandrels of the wall arcade, of a date not later than 1259, retain their rounded upper corners. (See figs. 2 and 15.) The next

form, with the upper corners square
(figs. 16, 17), came into vogue in the
second half of the thirteenth century, and
has continued always in use. Owing to the

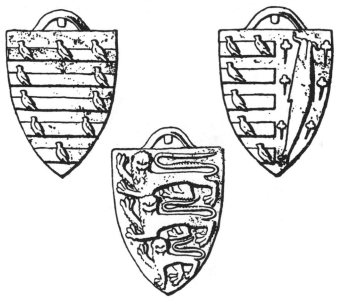

Fig. 16. Shields of English work from the tomb
of William earl of Pembroke (*ob*. 1296) in
Westminster abbey church.

elastic way in which its curves can be
slightly altered when required, it may
safely be adopted in general practice. In
the earliest examples the curves begin at
the top, or just below, but later on they
were so struck as to increase the area

67

of the lower part of the shield in order to make more room for the charges. In some fourteenth century instances the sides continue straight nearly to the bottom, so that the shield is practically an oblong with rounded lower corners, like the shields of

Fig. 17. Seal of Hugh Bardolf showing shield with square corners. From the Barons' Letter.

the royal arms on our coinage to-day (fig. 18 and pl. vi A). A tendency in the same direction is not uncommon throughout the fifteenth century. About the middle of the same century the fashion began to prevail, alongside the other, of representing a man's arms on the same irregularly shaped shield that he was wont to carry in the jousts. This is as wide at the bottom as the top, with its outline worked into curves, and has on the dexter, or right-hand side as borne, a deep notch

68

for the lance to rest in during tilting ; the top and bottom of the shield are often sub- divided into three or more lobes or shallow

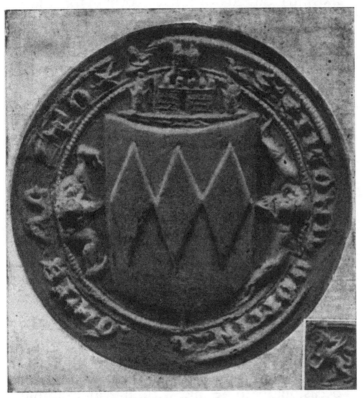

FIG. 18. Seal and counterseal of Simon lord of Montagu, with shield of unusual form supported by two bearded men and surmounted by the castle of Corfe, of which Simon became governor in 1298. The quadrangular signet displays a griffin. From the Barons' Letter.

curves. Good examples occur on seals and monuments, and some of the Garter stall-plates. (See pls. V A and B; VI B; XVII; and XXIII A.) Shields of a more ornate form are

FIG. 19. Shield of ornate form, from a brass at Stoke Poges, Bucks, 1476.

occasionally to be met with, like an example (fig. 19) on a brass at Stoke Poges of the date 1476, with graceful leaf-work curling over at the top and bottom. Shields similarly ornamented occur on the door-

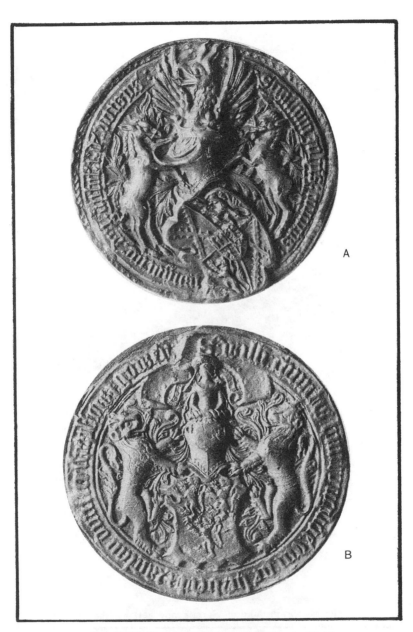

PLATE V.—Examples of shaped shields.

A John Tiptoft earl of Worcester, 1449.
B William Herbert earl of Huntingdon, 1479.

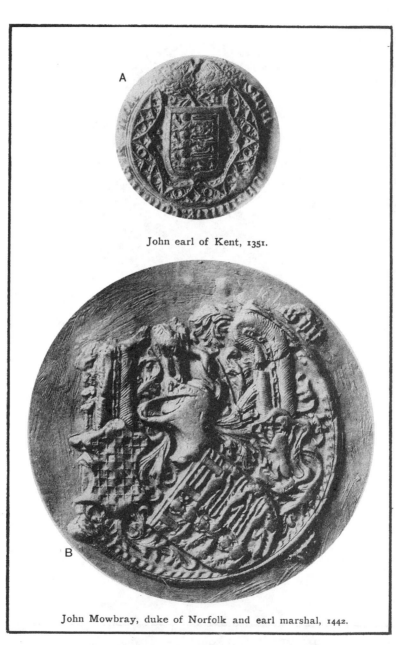

A

John earl of Kent, 1351.

B

John Mowbray, duke of Norfolk and earl marshal, 1442.

PLATE VI.—Various shapes of shields.

way of a citizen's house now built into the Guildhall at Norwich (fig. 20).

In the simpler forms the field of a shield in painted representations is invariably shown flat ; but in carvings, and occasionally on seals, a slight convexity, or even concavity, is often met with, the artistic advantages of which it is unnecessary to enlarge upon. In some of the later ornate forms, like those described above, the incurved or engrailed edge is accompanied by a field worked with a series of ridges and furrows (figs. 21 and 23). The effect of this may be good, but there is a danger of carrying it to excess and so injuring the appearance of the charges. If the shield be well covered by the bearings on it, it is generally better to use one of simple form than one with an irregular outline and ridged surface ; but there is, of course, no reason why both forms should not be used concurrently in architectural or other works, as they sometimes were of old.

The same principle as the ridging of a shield to relieve the plain surface was also applied to the ordinaries upon it. An early example may be seen upon the tomb of queen Eleanor at Westminster, which has the bends in the shields of Ponthieu ridged

71

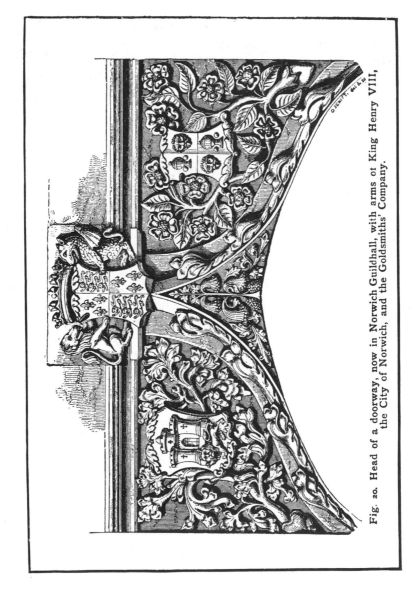

Fig. 20. Head of a doorway, now in Norwich Guildhall, with arms of King Henry VIII, the City of Norwich, and the Goldsmiths' Company.

along the middle line. The shield borne by Brian FitzAlan (*ob.* 1302) in his effigy at Bedale has the alternate bars of his arms (*barry of eight pieces gold and gules*) treated in the same way. Another instance may

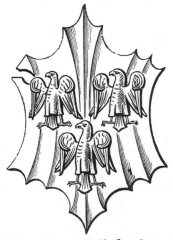

FIG. 21. Shield with engrailed edges (*c.* 1520), from the chantry chapel of abbot Thomas Ramryge in St. Albans abbey church.

be seen on the effigy of Sir Richard Whatton (*c.* 1325) at Whatton, Notts, in which a bend, though charged, is ridged. The shields on the tomb of Guy lord Bryen (*ob.* 1390) at Tewkesbury (fig. 22) furnish typical later examples, while during the fifteenth and early sixteenth centuries instances are as common as the curved and

ridged shields described above, especially as
regards crosses and saltires, as at St. Albans,
the George Inn at Glastonbury (fig. 23),
and elsewhere.

In monumental effigies the shield borne
by a knight often has a convex or rounded

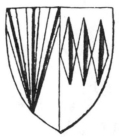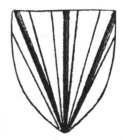

FIG. 22. Shields with ridged charges, from the
monument of Guy lord Bryen (*ob.* 1390) in
Tewkesbury abbey church.

surface (fig. 24), and in late fifteenth
century and Tudor architecture otherwise
flat shields sometimes have the middle
swelled out, as on dean Gunthorpe's oriel
at Wells, in a manner very popular in
Renaissance work. (See figs. 111 and 195.)

A reference to a number of good ancient
examples of heraldic shields or banners will
disclose the care that has been taken to
occupy the field, as far as possible, with
whatever is placed upon it (figs. 25, 26,
27). A lion or an eagle, for instance, will

74

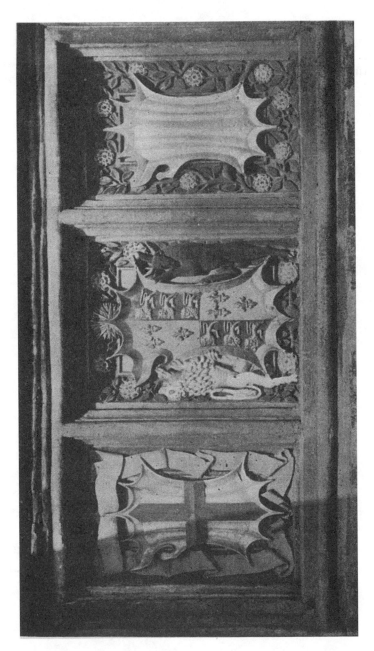

Fig. 23. Armorial panels, the middlemost with the arms, supporters, and badges of King Edward IV, from the George Inn at Glastonbury.

have the limbs and extremities so spread out as to fill every available space ; and the same will be found in every group or

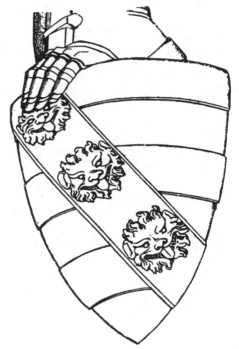

Fig. 24. Shield with curved surface, from an effigy of a Pembridge at Clehonger, Herefordshire.

combination of objects capable of arrangement or extension.

Even with most unpromising combinations, or a group that cannot be extended or

modified at all, or with a single charge like a fleur-de-lis, or ordinary such as a bend, (fig. 30), pale, or cheveron (pl. VIII A), a judicious adjustment of proportions, or

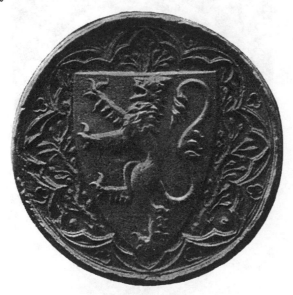

Fig. 25. Shield from the seal of Henry Percy (from the Barons' Letter) with well-drawn lion.

some equally common-sense method, enabled a medieval artist to make his shield look well.

Another point that may be noticed in all old work is that in shields containing several similar objects no two are exactly

alike. If the charges be, for example,
three roses or three roundels or three
lions (fig. 32), two will be placed in the

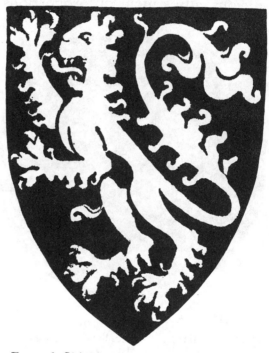

Fig. 26. Shield with a leaping lion, from
a brass (*c.* 1380) at Felbrigge in Norfolk.

upper and the third in the lower part of
the shield. But the latter will often be
somewhat larger than the others, and these,
in turn, will differ slightly the one from
the other as they do in nature. So, too,
78

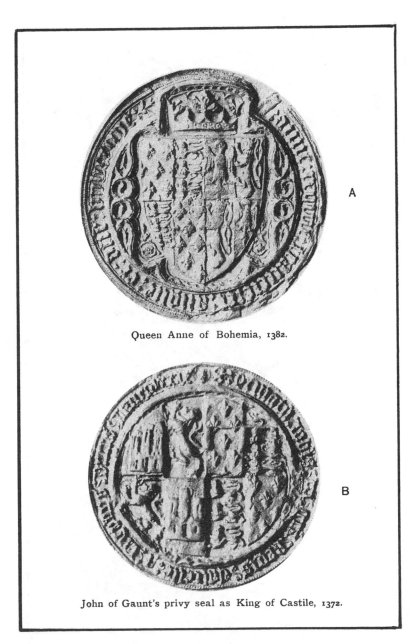

A

Queen Anne of Bohemia, 1382.

B

John of Gaunt's privy seal as King of Castile, 1372.

PLATE VII.—Examples of Quartering.

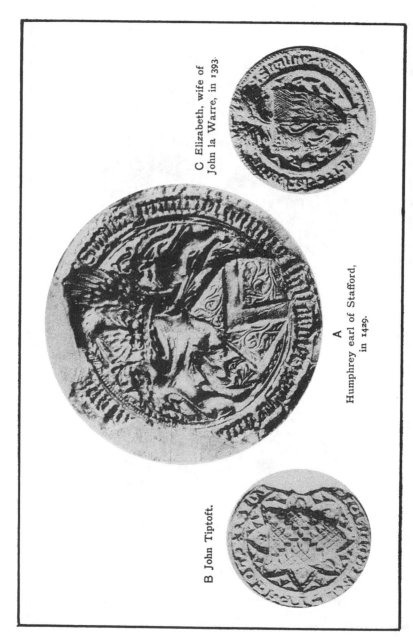

C Elizabeth, wife of
John la Warre, in 1393.

A
Humphrey earl of Stafford,
in 1429.

B John Tiptoft.

PLATE VIII.—Examples of diapered shields.

in a case like the three leopards of the King of England, whether displayed on shield or in banner, no two are exactly alike, but

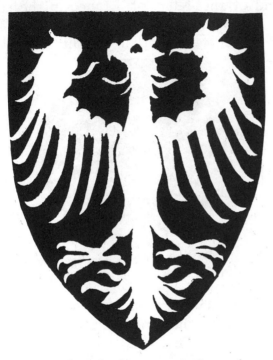

FIG. 27. Shield with an eagle from a brass at Great Tew, Oxon, *c.* 1410.

each differs somewhat from another in pose or in size (fig. 32). Even when the same charge is repeated many times, like the fleurs-de-lis in the old arms

79

of France, any possible chance of mechani-
cal monotony is avoided by a trifling
variation in the shape of each, as in the
shield of the King of France in the early
series at Westminster (fig. 34).

Another fact is that in the old work

Fig. 28. Seal of Queen's College, Oxford,
1341, with well-filled shields.

lines and curves are hardly ever quite true,
but drawn by hand instead of with pen or
compasses. The modern artist, on the
contrary, usually draws his lines and curves
with mechanical precision ; his charges are
exact copies one of another ; the fact that
they do not fill the field (*pace* the royal
arms on the coinage) is to him quite un-
important, and the final result is that under
no circumstances will his work look well.

80

Even in old stencilling a pleasing effect never seen in modern work of the kind was produced through a not too rigid adherence to a regularity of application.

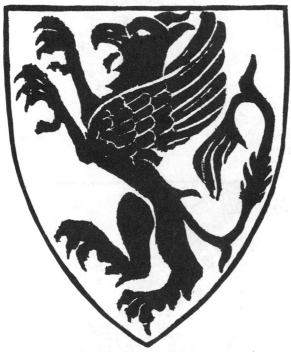

FIG 29. Shield with a griffin, from a brass of 1405 at Boughton-under-Blean, Kent.

Another cause of the bad effect of much modern heraldry is the unnecessary adherence to the rules laid down in some of the textbooks and manuals as to the relative

widths of ordinaries and subordinaries. The old heralds certainly did not fetter

FIG. 30. Seal of Peter de Mauley IV (from the Barons' Letter), showing a simple well-balanced shield.

FIG. 31. Shield with a bend counter-flowered, from the brass of Sir Thomas Bromfleet (1430) at Wymington, Beds.

themselves with such shackles. A cheveron, The Shield
a bend, a fesse, or a cross was drawn of the and its
best proportion to look well (figs. 35, 36). Treatment
If charged it would be wider than when

FIG. 32. Shield with three lions, from a
brass at Stanford Dingley, Berks, 1444.

plain. If placed between charges it was
drawn narrower, if itself uncharged, and
thus took its proper relative position with
regard to the size and arrangement of
the charges. So, too, with a border; if
uncharged or merely gobony (*i.e.* formed
of short lengths of alternate colours) or

83

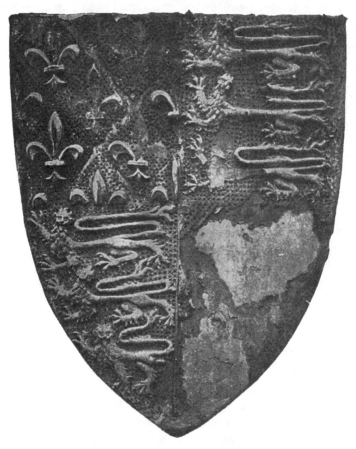

Fig. 33. Shield of the royal arms done in boiled leather, from the tomb of Edward prince of Wales at Canterbury, 1376.

engrailed, it was drawn very narrow, and even if charged it was not allowed much greater width (figs. 38, 39). It thus never unduly encroached upon the field or

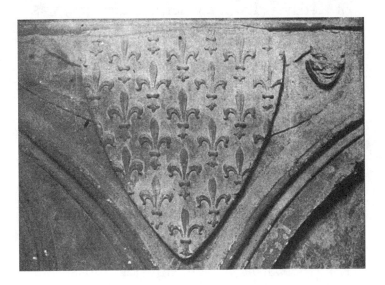

FIG. 34 Shield of the King of France (*c*. 1259) in the quire of Westminster abbey church.

other contents of the shield, and yet remained an artistic addition in itself. The curious bordering known as the tressure, which is almost peculiar to Scotland, and familiar to us through its occurrence in the shield of our Sovereign, is drawn sufficiently narrow in all good examples to leave

85

ample room for the ramping lion it fences
in, and its frieze of fleurs-de-lis is formed of
a good number of flowers, instead of the
eight considered sufficient in the royal arms
of to-day. Even a chief, if necessary, was
enlarged from the 'less than one-third of
the shield' of to-day to the one-half of it,
or even more, as may be seen in some of
the examples of the arms of the monastery
in the abbey church of Westminster, or in
those of the town of Southampton.

Another feature of early heraldry which
it is well to bear in mind is the sparing use
of what is known as quartering, or the
method of combining in one shield the arms
of two or more persons or families. One
of our oldest instances of this occurs on the
tomb of Queen Eleanor, the first wife of
King Edward I, at Westminster, and shows
her paternal arms of Castile and Leon so
arranged (fig. 40). Another early example
occurs in the Great Roll, *temp.* Edward II,
where the arms of Sir Simon Montagu (*ob. c.*
1316), *silver a fesse indented gules of three inden-
tures*, are quartered with *azure a gold griffin*.
So long as the shield contained only four
quarters, with the first and fourth, and
the second and third, respectively alike,
the effect was often good, as in the cases just

86

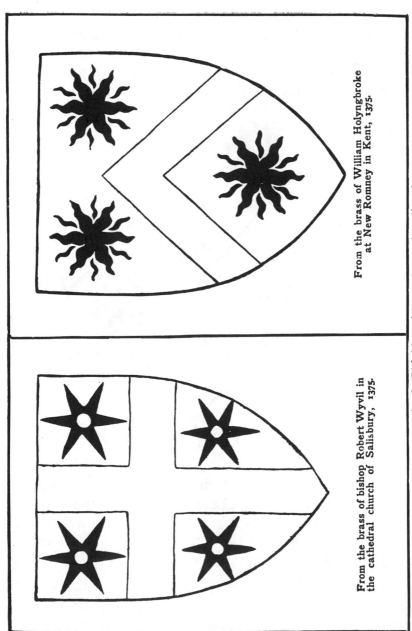

From the brass of bishop Robert Wyvil in the cathedral church of Salisbury, 1375.

From the brass of William Holyngbroke at New Romney in Kent, 1375.

Figs. 35 and 36. Shields with uncharged ordinaries.

noted, or in the beautiful arms of France and England combined used after 1340 by King Edward III (fig. 41). There are also many examples as in the well-known bearings of

Fig. 37. Shield with a charged bend, from a brass at Kidderminster, 1415.

the Veres and of the Despensers, where a quarterly disposition of the shield forms the basis of the arms. But when, as became common in the fifteenth century, quarters were multiplied or subdivided, the artistic

effect of the old simple shield was lost or destroyed. As the principle was further extended, especially in Tudor and Stewart times, the result became more and more confused in appearance, until the field resembled rather a piece of coloured patch-work than a combination of various arms all more or less beautiful in themselves.

The origin and growth of these combinations, which actually are perfectly lawful and proper, and yet often quite accidental, can easily be illustrated by a few typical examples.

In 1382 King Richard II, who used the same arms as his grandfather, a quarterly shield of Old France and England, married Anne of Bohemia, daughter of the Emperor Charles IV. As her shield was also a quartered one, the combined arms of the king and his queen, as shown upon her seal, formed a shield of eight quarters (pl. VII A). This was further complicated through the later assumption by King Richard of the arms assigned to St. Edward (fig. 43), a cross between five birds ; and the eight-quartered shield with this clumsy addition at one side may be seen on the Felbrigge brass.

These arms of St. Edward were used for

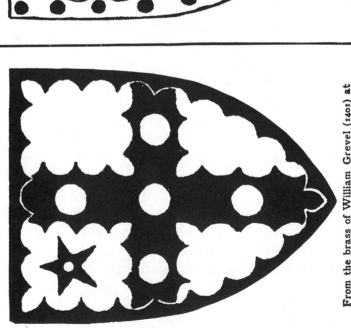

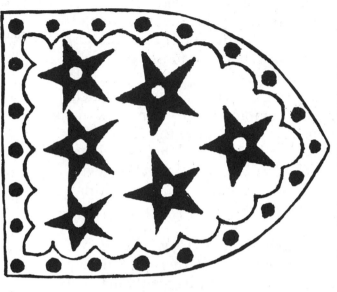

From the brass of Thomas Walysel (c. 1420)
at Whitchurch, Oxon.

From the brass of William Grevel (1401) at
Chipping Campden in Gloucestershire.

Figs. 38 and 39. Shields with engrailed borders, plain and charged.

FIG. 40. Quartered shield of Queen Eleanor of Castile,
from her tomb at Westminster, 1291.

a time duly 'differenced' in conjunction
with his own quarterly arms by Henry of

Lancaster, afterwards King Henry IV, and are impaled with those of his wife, Mary de Bohun, on his seal (1399) as duke of Hereford. Artistically the lop-sided effect so produced is quite unhappy.

Many fifteenth century shields show

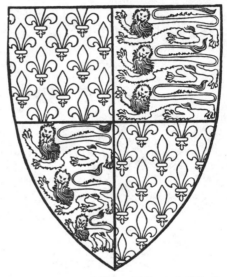

Fig. 41. Arms of King Edward III, from
his tomb at Westminster.

forth, by the simple quartering of a man's arms with those of his wife or his mother, his succession or summons as a lord of parliament, or his inheritance of great estates.

But this simplicity was gradually de-
stroyed when the added quartering was
itself quartered, as in the arms of Richard

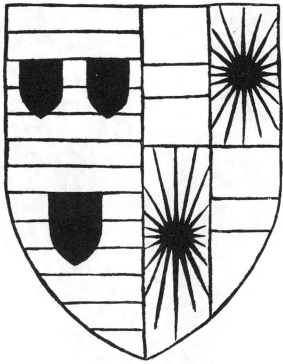

FIG. 42. Shield with impaled quarters, from
the brass of Peter Halle (*c.* 1420) at Herne
in Kent.

Nevill earl of Salisbury (see pls. XVII A and
XXII B), or the quarterings were all different,
as in the case of Humphrey Stafford duke

93

of Buckingham. When but a year old he
succeeded his father as earl of Stafford,
and on his mother's death he became earl

Fig. 43. Arms of St. Edward, from the tomb of Edmund
duke of York (*ob.* 1402) at King's Langley.

of Buckingham, Hereford, Northampton,
Essex, and Perche! These dignities are

94

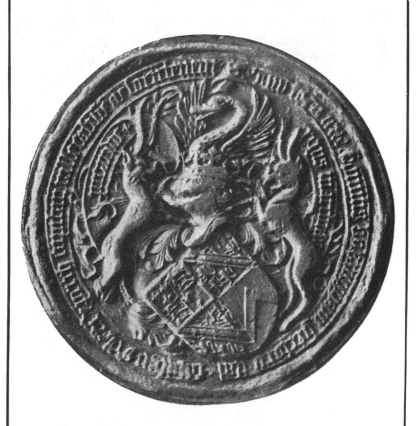

Fig. 44. Seal of Humphrey Stafford earl of Buckingham, Hereford, Stafford, Northampton, and Perche, as captain of Calais and lieutenant of the Marches. 1442.

duly displayed in the quarterings of his arms
on his seal, as follows: 1. The quartered arms
of his mother, for the earldom of Bucking-
ham. 2. Bohun of Hereford. 3. Bohun of
Northampton. 4. Stafford (fig. 44).

When Henry duke of Buckingham
succeeded in 1460 to all the dignities of
duke Humphrey his grandfather, he wisely
elected, by the advice of the kings-of-arms,
to drop the above quarterings, and to use
only the arms of his great-grandmother,
who as sister and heir of Humphrey duke
of Gloucester and earl of Buckingham
bore *France and England quarterly within a
border silver*.

About 1433 Margaret, daughter of
Richard Beauchamp earl of Warwick, was
married to John Talbot earl of Shrews-
bury, and she thereupon had a beautiful
seal engraved, with two large shields of
arms hung side by side by their straps
from a ragged staff, the badge of her
father's house (pl. xxvii b). This charm-
ing composition is, however, quite spoilt
through the complicated treatment of the
shields. One of these bears the arms of
husband and wife conjoined, the other
those of the lady's father. The earl of
Warwick's shield is a quartered one of

Beauchamp and Newburgh, with a small superimposed scutcheon. The earl of Shrewsbury's arms also consisted of four quarters, to which his wife added her four (omitting the scutcheon), and thus made a patchwork of eight.

A more remarkable and equally accidental case may be illustrated by the brass of Sir Humphrey Bourchier (1471) in the abbey church of Westminster.

This displays four shields : one has the arms of Bourchier quartering Lovain and impaling the quarterly arms of Berners ; and another, the six quarterings of Sir Humphrey's wife, Elizabeth Tylney. In a third shield these are quite properly impaled, with a resultant of fourteen quarters. In the fourth shield these are quartered together, and so produce a dreadful confusion of twenty-eight quarters ! It is not necessary here to show how these shields might have been simplified in themselves, but from the artistic standpoint there cannot be any doubt that the two first should at least have been kept separate. The many other examples to be found in the illustrations of this book will serve as useful reminders of the greater advantage artistically of simpler treatment.

97

It is moreover well to remember that in the majority of cases there is not the least need in actual work to produce a great many quarterings in a shield. In numerous examples, especially in the sixteenth century and later, they were assumed merely for display, and to reduce them to a reasonable few is often a most desirable thing.

It is difficult without knowledge of individual cases to lay down any definite rules for dealing with quarterings, but there can be no question that in general a shield looks best without any at all. In the case of a man with a compound name or title, who represents more than one family or dignity, it would be legitimate to add a quartering on that account, but only of the actual arms of the family or dignity represented. It is however so hard to draw a line or to restrain the wishes of clients that the fifteenth century example of Henry duke of Buckingham should ever be borne in mind.

As soon as the principle of hereditary descent of armorial bearings became established, the necessity arose of making some slight difference between the arms of a father and those borne by his sons. This was usually done by adding to the paternal

98

arms such more or less unobtrusive device
as a label, or narrow border, or a small
charge like a crescent or a molet.

The lord John of Eltham, son of King
Edward II, bears upon his tomb at West-
minster a beautifully carved shield of the
arms of England differenced by a border
of France ; and one of the sons of King
Edward III, Thomas of Woodstock,
differenced his father's arms by a silver
border, as at an earlier period did Edmund
earl of Kent, the youngest son of King
Edward I.

The label is a narrow band with long
pendent strips or pieces, usually three,
but sometimes four or five in number,
placed upon and across the upper part
of a shield (fig. 45). It is now used
to distinguish the arms of an eldest son
from those of his father, but this was
not always the rule, and younger sons of
King Henry III and King Edward I, and
at least three of the sons of King Edward
III, besides the Prince of Wales, bore dis-
tinctive labels for difference. Anciently,
the label was very narrow, and the pendent
pieces of equal or nearly equal width
throughout, even when charged with de-
vices, as they sometimes were. The colour

99

was also a matter of choice. The first
three Edwards, during their fathers' life-
time, successively bore blue labels, some-
times of three, sometimes of five pieces,

FIG. 45. Shield of Sir Hugh Hastings, from
the Elsing brass (1347), with diapered
maunch and a label of three pieces.

while the younger brother of King Edward
I, Edmund earl of Lancaster, used a label
of France (blue with gold fleurs-de-lis)
of four pieces, and Thomas of Brotherton,

100

second son of King Edward I, a silver label of three pieces.

In the case of the sons of King Edward III, the Prince of Wales bore at first a silver label of five and later of three pieces ; Lionel duke of Clarence seems to have borne at one time a gold label with a red cross on each piece for Ulster, and at another a silver label charged on each piece with a red quarter for Clare ; John of Gaunt duke of Lancaster bore an ermine label for his earldom of Richmond (pl. 11); and Edmund duke of York a silver label with three red roundels on each piece (pl. xxi b). The rolls of arms furnish instances of labels of all colours, and with pieces charged with various devices, such as leopards, eagles, castles, martlets, etc.

Differencing with labels was likewise extended to crests, and a good example may be seen on the monument of Edward prince of Wales (*ob*. 1376) at Canterbury (fig. 46), as well as in fig. 139.

In modern heraldry the label is often drawn unduly wide, with short and ugly wedge-shaped pieces hanging from or sticking on to it, and sometimes it does not even extend to the sides of the shield. The result is that instead of its being a

comparatively unobtrusive addition to the arms the label becomes unduly conspicuous and void of all artistic effect.

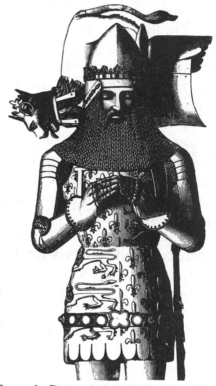

FIG. 46. Part of the gilt-latten effigy of Edward prince of Wales at Canterbury, showing labels over both the arms and the crest.

The old way of differencing by the addition of a crescent, molet, or similar device

was generally carried out in quite an artistic fashion on account of the care taken to place the device agreeably, a favourite position being on the principal ordinary or charge of the arms.

Many cadets of the great family of Nevill, for example, differenced the arms of their house, *gules a saltire silver*, by placing the device on the middle of the saltire, and some of the Beauchamps placed the differencing mark on the fesse of their arms. In other cases the device was placed in the upper part of the shield, or in some other such point where it would least interfere with or be confounded with the charges.

One of the most difficult differences an artist has to contend with to-day is the silver scutcheon with a red hand which is placed upon the arms of baronets. Its position of course varies, and may often be altered with advantage, and it looks all the better if drawn not unduly large and with a simple heater-shaped shield. But some artists wisely leave it out altogether.

In the case of all devices introduced as differences it will generally be found advisable to draw them to a somewhat smaller scale than the charges already in the arms.

103

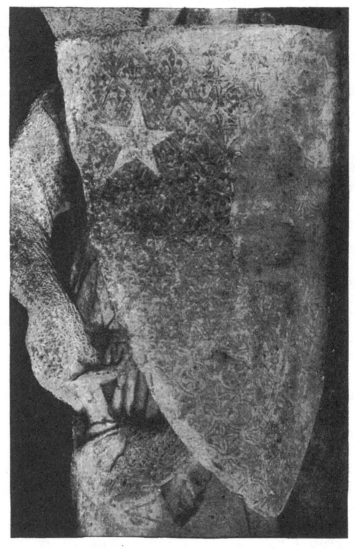

Fig. 47. Diapered shield of the arms of Vere, from an effigy
in Hatfield Broadoak church, Essex.

In many ancient heraldic shields, especially in painted glass, and to a lesser extent in carved work and on seals, the plain uncharged surfaces of the field or ordinaries are relieved by covering them

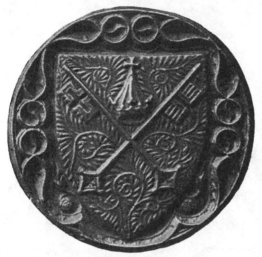

FIG. 48. Diapered shield from the seal of Robert Waldby archbishop of York, 1390, for the regality of Hexham.

with the purely ornamental decoration called diapering (figs. 45, 48). An early instance in relief occurs on the shield of the effigy in the Templars' church in London usually ascribed to Geoffrey de Magnavilla; and another delicately sculptured example of later date

105

is to be seen on the Vere effigy in Hat-
field Broadoak church in Essex (fig. 47).

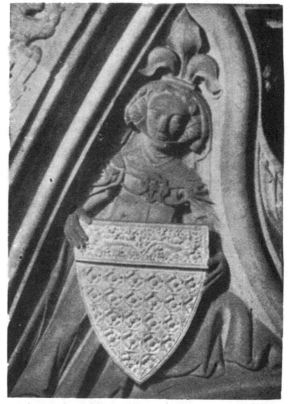

FIG. 49. Diapered shield of the arms of Clun,
from the monument of the lady Eleanor
Percy (*ob*. 1337) in Beverley minster.

Several fine instances of painted diapering
will be found in Stothard's *Monumental*

Effigies. This beautiful treatment has,
happily, been largely revived of late years

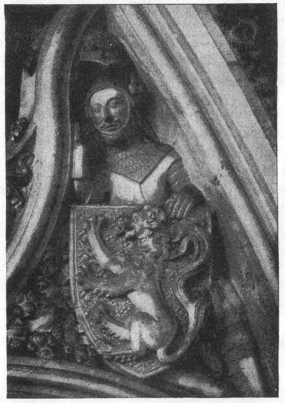

FIG. 50. Diapered shield of the arms of Percy, from the monument of the lady Eleanor Percy (*ob.* 1337) in Beverley minster.

by the glass painters, who use it quite successfully, probably from the ease with

which in their case it can be applied. Modern carvers use it very sparingly, and this perhaps is as it should be, for diapering needs to be done with great skill in sculpture to look well. A careful study therefore of old examples is advisable, in order thoroughly to understand the principles of its application.

Some of the finest diapered shields in carved work occur in the spandrels of the splendid monument of the lady Eleanor Percy in Beverley minster (figs. 49, 50). Good instances are to be found on seals, and a number of these are here illustrated in order to show the proper treatment of diapering. (See pls. VIII, XII, and XXVII A.)

It is of course to be borne in mind that diapering is merely a surface decoration, and it must not on any account be emphasized by any difference of colour from that of the field or ordinary it relieves, nor must it be treated with such prominence as to render it liable to be mistaken for a charge or charges.

Diapering can be represented effectively in embroidered work by the use of flowered or patterned damasks, as may be seen in the banners in St. Paul's cathedral church in the chapel of the Order of St. Michael and St. George.

CHAPTER III

THE SHIELD AND ITS TREATMENT
(*continued*)

Armorial Bearings of Ladies ; Use of Lozenges
and Roundels as variant forms of Shields ; Arms
of Men on Lozenges ; Combinations of Shields
with Lozenges and Roundels of Arms on Seals
and in Embroideries.

BEFORE leaving the subject of the shield
a few words must be written about the
armorial bearings of ladies.

It has always been the practice for the
daughters of a house to bear, without
difference or alteration, the arms of their
father. This practice has been departed
from only in quite modern times, by the
addition of distinctive labels to the arms
borne by our princesses. To the manner
in which married ladies have arranged or
' marshalled' their arms reference will be
made later, but it is necessary here to call
attention to the fact that it has been
customary for a long time to place the
arms of widows and single ladies upon
shields that are lozenge-shaped. A good

109

early example is that from the monument
in Westminster abbey church of Frances

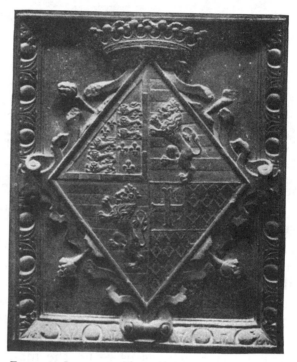

FIG. 51. Lozenge of arms from the monument
at Westminster of Frances Brandon duchess
of Suffolk (*ob.* 1559).

Brandon duchess of Suffolk (*ob.* 1559),
shown in fig. 51.

This singularly inconvenient form of
shield, upon which it is often impossible

to draw the arms properly, began to be used early in the fourteenth century.

It was not, however, used for or restricted to the arms of ladies, since the evidence of seals shows that it was at first used to contain the armorial bearings of men. There can likewise be little doubt that it and the roundel, which was also charged with arms, were contemporaneously invented by the seal engravers as variants from the ordinary form of shield ; and it is interesting to note that the majority of the examples occur on seals which have a background or setting of elaborate tracery.

The roundel seems to have originated in the covering of the entire field of a circular seal with the arms of its owner, such as the leopards of England which are so disposed in a counterseal of Edward of Carnarvon as prince of Wales. Two seals of John of Gaunt duke of Lancaster, engraved probably in 1372, show a similar treatment : the one bearing his arms impaling, and the other his arms impaled with, those of Castile and Leon (pl. VII B). The former commemorates his marriage with Constance of Castile, and the latter the duke's claim in right

111

of his wife to the kingdom of Castile
itself.

A large enamelled roundel, *party gules and azure with a gold charbocle,* accompanies the shield and crested helm which, with it, form the stall-plate of Ralph lord Bassett (*c.* 1390) at Windsor.

One of the lesser seals appended to the

FIG. 52. Seal of Robert FitzPain,
with arms in an oval.

Barons' Letter, that of Robert FitzPain, is an oval filled with the owner's arms (fig. 52).

One of the earliest examples of arms on a lozenge is on a seal of Thomas Furnival, who died in 1279, and another but little later is furnished by the seal of William de Braose, appended to a deed of either 1282 or 1314 at Magdalen College, Oxford (pl. IX B).

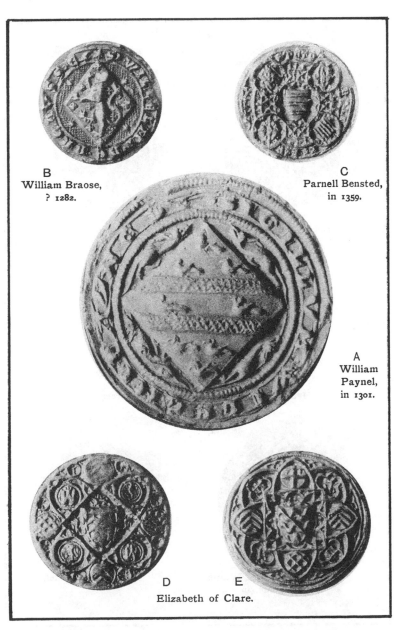

B
William Braose,
? 1282.

C
Parnell Bensted,
in 1359.

A
William
Paynel,
in 1301.

D E
Elizabeth of Clare.

PLATE IX.—Use of lozenges and roundels of arms.

A

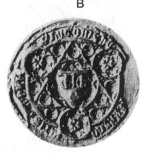

B

John de Bohun earl of
Hereford, 1322.

Hugh Courtenay earl of
Devon, 1334.

C

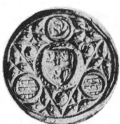

Henry Sturmy, lord of Savernake Forest, 1355.

D

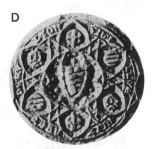

E

Elizabeth, wife of Walter
Bermyngham, in 1341.

Sibyl, wife of Sir
Edmund Arundel,
1350.

PLATE X.—Use of lozenges and roundels of arms.

That of William Paynel, appended to the Barons' Letter, also has his arms on a lozenge (pl. IX A).

The first seal of a lady in which lozenges of arms occur is probably that of Joan, daughter of Henry count of Barre and

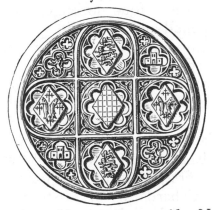

FIG. 53. Seal of Joan de Barre, wife of John de Warenne earl of Surrey, 1306.

Eleanor daughter of King Edward I, who married, in 1306, John de Warenne earl of Surrey (fig. 53). This has five lozenges arranged in cross : that in the middle has her husband's checkers, those on each side her father's barbels, etc. and those above and below the three leopards of England. The lady's descent from King Edward is further shown by the castles and lions of his consort Eleanor of Castile.

113

Another interesting example, of a date about 1320, is the seal of Parnel, daughter of H. de Grapenell, and widow (1) of John FitzJohn and (2) of Sir John Bensted (*ob.* 1323). This has in the middle a shield of the arms of Bensted, *gules three gold gemell-bars*, between four lozenges, apparently for Grapenell and FitzJohn (pl. ix c).

Contemporary with Parnel Bensted's seal are two others in which roundels are used instead of lozenges. Both are traceried seals of Elizabeth daughter of Gilbert of Clare earl of Gloucester, and Joan daughter of King Edward I and Queen Eleanor of Castile. She was thrice married : first, about 1306 to John of Burgh, son of Richard earl of Ulster ; secondly to Theobald lord Verdon ; and thirdly to Roger lord d'Amory, who died in 1322.

One of these seals has in the middle, in a shield, Elizabeth's own arms of Clare impaling Burgh within a black border bedewed with tears. Above and below are roundels of Clare, and on either side other roundels of Verdon and d'Amory. In the interspaces are the castles and lions of Castile and Leon (pl. ix D).

The other seal is similarly arranged, but has in the middle a large shield of d'Amory,

114

between roundels of arms of the lady's other husbands above and below, and of Clare for her father or herself on either side. The interspaces again contain castles and lions (pl. IX E).

Four other early seals of great artistic merit displaying roundels may also be described, especially since they are apparently the work of the same engraver. They are filled with tracery, consisting of a triangle enclosing a circle, which contains a large shield, with cusped circles on its sides containing roundels or devices.

The first is for Mary de Seynt-Pol, who married in 1322 Aymer of Valence earl of Pembroke (fig. 54). The shield bears the dimidiated arms of husband and wife; on a roundel in base are the arms of her mother; and higher up are roundels of England and France, out of compliment to King Edward II and Queen Isabel.

The second is for John de Bohun earl of Hereford, and has a large shield of Bohun with roundels also of Bohun. It was probably engraved in 1322, and before the earl's marriage in 1325 (pl. X A).

The third is for Richard FitzAlan earl of Arundel (1330–1), who succeeded to the vast Warenne estates in 1347. It has

115

in the middle a shield of FitzAlan, and
about it three roundels with the checkers
of Warenne.

The fourth is for Hugh Courtenay earl
of Devon (1334-5–40) or his son Hugh
(1340–77). The shield displays the arms

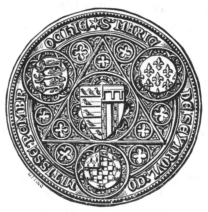

FIG. 54. Seal of Mary de Seynt-Pol, wife of
Aymer of Valence earl of Pembroke, 1322.

of Courtenay and in each of the outer
circles is a sexfoil (pl. x B).

To these examples may be added a fifth
of about the same date, for Henry Sturmy
or Esturmy, lord of the forest of Savernake.
This has the Sturmy shield in the middle,
between two roundels of the Hussey arms,
and a third roundel above with the tenure
horn of Savernake Forest (pl. x c).

116

Other seals that may be quoted in illustration of the indiscriminate use of shields, roundels, and lozenges during the fourteenth century are those of : (1) Juliana, daughter of Thomas Leybourne, and wife of John lord Hastings (*ob.* 1325), with a shield of Hastings impaling Leybourne, encircled by six lozenges of arms indicative of other alliances and descents, derived from the fact of the lady having been married thrice ; (2) Elizabeth de Multon, wife of Walter Bermyngham, with the shield of Bermyngham surrounded by six roundels of other arms ; (3) Maud, daughter of Bartholomew Badlesmere, and wife in 1336 of John de Vere earl of Oxford (fig. 55), with a shield of Vere between lozenges of Clare, Badlesmere (her father and herself), Clare with label (mother), and FitzPayn (first husband) ; (4) Maud, daughter of Henry earl of Lancaster, married first to William of Burgh earl of Ulster, and secondly (in 1343–4) to Sir Ralph Ufford (fig. 56), with lozenges of Lancaster (father and herself) above and Chaworth (mother) below, and shields of Burgh and Ufford (husbands) ; (5) Sybil, daughter of William Montagu earl of Salisbury and Katharine Graunson, with shield of FitzAlan with a

117

label, for her husband Sir Edmund of
Arundel, second son of Edmund FitzAlan
earl of Arundel, between lozenges of
Montagu and Graunson (pl. x E) ;* and (6)
Elizabeth, widow of Sir Gilbert Elsefield,
with a lozenge of Elsefield between four
roundels of other arms (impression 1382–3).

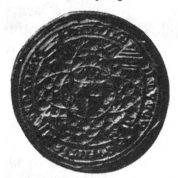

FIG. 55. Seal of Maud Badlesmere, wife of John de
Vere earl of Oxford, 1336.

Alice, wife of Thomas of Heslerton,
has on her seal (impression 1374) a large
lozenge of the arms of Heslerton (*gules
six silver lions with gold crowns*) within a
quatrefoil, outside of which are four small
banners of arms with martlets between.

Lastly may be noted a seal of Roger
Foljambe, attached to a deed of 1396–7,

* Impression attached to a deed in the British
Museum, 1350–1.

118

having a lozenge of his arms (*a bend and six scallop shells*) surrounded by his word or motto.

But seals are not the only authorities for the indiscriminate use of roundels and lozenges as well as shields of arms. In the Victoria and Albert Museum at South

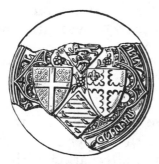

FIG. 56. Seal of Maud of Lancaster, wife (1) of William of Burgh earl of Ulster, and (2) of Sir Ralph Ufford, 1343-4.

Kensington is an enamelled coffer of late thirteenth century work decorated with lozenges of arms of England, Valence, Dreux, Angoulême, Brabant, and Lacy. The famous Syon cope *de opere Anglicano*, also in the Victoria and Albert Museum, has the existing orphrey filled with large armorial roundels and lozenges, and its border is composed of a stole and fanon embroidered throughout with lozenges of

119

It may also be noted that the pillows
(*c.* 1275) are both covered with heraldic
Redvers ; on the lower with the vair cross

* 'consuta de losenges cum armis regis Anglie et
† 'consuta de armis de Northwode et Ponyngg
‡ 'consuta de diversis armis in lozengis cum

The Shield and its Treatment

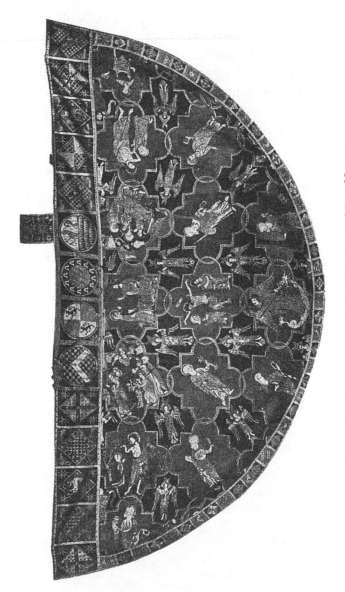

Fig. 57. The Syon Cope, now in the Victoria and Albert Museum.

with the original enamel ; the workman-
ship of this, however, is probably French.

The restriction of the lozenge to the arms of ladies has clearly therefore no medieval precedent, and there is not any reason why the modern custom should not be set aside when for artistic reasons a shield or roundel is preferable.

CHAPTER IV

THE TREATMENT OF CRESTS

Origin of Crests ; Earliest examples of Crests ; Ways of wearing Crests ; The Helm and its treatment ; Modern use of Helms ; Absurd Crests ; Use of Crests other than by individuals ; The comparative sizes of Helms and Crests.

A CREST was originally, as its name reminds us, a tuft or plume on the head of a bird. Such a plume or tuft, or bush as it was often called, was fixed in early times as an ornament on the top of a helm, of which it thus formed the crest. Other devices, such as could conveniently be so worn, were soon used for the same purpose, and like armorial bearings became associated with particular individuals. In later days when the helm enveloped the whole head, the crest played a useful part in revealing the wearer's identity, though his face was hidden.

One of the earliest suggestions of a crest in English armory appears on the second great seal (of 1198) of King

Richard I, whose cylindrical helm has a leopard upon the cap with two wing-shaped fans above turned in opposite directions. On many seals of the second half of the thirteenth century, as, for instance, on those of Robert de Vere earl of Oxford (1263)

Fig. 58. Seal of Thomas de Moulton, with fan-shaped crest on helm and horse's head. From the Barons' Letter.

and Henry de Laci earl of Lincoln (1272), the knight is represented as riding in full armour, with the helm surmounted with a fan-shaped plume, which is also repeated upon the horse's head. (See also fig. 58 and pl. xi b.)

124

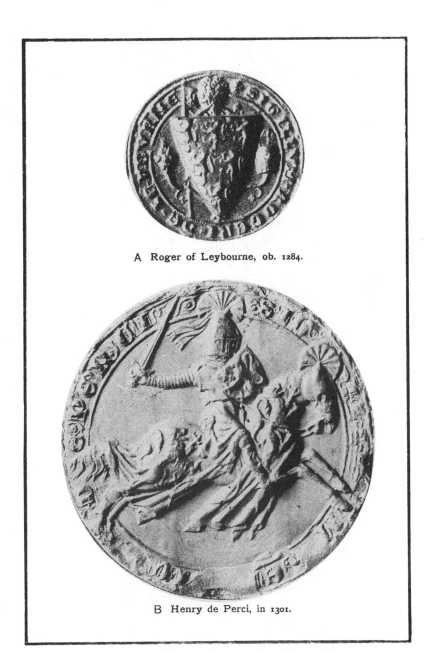

A Roger of Leybourne, ob. 1284.

B Henry de Perci, in 1301.

PLATE XI.—Early examples of crests.

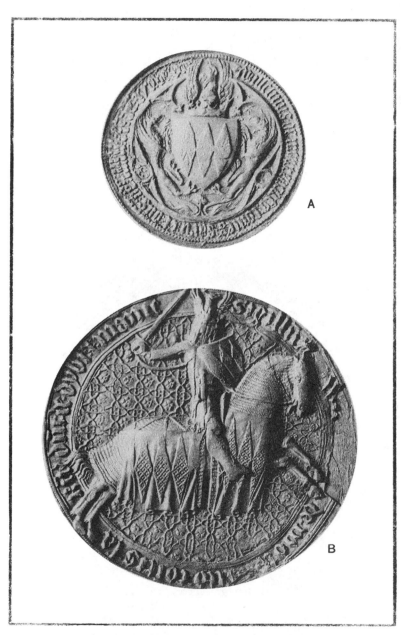

PLATE XII.—Early uses of crests, on seals of William
Montagu earl of Salisbury, 1337-44.

An early use of a crest proper is furnished by the seal of Roger of Leybourne (*ob.* 1284). This shows his shield of arms (bearing six lions) hung upon a tree, with his banner (charged with one lion only) behind, and at one side a helm with lion crest (pl. xi a). Thomas of Berkeley in 1295 has upon his seal a shield flanked by two mermaids and surmounted by a helm carrying a mitre for a crest. Thomas earl of Lancaster (1296) on two separate seals has a wiver, or two-legged dragon, upon his helm, and this again is repeated upon his horse's head (fig. 59). The seal of his brother Henry of Lancaster, appended to the Barons' Letter, also shows his helm crested with a wiver (fig. 60). Two other early examples of crests on seals from the Barons' Letter are shown in figs. 61 and 62. Sir John Peche, on a seal appended to a deed of 1323–4, has his shield flanked by wivers and surmounted by a helm with squirrel crest. William Montagu earl of Salisbury (1336–7), in the mounted figure of himself on his fine seal, has a demi-griffin fixed upon his crowned helm (pl. xii b), and King Edward III shows for the first time, on his seal of 1340, his crest of a crowned leopard standing upon the cap of estate which surmounts his helm.

125

During the first half of the fourteenth
century there is an interesting diversity in

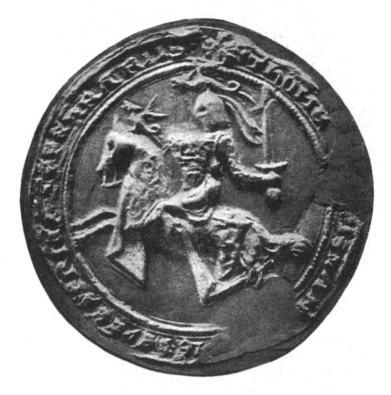

Fig. 59. Seal of Thomas earl of Lancaster, Leicester, and Ferrers, showing wiver crest on his helm and horse's head. From the Barons' Letter.

the manner of representing crests, when
not being worn by their owners.

126

William Montagu earl of Salisbury shows on his counterseal (pl. XII A) his shield supported by two griffins, and

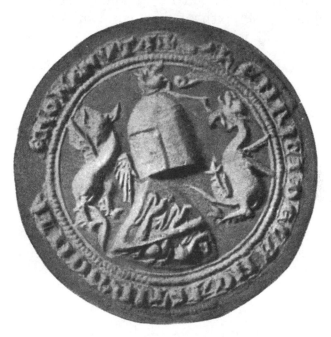

FIG. 60. Seal of Henry of Lancaster, lord of Monmouth, with wiver crest and quasi-supporters.

ensigned by the demi-griffin issuing from an open crown which in his seal he carries upon his helm. John Engayn, in 1349, has upon the upper edge of his shield a wolf or fox

walking under a tree. Henry duke of
Lancaster (1341) ensigns the shield of his
arms with a cap of estate surmounted by
a leopard (pl. XIII c); and Peter de
Mauley, the sixth of that name, in 1379-80
has a seal with his simple arms (*a bend*)
supported by two ramping leopards, and

FIG. 61. Seal of Robert
de la Warde, with
fan crest.

FIG. 62. Seal of Walter
de Mounci, with the
helm surmounted by
a fox as a crest.

surmounted by a fierce dragon breathing
defiance (pl. XX B). In none of these cases
does a helm appear.

After the middle of the fourteenth
century the crest is invariably shown as
part of the helm.

The helm, it is hardly necessary to say,
was such an one as formed part of the war

128

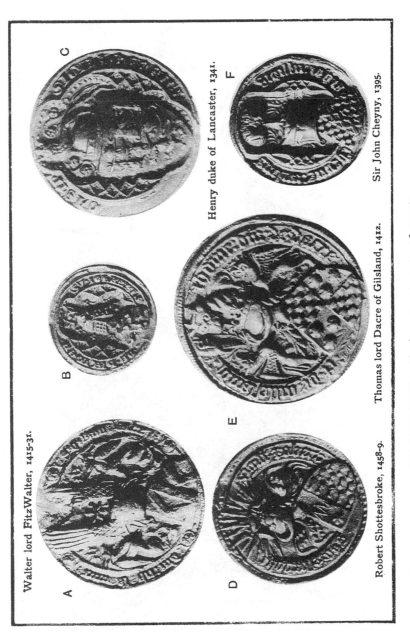

Walter lord FitzWalter, 1415-31.

Thomas lord Dacre of Gilsland, 1412.

Robert Shottesbroke, 1458-9.

Henry duke of Lancaster, 1341.

Sir John Cheyny, 1395.

PLATE XIII.—Various treatments of crests.

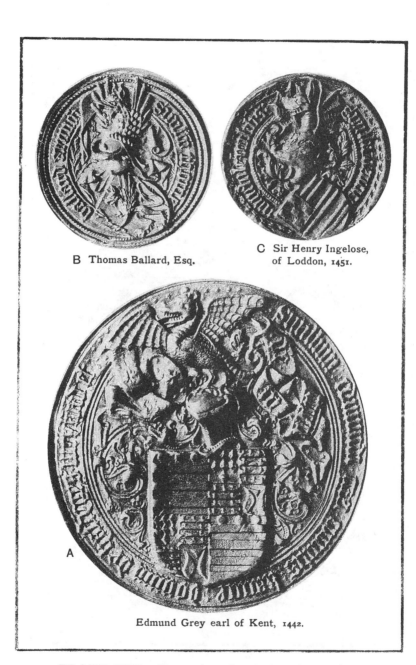

B Thomas Ballard, Esq.

C Sir Henry Ingelose,
of Loddon, 1451.

Edmund Grey earl of Kent, 1442.

PLATE XIV.—Examples of crests and mantlings.

harness of the time, and in the numerous armorial representations that may be found on seals or on monuments or buildings it is almost invariably shown in profile. This was, however, merely on account of its being the most convenient way of displaying the crest, and, in accordance with the usual medieval common-sense, examples are to be found which show the helm and crest facing the observer.

Thus Thomas de Holand (1353) has on his seal a shield of his arms hung from a tree and flanked by two fronting helms, each encircled by a crown and surmounted by a huge bush of feathers ; Sir Robert de Marni (1366) flanks his shield, which is also hung from a tree, with two fronting helms, each crested with a tall pair of wings rising from the sides of a cap of estate (fig. 63) ; Sir Stephen Hales (1392-3) on his seal has a couched shield of his arms surmounted by a fronting helm, with a crown about it from which issue two fine wings ; Robert Deynelay (1394-5) in like manner shows his helm crested with two ears of a bat or hare ; and Walter lord FitzWalter (1415-31) has on his seal a couched shield, and on a fronting helm above a cap of estate surmounted by a star between two large

129

wings (pl. xiii a). Another example of
a fronting helm is shown in pl. v b.

The present custom of using various
types of helm facing different ways to
denote grades of rank is comparatively
recent as well as often inconvenient, and
utterly subversive of the proper method of

Fig. 63. Seal of Sir Robert de Marni, 1366,
with crested helms flanking the shield.

displaying a crest, which should invariably
face the same way as its wearer. This fact
is amply illustrated by the early stall-plates
at Windsor, but the modern crested helms
surmounting the stalls there were for a long
time the scoff of students of heraldry owing
to the absurd manner in which the crests
were set athwart the fronting helms. It is
pleasant to be able to add that the crests
have lately been replaced almost throughout

130

by a new and larger series, worthy of their surroundings, and set upon the helms in the proper way. Under the same enlightened administration the most recent

Fig. 64. Crest, etc. of Sir John Astley, from a MS. *c.* 1420.

stall-plates are enamelled creations of real artistic and heraldic excellence.

The crest was, of old time, almost always something that could actually be set upon a helm, and such objects as naturally were

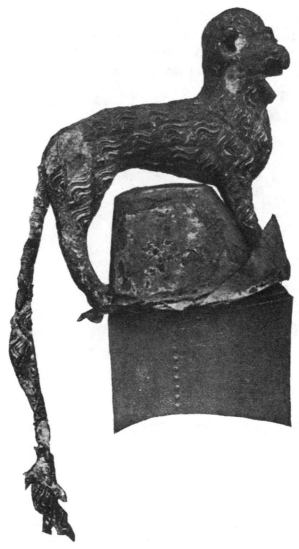

Fig. 65. Crest of Edward prince of Wales, 1376 of leather
and stamped gesso, from his tomb at Canterbury.

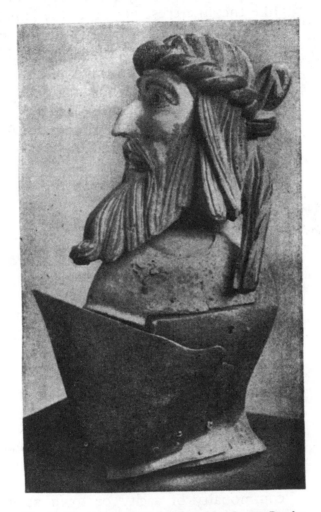

Fig. 66. Funeral helm and wooden crest of George Brooke
lord Cobham (*ob.* 1558) in Cobham church, Kent.

too large or too heavy were modelled in boiled leather, wood, or other light material : like the fine crest borne at the funeral of Edward prince of Wales, now over his tomb at Canterbury, which is a leopard standing upon a cap of estate and modelled in leather covered with stamped gesso (fig. 65) ; or the soldan's head of carved wood that surmounts the funeral helm of George lord Cobham, in Cobham church, Kent (fig. 66).

Such impossible crests as the pictorial scenes and other absurdities granted by the kings-of-arms during the eighteenth and nineteenth centuries, and even back to Elizabethan days, would not have been thought of at an earlier period, when heraldry was a living art.

The degradation of the proper use of a crest, other than by those entitled to wear one, began as soon as the kings-of-arms presumed to grant armorial bearings by their bestowing crests upon impersonal corporate bodies like the London livery companies, such as the Tallow Chandlers (1456), Masons (1472), and Wax Chandlers (1485–6).

Arms were borne by the mayor and commonalty of a city or town at least as

134

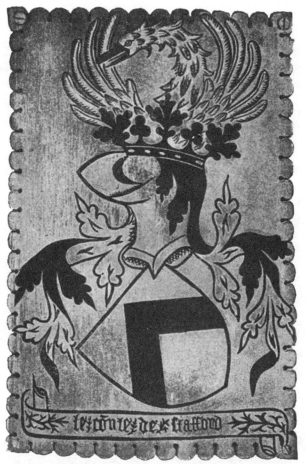

Fig. 67. Stall-plate of Humphrey duke of
Buckingham as earl of Stafford, *c.* 1429.

early as 1283 in the case of Chester, and of
1305 in the case of Dover (or the Cinque

135

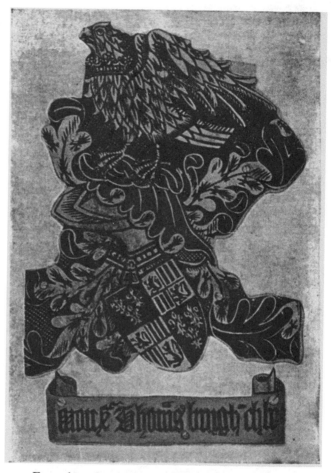

Fig. 68. Stall-plate of Sir Thomas Burgh,
c. 1483.

Ports), but none presumed to use a crest
until London did so on the making of a

new seal in 1539, and no crest was granted to a town before 1561.

Before leaving crests a word must be said as to their comparative sizes.

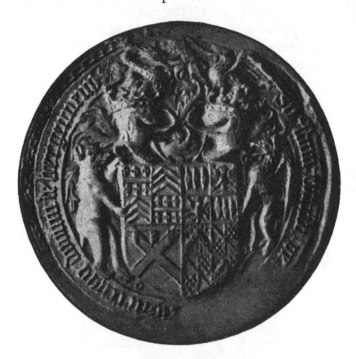

FIG. 69 Seal of Richard Nevill with separate crests and supporters for his earldoms of Salisbury and Warwick.

Throughout the best period of heraldic art the crested helm and the shield in pictorial representations practically balance

137

one another, but there is occasionally a tendency to diminish the shield, and so apparently to enlarge the crest. This may be seen, for example, in several of the early stall-plates at Windsor (figs. 67, 68), which otherwise are admirable models as to the treatment of crests in general. They also show very clearly how easily and comfortably the crests surmount the helms.

A remarkable early English example of the use of *two* crests is furnished by a seal of Richard Nevill (1449–71), the 'Kingmaker,' who was earl of Salisbury, and, in right of his wife, also earl of Warwick (fig. 69). This exhibits two helms above the multi-quartered shield, the one carrying the Beauchamp swan for the earldom of Warwick, the other the Montagu griffin for the earldom of Salisbury.

CHAPTER V

MANTLINGS

*Origin of Mantlings ; Simple early forms ;
Colours of Mantlings ; Medieval usage as to
colours of Mantlings.*

In actual use the helm seems often to have
been covered behind by a hanging scarf or
cloth of some kind, perhaps to temper the
heat of the sun, like a modern puggaree.
Heraldically this is represented by what is
now called the mantling.

At first this was a simple affair, worn
puggaree-wise, but by degrees it was
enlarged in representations until it ex-
tended on either side beyond the helm,
and was disposed in graceful twists and
folds with dagged edges, which have been
supposed to represent the cuts it was liable
to receive during fighting (figs. 70, 71).

The usual colour for the mantling, for a
long time, has been red, and its lining of
ermine or white fur, but there is ample
precedence for a difference of treatment, as
may be seen in that rich collection of

139

ancient heraldic art, the stall-plates at Windsor.

The earliest surviving plate, that of Ralph lord Bassett (K.G. 1368-90), has a

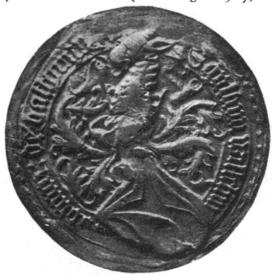

Fig. 70. Seal of William lord Hastings, *c.* 1461.

short black mantling, to match the boar's head that forms his crest (fig. 72). A large group of plates set up in 1421 exhibits a considerable variety. Thus the plate of Sir Sanchet Dabrichecourt has a red mantling powdered with gold lozenges, a treatment suggested by two bands of red similarly decorated which encircle the bush of feathers forming his crest (fig. 73). The

140

mantling of William lord Latimer is of red and silver stripes, and that of John lord Beaumont, like the field of his shield, is, together with the cap of estate, of blue

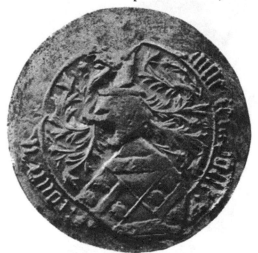

Fig. 71. Seal of William de la Pole earl of Suffolk, 1415.

powdered with gold fleurs-de-lis. Sir Walter Pavely has also a blue mantling.

Sir William FitzWaryn's mantling is quarterly per fesse indented of red and ermine, like his shield of arms. The Captal de Buch, Raynald lord Cobham, Hugh lord Burnell (fig. 77), Hugh lord Bourchier (pl. xvi), and Sir Thomas Banastre have black mantlings,

141

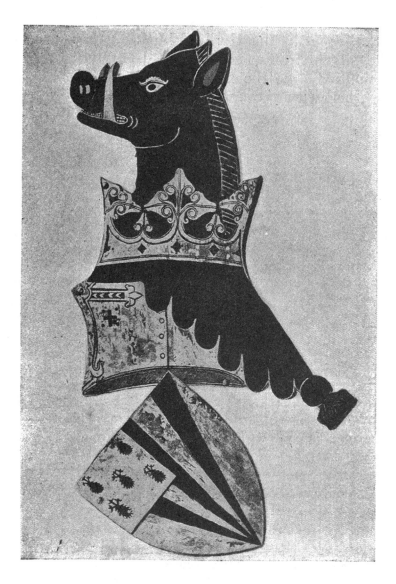

Fig. 72. Stall-plate of Ralph lord Bassett, showing simple
form of mantling.

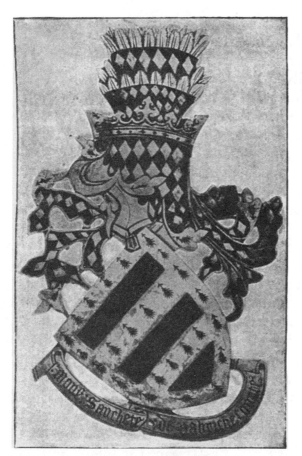

Fig. 73. Stall-plate of Sir Sanchet Dabriche-
court, c. 1421.

and John lord Bourchier and William
lord Willoughby d'Eresby (pl. xv) white
mantlings lined with red. Sir Miles

143

Stapleton and the Soudan de la Trau have black mantlings lined with red. Several early mantlings, too, are formed entirely of silver feathers, with red, black, or other linings. These usually accompany a feathered crest, like Sir William Arundel's griffin (fig. 74), or the earl of Warwick's swan (fig. 75), or Sir Thomas Erpingham's bush of feathers. Another curious variation, which is found on four early plates, has the colour of the mantling different on the two sides of the helm, such as red on one side, and blue or black on the other. In about a dozen plates between 1450 and 1470 the red, and in one case the blue, ground of a mantling is relieved by a trailing pattern in gold, sometimes in lines only, but more usually as leafwork or flowers. In the plate of Walter lord Hungerford (el. 1421) the mantling on his banner-like plate is barred with red and ermine (see fig. 136), in allusion to the arms of his lordship of Hussey. Lastly, in the plate of Richard lord Rivers (el. 1450) the mantling is red, sown with gold trefoils, and lined with white, with gold tassels at the ends (fig. 76). This is derived from the crest, which is the upper part of a man brandishing a scimitar,

144

and clad in a red tunic with standing collar Mantlings and large hanging sleeves, also sown with

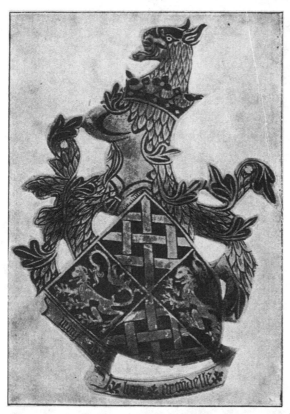

Fig. 74. Stall-plate of Sir William Arundel, *c.* 1421.

trefoils. The sleeves are cleverly arranged in the plate, as if forming part of the

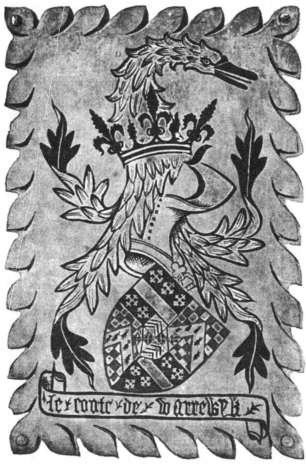

FIG. 75. Stall-plate of Richard Beauchamp earl of
Warwick, after 1423.

mantling, and are similarly dagged and
lined and tasselled. On the stall-plate

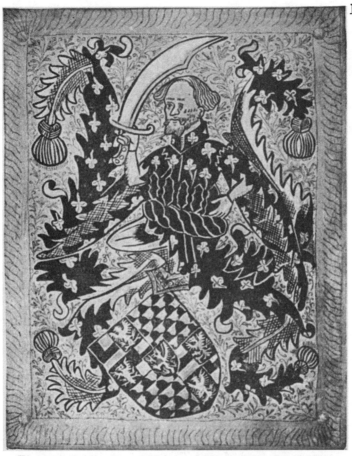

Fig. 76. Stall-plate of Richard Wydville lord Rivers,
c. 1450.

(*c.* 1483) of Francis viscount Lovel the
mantling is of purple sown with gold
hanging locks.

147

CHAPTER VI

CRESTS AND CROWNS, CAPS OF ESTATE, AND WREATHS

Crests within Crowns ; Nature and treatment of Crowns ; Caps of Estate : Their possible origin and introduction into Heraldry ; The colour of Caps ; The placing of Crests upon Caps ; Wreaths or Torses ; Their Colour ; Crests and Mottoes ; Use of Crests by Bishops ; The ensigning of Arms with Mitres, Cardinals' and Doctors' Hats, and Caps of Estate.

THE treatment of the crest varies. In the earliest examples it is set directly upon the mantled helm (fig. 77 and pls. XIV A and XVII B), to which it was actually attached by wires through holes on top. But from the first large numbers of crests were fixed, or rose as it were, from within a crown or coronet encircling the helm, or stood upon a cap or hat of estate that surmounted it. (See figs. 65, 67, 72, 73, 74, 75, and pls. XIII E and F, XVII A, XXI, XXII, XXVII A, etc.)

The crown was merely ornamental, and had no reference to the dignity of the

148

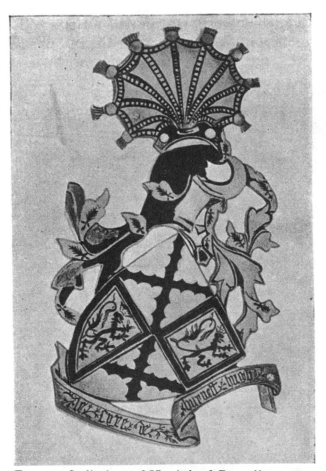

FIG. 77. Stall-plate of Hugh lord Burnell, *c.* 1421.

wearer, but was used alike heraldically by prince and peer, knight and esquire, and the same may be said of the cap of estate.

149

Crowns were anciently formed of a
number of leaves or fleurons set upright
upon the band, sometimes with lesser
leaves or jewels between them ; the bands

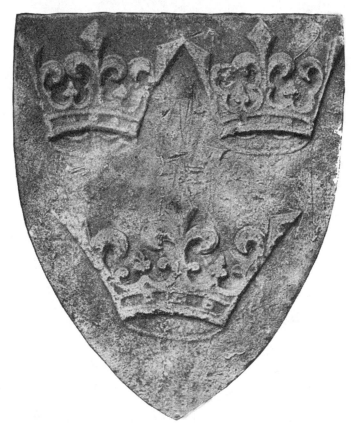

FIG. 78. Arms of St. Edmund, from the tomb of Edmund
duke of York (*ob*. **1402**) at King's Langley.

150

too were often jewelled. But in practice only three (fig. 78), or sometimes five, principal leaves are shown when the crown is drawn in profile (fig. 83).

Beyond the fact that the thing was a crown, there was no strict rule as to the design, which varied according to the taste of the artist. Two examples among the early stall-plates at Windsor, those of Hugh Stafford lord Bourchier (fig. 79 and pl. XVI) and Richard lord Grey of Codnor (both *c.* 1421), illustrate this in a pretty way (fig. 80). In both cases the plate after being finished has been cut up, partly reversed, and in part re-engraved ; not because anything was wrong with the heraldry, but to make the crested helms face the other way. These have accordingly been turned over, but in cutting them afresh the engraver has slightly varied the designs of the crests and of the crowns with which each is encircled, without however in any way altering their heraldic character. In the earliest existing plates the crested helms are all drawn turned towards the high altar, consequently those on the north side of the quire face heraldically towards the sinister. The two plates just noted, and at least one other, have been

151

Crests and Crowns, Caps of Estate, and Wreaths

transferred from one side of the quire to the other.

One of the first instances of a crown

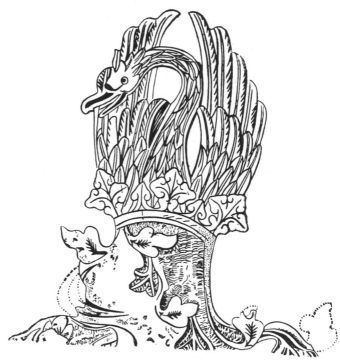

FIG. 79. Crest from the reverse of the stall-plate of Hugh Stafford lord Bourchier.

about a crest is on the seal of William Montagu earl of Salisbury, 1337 (pl. XII).

Crowns were not by any means always of gold or silver, and quite a number of

pre-Tudor stall-plates have them enamelled red, and in two cases blue.

These heraldic crowns must not be con-

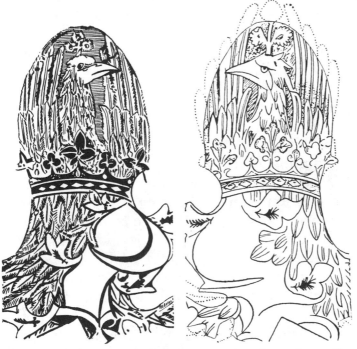

FIG. 80. Two forms of the same crest, from the stall-plate of Richard lord Grey of Codnor.

founded with the coronets, as they are now called, worn of different patterns by peers and peeresses according to their degree; some reference to these will be made later.

153

The cap of estate is generally depicted in English heraldic art as a high crowned conical hat or cap with flattened top, and a broad brim lined with ermine. The brim is usually turned up high in front, but gradually lessens along the sides towards the back, where the brim extends horizontally to its full width.

The cap of estate first appears, surmounted by his leopard crest, on the head of King Edward III in the great seal made for him in February 1339–40 on his assumption of the title of King of France. Whether the cap has any connexion with the assumption of the king's new title it is difficult to say, but its more common name of 'cap of maintenance' would acquire a significant meaning could such connexion be proved. It is however more probable that the cap was worn by the king for his dignity of duke of Normandy and of Aquitaine, and it was long the custom for representatives of those duchies to take part in coronation processions wearing robes and caps of estate. According to the *Little Device* for the coronation of Henry VII, there were to ride before the king in the procession from the Tower 'ij Squiers for the kinges bodie bearing in baudrick

154

wise twoo mantells furred wt Ermyns, wearing twoo hattes of Estate of Crymsen clothe of golde beked on, beks turnyd upp behinde, and furred also wt Ermyns in reprecentacion of the kinges twoo duchesses of Gyen and Normandie.'*

Although the cap may at first have been restricted to the king, it was certainly used by the sons of Edward III, and may be seen of like form and fashion upon the seals of Edward as prince of Wales (1343), of John of Gaunt as duke of Lancaster (1362) and of Edmund of Langley as duke of York (pl. xxi), and of Thomas of Woodstock as duke of Gloucester in 1385. It was no doubt in each case given by personal investiture by the Sovereign, but only to those who were made dukes.

In heraldry, however, the cap of estate was used after 1350 by many who were not only dukes who had been invested with it, but by earls and barons who had not been so invested, and even by mere knights (pl. xiii f).

It would be as rash to argue from this that such persons were all entitled to wear for dignity the cap of estate as it would be

* L. G. Wickham Legg, *English Coronation Records* (Westminster, 1901), 223.

155

to insist that the equally common use of a
crown round the base of a crest entitled
every knight or baron on whose seal it
occurs to wear a coronet.

The colour of the cap of estate was
almost invariably red, with a lining of
ermine, but in two of the early stall-plates
it is blue. The crest is generally placed
directly upon it, but representations of two-
legged or four-legged creatures often stand
upon the brim with their feet on either side
of the flat-topped cap (figs. 112, 138). It
is hardly necessary to say that the crested
cap is always placed upon the helm, with
the mantling issuing from under it.

It is a common practice nowadays,
quite wrongly, to represent crests apart
from the helm, and as standing upon a
twisted bar, or wreath as it is called. A
little research will show that this bar re-
presents the twisting together of two or
three differently coloured stuffs, and fixing
the wreath so formed round the base of
the crest to mask its junction with the top
of a helm. Once invented it came into
common use, and crests of all kinds were
fixed within it.

When seen sideways the rounded top of
the helm causes the crest to appear as if

156

standing upon the wreath, and this has no doubt given rise to the present malpractice.

The Rev. C. Boutell in his smaller *English Heraldry* quotes the Hastings brass at Elsing, of the year 1347, as the earliest instance of a wreath about a crest (fig. 81).

FIG. 81. Helm with crest and wreath, from the Hastings brass at Elsing, 1347.

But this brass is probably French, and in English work the wreath does not come into being much before the close of the fourteenth century, and was not regularly used until about 1450.

The wreath or torse, as it was also called, from being a twist, was usually of two colours, derived from the principal metal and colour of the arms ; but the fifteenth century stall-plates show many variations from this rule. Thus Lewis lord Bourchier (*c.* 1421) has a torse of blue, gold, and

157

black, and John earl of Tankerville
(*c.* 1421) one of green, red, and white.
John lord Bourchier (*c.* 1421) and Henry
lord Bourchier (*c.* 1452) both have black
and green torses. Richard Wydville lord
Rivers (*c.* 1450) has the crest issuing from
a green torse, crested with a crown of holly
leaves. Thomas lord Stanley (*c.* 1459)
has a torse of gold and blue with red
spots or jewels between, and Sir William
Chamberlayne (*c.* 1461) a red and blue
torse.

The modern practice is that the twists
of a torse shall be only six in number ;
but in old heraldry there was no such rule,
and any number from four may be found,
whatever would look best. In the Har-
sick brass (fig. 82) there are eleven twists.

Crests occasionally had mottoes or
'words' associated with them, quite apart
from the ordinary 'word' or 'reason' of
the family or individual. Thus the ermine
bush of feathers that formed the crest of
Sir Simon Felbrigge is accompanied on his
stall-plate (*c.* 1421) by a scroll lettered
𝕾𝖆𝖓𝖟 𝖒𝖚𝖊𝖗 (fig. 83), and on that of John
lord Scrope (el. 1461) the crest, which is
likewise a bush of feathers, has above it the
'reason' 𝖆𝖚𝖙𝖗𝖊 𝖖𝖟꞊𝖊𝖑𝖑𝖊. Two of the fine

158

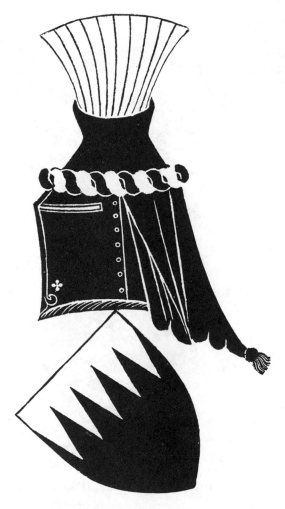

Fig. 82. Helm with crest and torse and simple
form of mantling, from the Harsick brass
at Southacre, 1384.

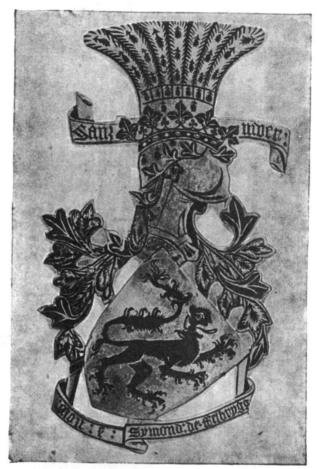

Fig. 83. Stall-plate of Sir Simon Felbrigge,
c. 1421.

seals of Richard Nevill earl of Salisbury
(1428–60) have behind his demi-griffin

160

crest a scroll lettered apparently **ma** [*or* **do**]
plefier (pls. XVII A and XXII B), and the
seal of John Talbot earl of Shrewsbury,
as marshal of France (1445), has a scroll
with his 'word' issuing from the mouth
of his lion crest (pl. XVII B).

From what has been said above as to
the ancient association of helm and crest,
it follows that the present fashion of re-
presenting the crest by itself, apart from
the helm to which it was always attached,
is entirely wrong. It at once renders the
crest meaningless : in appearance it forth-
with becomes insignificant ; and attempts
to treat it artistically generally end in
failure.

Let crests be shown as crests, properly
set upon practicable helms, and with
competent mantlings treated with all the
freedom that they are capable of.

It may here be noted that it has not been
customary, nor is it logically correct, for
ladies and other non-combatant persons,
such as the ministers of the Church, to use
crests ; arms they have ever been allowed
to bear. Examples, however, of the breach
of the rule as to crests even by bishops
are afforded by several of their privy seals.
Thus Henry le Despenser bishop of

Norwich (1370–1406) has his differenced
shield of arms surmounted by a mantled
helm upon which a mitre, with a griffin's
head and wings issuing therefrom, is placed
as a crest (fig. 84) ; and Alexander Nevill
archbishop of York (1374) shows his shield

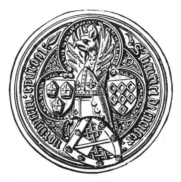

Fig. 84. Privy seal of Henry le Despenser
bishop of Norwich, 1370–1406.

hanging below a crowned helm surmounted
by the bull's head crest of his house and
supported by two griffins.

William Courtenay, as archbishop of
Canterbury (1381–96), similarly displays a
shield of his arms, ensigned by a helm sur-
mounted by a cap of estate with a dolphin
on top. A helm crested with a lovely
bunch of columbines is also carved with
his arms above the tomb of James Goldwell

162

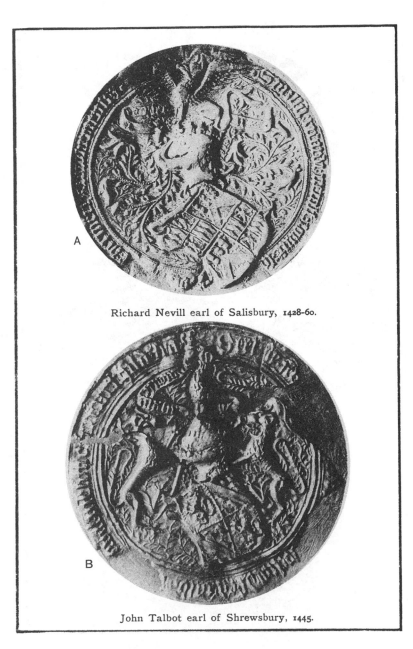

Richard Nevill earl of Salisbury, 1428-60.

John Talbot earl of Shrewsbury, 1445.

PLATE XVII.—Crests with mottoes.

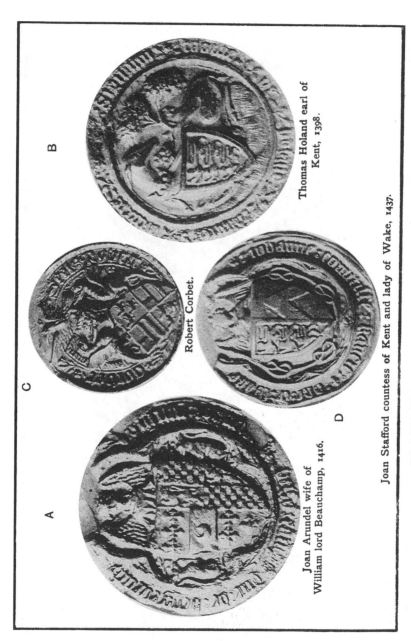

B

Thomas Holand earl of
Kent, 1398.

C

Robert Corbet.

D

Joan Stafford countess of Kent and lady of Wake, 1437.

A

Joan Arundel wife of
William lord Beauchamp, 1416.

PLATE XVIII.—Examples of supporters.

bishop of Norwich (*ob.* 1498–9) in his cathedral church.

Robert Nevill on his privy seal as bishop of Durham (1438–57) surmounts his shield with a beautiful labelled mitre, from which issues a bull's head with a scroll lettered **en grace affie.**

Many of the bishops of Durham, on their great seals in chancery, in virtue of their secular palatinate jurisdiction, are represented as riding in complete armour with helms on their heads. The first to be so represented was Thomas Hatfield (1345), who wears a large crowned helm surmounted by a mitre, from which issues a bush of feathers. John Fordham (1381) also surmounts his crowned helm with a mitre, on which is perched a bird. Walter Skirlaw (1388) and Thomas Langley (1406) set within the crowns crests without mitres; in one case the bust of an angel, in the other a bush of feathers. Robert Nevill (1438) surmounts his crowned helm with a mitre, from which issues a bull's head, as on his privy seal above noted. Cuthbert Tunstall (1530) has a mitre alone upon his helm.

The usual practice in displaying a bishop's arms has been, for a long time, to ensign

163

them simply with his own official headgear
in the shape of a mitre, and the same
custom prevailed with regard to the arms
of mitred abbots and priors. Robert
Nevill's privy seal is an early example.

Cardinals ensigned their shields with the
tasselled hat of their order, as may be seen
on the seal-of-arms of Henry Beaufort
bishop of Winchester (1405), and in a
carving of his arms in Southwark cathedral
church. A cardinal's hat is displayed, with
his rebus and sundry royal badges, on the
arch about the cenotaph of John Morton
archbishop of Canterbury and cardinal in
the undercroft of his cathedral church.

Doctors also sometimes surmounted their
arms with the round cap pertaining to their
dignity.

On the monument at St. Albans of
Humphrey duke of Gloucester (*ob*. 1446)
his arms are ensigned alternately by his
mantled and crested helm, and by a large
cap of estate encircled by a crown or coronet.
Jasper duke of Bedford (1485) on his
seal likewise surmounts his arms with a
cap of estate encircled by a delicate crown.

There is not any necessity at the present
day to represent any crown or coronet with
the cap of estate within it.

CHAPTER VII

THE USE OF BADGES, KNOTS, AND THE REBUS

CLOSELY allied with crests, but borne and
used in an entirely different way, are the
devices called badges.

The whole history of these is in itself
of great interest, and the facility with which
they lend themselves to artistic heraldic
decoration renders badges of peculiar value.

A badge is, properly speaking, any dis-
tinctive device, emblem, or figure assumed
as the mark or cognisance of an individual
or family ; and it should be borne alone,
without any shield, torse, or other accessory.
But a badge may be and often was, like a
crest, accompanied by a word, reason,
or motto. There is however this im-
portant difference between a crest and a

165

badge, that the crest was pre-eminently the personal device of its owner, while his badge might also be used by his servants and retainers. Such a use of the badge still survives in the 'crest' on the buttons of liveried servants.

The most famous and best known badge is that of the three ostrich feathers encircled by a crown or coronet borne by the Prince of Wales. It was probably introduced by Queen Philippa, who is known to have possessed plate ornamented with 'a black scocheon of ostrich feathers,' perhaps allusive of the Comté of Ostrevant, the appanage of the eldest sons of the house of Hainault. A single ostrich feather, alone or stuck in a scroll, occurs after 1343 in several seals of Edward prince of Wales, and on his tomb at Canterbury the shield of his own arms alternates with his mother's black shield with three silver ostrich feathers, each transfixing a scroll with the word 𝖎𝖈𝖍 𝖉𝖎𝖊𝖓𝖊; over the shield is likewise a scroll inscribed with the same words (fig. 85). John of Gaunt duke of Lancaster is said to have borne an ostrich feather powdered with ermine tails, and Thomas of Woodstock duke of Gloucester, the youngest

166

of Queen Philippa's sons, bore the feathers with a strap (which some have regarded as a Garter) extended along the quill (fig. 86). The Queen's great-grandson, Richard duke of York and earl of March (1436), bore the feather with a chain similarly placed ;

Fig. 85. Shield with ostrich-feather badge from the tomb of Edward prince of Wales (*ob.* 1376) at Canterbury.

perhaps Edmund of Langley, his grand-father, had done the same. Henry of Lancaster, the son of John of Gaunt, on his seal as earl of Derby in 1385 (pl. xxiv c) and on that as duke of Hereford in 1399, has an ostrich feather stuck in the end of a scroll which is entwined about the feather and inscribed with the significant word **souvereyne,** and the same word is

167

repeated many times on his tomb as King
Henry IV at Canterbury.

Another notable badge is the couched
white hart of King Richard II, with which
may be named the white hind borne by his

Fig. 86. Seal of Thomas of Woodstock duke
of Gloucester with ostrich-feather and
Bohun swan badges.

kinsman, Thomas Holand earl of Kent
(pl. xviii b).

The fetterlock-and-falcon (fig. 87) and
the white rose of the house of York, the
white lion of the earls of March, the rayed
rose of Edward IV, and the silver boar of
Richard III are of course well-known

168

badges ; as well as the red and the red and white roses, the crowned fleur-de-lis, and the Beaufort portcullis, used by the Tudor kings (fig. 88).

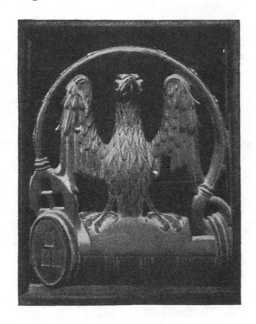

Fig. 87. Fetterlock-and-falcon badge of the house of York, from Henry VII's chapel at Westminster.

When badges first came into use in this country is uncertain, but after the middle of the fourteenth century they abound. They are foreshadowed by the free treat-

169

ment of earlier decorative heraldry, such as the little leopards on the footgear and pillows ot King Henry III's gilt-latten effigy at Westminster, and the plate with

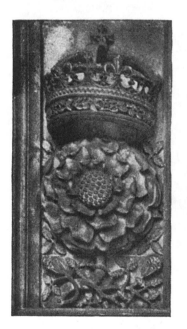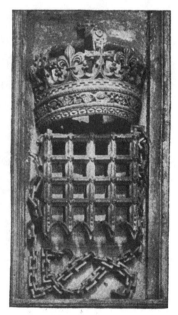

Fig. 88. Crowned rose and portcullis from King's college chapel at Cambridge.

its lozengy diaper of leopards on which it lies ; also the lozengy diaper of castles and lions which covers the metal plate whereon lies the effigy of Queen Eleanor of Castile.

170

Many badges, too, originated in devices borrowed from various sources and arranged about the shield on seals, as in figs. 89 and

Fig. 89. Seal of Robert de Clifford, with arms surrounded by rings in allusion to his mother Isabel Vipont.

Fig. 90. Seal of Robert de Toni as CHEVALER AU CING with the arms encircled by swans and talbots.

171

90, which are only two out of a number
of such appended to the Barons' Letter.

The famous white swan badge of the
Bohuns (fig. 91) is found perched upon the
shield in the seal of Humphrey Bohun earl
of Hereford and Essex, 1298 (pl. xix b).

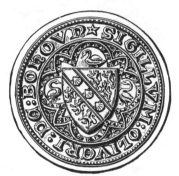

FIG. 91. Seal of Oliver Bohun with swans
about the shield.

Later on its neck was encircled by a crown
for a collar, with a chain attached, and in
this form it appears on the seals of Thomas
of Woodstock, who married Eleanor Bohun
(fig. 86), and on that lady's brass at West-
minster. It was also borne by the sons and
descendants of King Henry IV by his wife
Mary Bohun.

The gilt-latten effigies of Richard II
(fig. 92) and Anne of Bohemia have their
dresses pounced all over with badges, such

172

as the white hart, the sun-burst, and the
broom sprigs on that of the king, and the

FIG. 92. Gilt-latten effigy at Westminster of King
Richard II, pounced with badges, etc.

173

ostrich and a peculiar knot on that of the
queen. In 1380 Edmund Mortimer earl of
March left a bequest of 'our large bed
of black satin embroidered with white lions
and gold roses, with scocheons of the arms
of Mortimer and Ulster,' and in 1385
Joan princess of Wales bequeathed to
her son the King (Richard II) 'my new
bed of red velvet embroidered with ostrich
feathers of silver and leopards' heads
of gold with boughs and leaves issuing
from their mouths.' In 1397, Sir Ralph
Hastings, whose arms were a red maunch
or sleeve on a gold ground, and his crest
a bull's head, left bequests of a silver bason
and laver 'stamped with a bull's head
(*cum capite tauri*), a vestment of red cloth
of gold with orfreys before and behind
worked with maunches (*cum maunches*) and
with the colours of mine arms,' and six
salts stamped with maunches. In 1388
John of Gaunt duke of Lancaster men-
tions in his will 'my great bed of cloth of
gold, the field powdered with roses of gold
set upon pipes of gold, and in each pipe
two white ostrich feathers,' also 'my new
vestment of cloth of gold the field red
worked with gold falcons.' Two falcons
holding hanging locks in their beaks are also

174

shown on one of the duke's seals (pl. xxi A). In 1400 Thomas Beauchamp earl of Warwick left a bed of silk embroidered with 'bears of mine arms'; and in 1415 John lord le Scrope mentions in his will documents sealed *cum signato meo de Crabb*, and in a codicil made in 1453 he bequeaths 'j fayre pile of coppis conteyning xij coppis of gilt, with crabbis in ye myddes, and two coveryngis to thame with crabb.' In the north of England a crab is often called a scrap, whence its assumption by the Scropes.

Such examples as the foregoing could be multiplied indefinitely, but they will suffice to show the prevalence of badges and the many ways in which they were used. They of course abounded on seals as well as on monuments of all kinds, and in conjunction with architecture. Under this last head may be quoted such examples as the arches in Wingfield church, Suffolk (fig. 93), studded with leopards' heads, wings, and Stafford knots, commemorative of Michael de la Pole earl of Suffolk (*ob.* 1415) and his wife Katharine Stafford; the porch and other parts of Lavenham church, displaying the boars and molets of John de Vere earl of Oxford; bishop Courtenay's chimneypiece in the bishop's palace at Exeter

175

Fig. 93. Piers and arches in Wingfield church, Suffolk, with badges of Michael de la Pole earl of Suffolk (*ob*. 1415) and his wife Katharine Stafford.

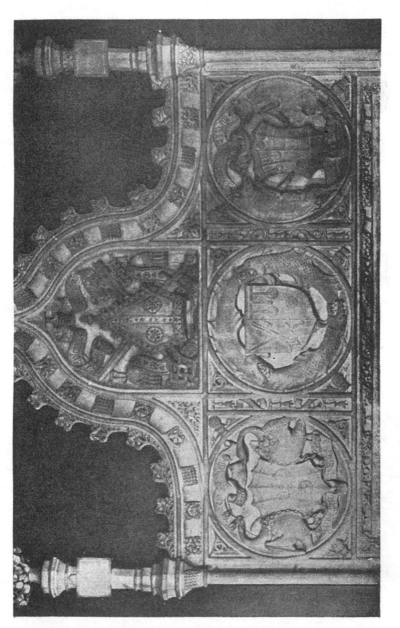

Fig. 94. Chimney-piece in the Bishop's Palace at Exeter with the arms and badges of bishop Peter Courtenay, 1478-87.

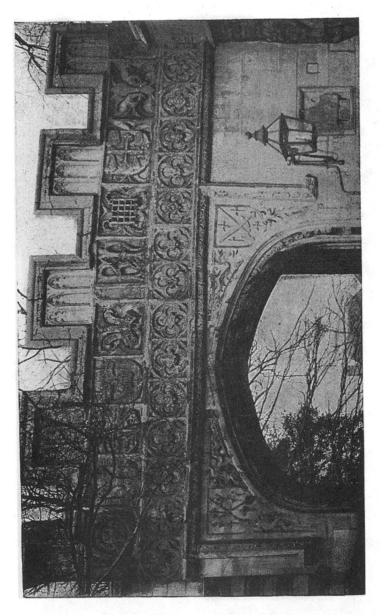

Fig. 95. Gateway to the Deanery at Peterborough. Built by Robert Kirkton abbot 1497–1526.

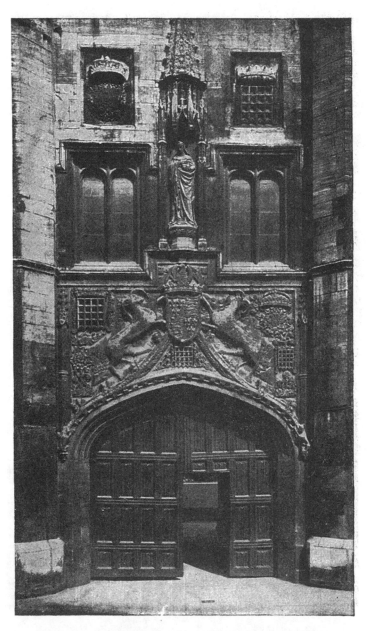

Fig. 96. The gatehouse of Christ's College, Cambridge.

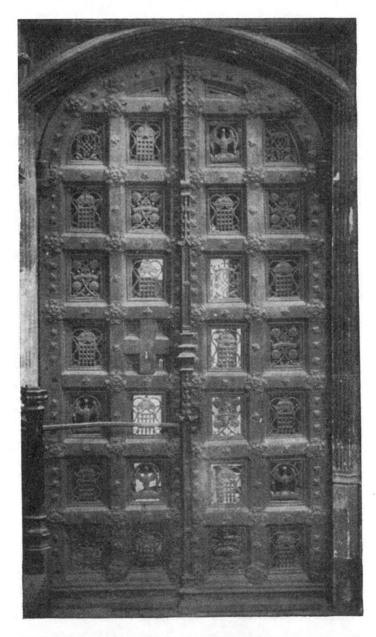

Fig. 97. Bronze door with badges of York and Beaufort, from the
Lady chapel of Westminster abbey church.

(fig. 94); and the great displays of Tudor badges on the deanery gateway at Peterborough (fig. 95), the gatehouses at Christ's (fig. 96) and St. John's Colleges (fig. 172) at Cambridge, and the noble chapel of King's College. Special mention must also be

FIG. 98. Signet with badge and crested helm of Lewis lord Bourchier, 1420.

FIG. 99. Seal of Hugh de Vere with boar badge and two wivers as supporters. From the Barons' Letter.

made of the magnificent bronze doors of Henry VII's chapel at Westminster, than which no more beautiful example of the use of badges for decorative purposes could possibly be found (fig. 97).

The sources of badges were various. As a matter of fact a man's badge was often the same device as his crest, like the

181

Courtenay dolphin, or the boar of the
Veres, or the sickle of the Hungerfords.
Sometimes the badge was derived from a
part of the arms, such as the leopards'
heads and the wings of the de la Poles, the
water-bougets of the Bourchiers (fig. 98),
the silver molet of the Veres (fig. 99), and

FIG. 100. Signet of
William Phelip
lord Bardolf(*c.*1410)
with eagle badge de-
rived from his arms.

FIG. 101. Signet with
flote badge and
word of Sir William
Oldhalle in 1457.

the Phelip eagle (fig. 100). If by chance
a badge could have any punning or allusive
meaning it was the more popular, and it
then often served as a rebus. The boar
(*verre*) of the Veres (fig. 99), the crab or
scrap of the Scropes, the pike or luce of
the Lucys, the long swords of Longespee
(pl. xix A), the *gray* or badger of Richard
lord Grey of Codnor (fig. 102), and the
wood-stock or tree stump of Thomas duke
of Gloucester, who was born at Wood-
stock, are all good examples of a practice
182

that should be followed whenever possible,
even in these degenerate days.

But in a large number of cases the badge

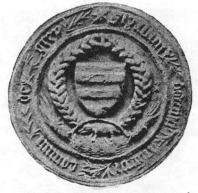

Fig. 102. Seal with badge (a *gray* or badger) of Richard lord Grey of Codnor, 1392.

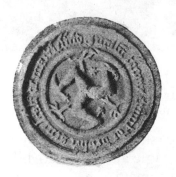

Fig. 103. Seal of Thomas lord Stanley as earl of Derby and seneschal of Macclesfield, 1485, with the eagle's claw badge of Stanley and the legs of the Isle of Man.

The use of **Badges, Knots, and the Rebus** has a different and often quite obscure origin, like the Bohun swan, the Percy crescent and swivel, the Beauchamp bear

Fig. 104. Daisy plant (*marguerite*) badge of the Lady Margaret Beaufort, from Henry VII's chapel at Westminster.

and ragged staff, the Lovel hanging-lock, the Zouch eagle and crooked billet, and the Berkeley mermaid.

A few families, *e.g.* the Staffords (fig. 105), the Bourchiers, and the Wakes, used as a badge some special form of knot, and

184

attention has already been called to the peculiar knots pounced upon the effigy of

FIG. 105. Part of the brass at Exeter of canon William Langeton, kinsman of Edward Stafford bishop of Exeter, 1413, in cope with an orphrey of \mathfrak{X}'s and Stafford knots.

Queen Anne of Bohemia. Interesting examples of the Bourchier knot may be seen on the tomb of archbishop Thomas

185

Fig. 106. Elbow-piece and Bourchier knot, from
the brass of Sir Humphrey Bourchier (*ob.*
1471) in Westminster abbey church.

Bourchier at Canterbury, and on the brass
of Sir Humphrey Bourchier at Westminster
186

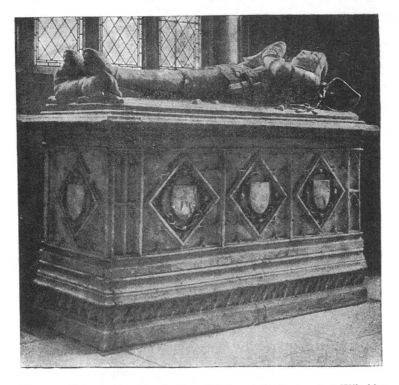

Fig. 107. Alabaster tomb and effigy of Edward Stafford earl of Wiltshire (*ob.* 1498) in Lowick church, Northamptonshire.

(fig. 106), and a good instance of the application of the knot is afforded by the seal of Joan Stafford countess of Kent and lady of Wake, who encircles her impaled shield with a cordon of Stafford knots (pl. xviii d). On the tomb at Lowick (Northants) of

Fig. 108. Rebus of abbot Robert Kirkton, from the Deanery Gate at Peterborough.

Fig. 109. Rebus of Thomas Beckington bishop of Bath and Wells, 1477.

Edward Stafford earl of Wiltshire (*ob.* 1498) the shields are encircled with cordons of Stafford knots with another Stafford badge, the nave of a wheel, alternating with the knots (fig. 107). On the canopy of the tomb at Little Easton in Essex of Henry Bourchier earl of Essex (*ob.* 1483) and his wife Isabel, sister of Richard duke of York, is a badge formed by placing a Bourchier knot within a fetterlock of York.

188

Mention has been made above of the rebus. This was invariably a badge or device forming a pun upon a man's surname, and at one time was exceedingly popular. It no doubt originated in the

FIG. 110. Rebus of John Islip abbot of Westminster, from his chantry chapel.

canting or allusive heraldry of earlier days, like the boars' heads of the Swynburnes, the trumpets of the Trumpingtons, the hammers (Fr. *martel*) of the Martels, or the scallop shells of the Scales. The *ox* crossing a *ford* in the arms of Oxford, and the *Cam* and its great *bridge* in the arms of Cambridge are also kindred examples. A large number of rebuses on names ending

189

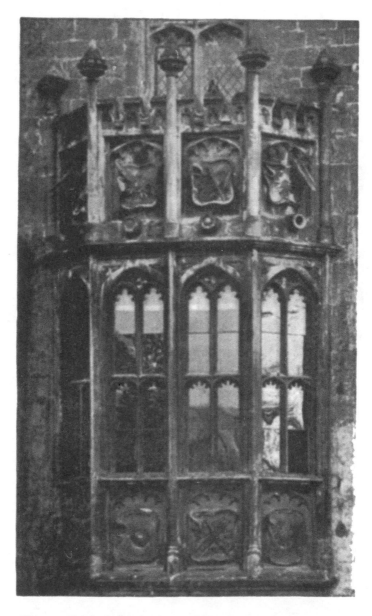

Fig. 111. Oriel window in the Deanery at Wells with badge of King Edward IV, and rebus of Dean Gunthorpe.

in 'ton' are based upon a tun or barrel, like the *lup* on a *ton* of Robert Lupton provost of Eton 1503–4, or the large church (*kirk*) and *ton* of abbot Kirkton on

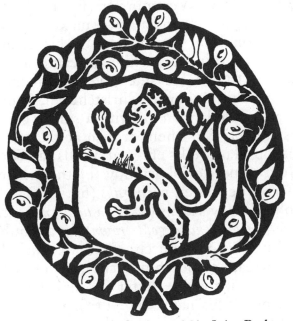

FIG. 112. Arms and rebus of Sir John Pechey (*ob.* 1522), from painted glass in Lullingstone church, Kent.

the deanery gate at Peterborough (fig. 108), or the *beacon* rising from a *ton* of bishop Thomas Beckington at Wells (fig. 109). The *gold wells* of bishop Goldwell and the *harts ly*ing in *water* of bishop Walter Lyhart

191

in their cathedral church at Norwich are well
known, as are probably the *eye* and the *slip*
of a tree which form, together with a man
falling from a tree (I slip!), the rebuses of
abbot Islip at Westminster (fig. 110). An
ox, the letter N, and a *bridge* make the rebus
of canon John Oxenbridge in his chantry
chapel at Windsor, while an eagle and an
ox with ne on his side gives the name of
prior John Oxney at Christchurch, Canter-
bury. Two large *hares* with a spring or *well*
rising between them crouch at the feet of
bishop Harewell's effigy at Wells; and dean
Gunthorpe's oriel window in the deanery
there is decorated with *guns* (fig. 111). Sir
John Pechey's arms (*azure a lion ermine with
a forked tail and a gold crown*), in a window
in Lullingstone church, Kent, are encircled
by a wreath of peach-branches, with peaches
charged with the letter e for the final
syllable of his name (fig. 112).

Here again it is needless to multiply
examples of rebuses, but the fun to be got
out of them is ample justification for urging
their adoption and use in connexion with
decorative heraldry.*

* The Rev. E. E. Dorling has taken for his rebus
a little door (doorling!) with the hinges ending in
E's, and the author of this book might fitly content
himself with the anchor of Hope!

192

CHAPTER VIII

SUPPORTERS

The probable Origin of Supporters ; Quasi-Supporters ; True Supporters: their Introduction ; Supporters of Crested Helms ; Pairs of Supporters ; Dissimilar Supporters ; The use of Supporters by Ladies ; Other ways of supporting Shields.

THE misuse of crests to which reference has been made unfortunately does not stand alone, for modern artists are quite as much at fault with regard to the proper treatment of supporters.

There can be little doubt that these charming adjuncts to heraldic compositions originated with the seal engravers, in their desire to fill up the vacant space in a round seal between the shield and its surrounding margin. In the oldest examples this was done by adding scrollwork or leafage, but in the seal of Humphrey Bohun earl of Hereford, 1220, the large shield of his arms is flanked by two smaller shields of his other earldom of Essex. The same

193

treatment occurs in the seal of his grand-son, another Humphrey Bohun earl of Hereford and Essex, 1298–1322 (pl. XIX B). Henry de Laci (1257) has the side spaces filled by two small wivers, and in the seal of Stephen Longespee (*ob.* 1260) the shield is flanked by two *long swords* (pl. XIX A). Gilbert of Clare earl of Gloucester (1262) has his shield hung on a peg and accompanied by two lions back to back, while in the seal of Edmund earl of Cornwall (1272) and son of Richard king of the Romans the shield is held up in the beak of an imperial eagle splayed or spread out behind it. Thomas earl of Lancaster (1296) on both his larger and his lesser seals has the shield flanked by two wivers, as has also his brother Henry of Lancaster (1298) (fig. 60).

Sometimes the shield is hung about the neck of a bird (fig. 113), or about a beast, as in the seal of Alan la Souche, which likewise has the shield surrounded by a number of lions (fig. 114).

During the first half of the fourteenth century little definite progress was made towards true supporters. Shields, whether hung from pegs or upon trees, or sur-mounted by crested helms, still continued

194

A

Stephen Longespee, ob. 1260.

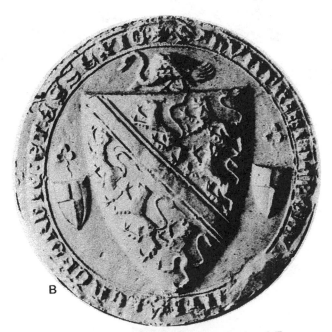

B

Humphrey de Bohun earl of Hereford and Essex,
constable of England, 1298.

PLATE XIX.—Origin of supporters.

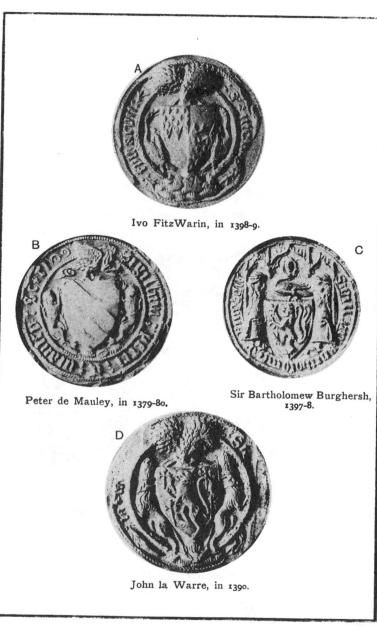

A

Ivo FitzWarin, in 1398-9.

B

Peter de Mauley, in 1379-80.

C

Sir Bartholomew Burghersh,
1397-8.

D

John la Warre, in 1390.

PLATE XX.—Shields with supporters.

to be flanked by quasi-supporters, which of
course varied much in character.

Pairs of wivers, dragons, and lions, usually back to back, the better to fit the space, and sometimes with entwined tails, were common early in the century, and

Fig. 113. Seal of John de Moun with the shield slung from an eagle and flanked by two leopards. From the Barons' Letter.

shields with splayed eagles behind may not infrequently be found (figs. 115, 116). What may be regarded as true supporters appear on the lesser seal (pl. XII A) of William Montagu earl of Salisbury (*circa* 1337), wherein two griffins seem to be holding up the shield, but it is not until well on in the second half of the fourteenth century that further definite instances become fairly common.

195

Interesting transitional usages may also be found. Thus on a seal (*c.* 1350) of Margaret Graunson two wivers uphold by their beaks the upper corners of a shield of her husband's arms, while a third wiver

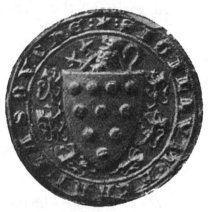

FIG. 114. Seal of Alan la Souche in 1301.

similarly grips the point. Guy de Bryen (*c.* 1350) has his shield hung upon a tree and supported at the corners by two wivers holding it by their beaks. Another lady, Joan FitzAlan, who married in 1362 Humphrey Bohun earl of Hereford, has an impaled shield of their arms held up in their beaks by two Bohun swans; and another pair of swans perform the same office in a FitzWarin seal used in 1398–9 (pl. xx A).

196

A curious variant from the ordinary flanking pair of beasts occurs on the seal

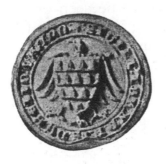

FIG. 115. Seal of John Beauchamp of Hacche with shield on breast of an eagle.

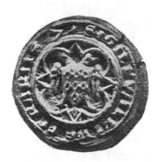

FIG. 116. Seal of William de Ferrers with shield upon an eagle with two heads.

of Edmund Mortimer earl of March (1360–81), where the arms are accompanied

197

by a pair of lions with their heads covered
by large helms with the earl's crest, a bush
of feathers rising from a crown. A similar
treatment is to be seen on a seal of John
la Warre, as used in 1390 (pl. xx D).

Analogous cases will be noted on the
seal of Sir Robert de Marni (1366) (fig.
64), whose shield hangs from a tree and is
flanked by two fronting helms with tall
pairs of wings rising from caps of estate as
crests ; also in a seal of Sir Bartholomew
Burghersh (1397–8), which has the shield
flanked by two helms crested with tall
soldans' heads, and surmounted by what
is probably his badge, a swan with a lady's
head (pl. xx c). A seal of Sir Roger
Scales (1369–86) has his seal flanked by
two long-necked wivers, and hung by a
strap from another wiver which has twisted
itself into the shape of the letter S, and
perched itself on the upper edge of the
shield.

Another case of true supporters is
afforded by a seal of Peter de Mauley in
1379–80, where a shield surmounted by a
fierce dragon (perhaps a badge) is upheld
by small lions (pl. xx B). Other supporters
of shields only may be seen on seals of
Thomas Beauchamp earl of Warwick (1369),

198

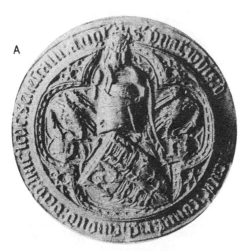

A

John of Gaunt duke of Lancaster, 1362.

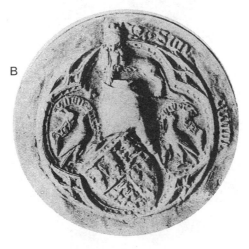

B

Edmund of Langley duke of York, 1385.

PLATE XXI.—Shields accompanied by Badges.

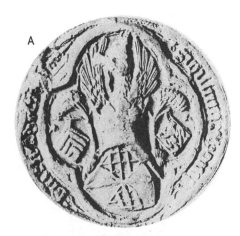

Thomas lord Despenser, before 1397.

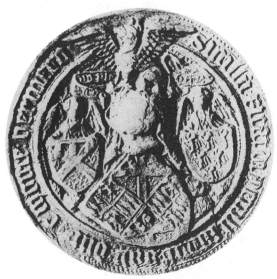

Richard Nevill earl of Salisbury, 1429.

PLATE XXII.—Quasi-supporters.

where they are bears ; and of Roger Mor-
timer earl of March and Ulster (1381),
where they are lions, as is also the case in
a seal of John Batour used in 1418–9.
In each of these cases the shield is hung
upon a tree.

In heraldic representations where the
shield of arms is surmounted by a helm
and crest, there is the same hesitation in
arriving at true supporters ; the space at
the sides being filled at first by a badge
or such device. Thus John of Gaunt
duke of Lancaster (in 1362) introduced a
pair of eagles with hanging locks in
their beaks, and his brother Edmund of
Langley duke of York (in 1385) followed
suit with a couple of falcons having in their
beaks scrolls with scriptures (pl. xxi).
John Nevill lord of Raby and seneschal of
Bordeaux (1378) flanked his arms, etc. with
two letters ƀ, while his kinsman, Sir William
Nevill, used in 1390 a seal with his arms
and crested helm accompanied by two large
stars.

The fine seal of Thomas lord Despenser
(before 1397) has on either side of his
shield and crested helm a tree from which
hangs a lozenge of arms : the one bearing
the three cheverons of Clare, for his lordship

199

of Glamorgan; the other the forked-tailed lion of the barony of Burghersh, which came to him through his mother (pl. XXII A). Richard Nevill earl of Salisbury in 1429 similarly places two angels bearing shields: one with the arms of Nevill, the other with the lions of Longespee in virtue of his earldom of Salisbury (pl. XXII B). Henry of Lancaster (afterwards King Henry IV) as earl of Derby, etc. (*c.* 1385) flanks his arms and crested helm with two ostrich feathers entwined with a scroll with the scripture **souvereyne** (pl. XXIV c), and others of the royal house similarly used ostrich feathers of other forms. Edward V as prince of Wales in 1471 flanked his arms with two scrolled ostrich feathers standing on large York roses. Thomas duke of Exeter (1416) placed a swan on either side of his armorial achievement, and William lord Lovel and Holand (1423) a hanging lock (pl. XXIII A); while Sir John Pelham (*c.* 1430) flanked his crest with his buckle badge (pl. XXIII B). On the fine seal of Thomas lord Roos of Hamlake or Helmsley (1431–64) his peacock crest is flanked by two large flowering plants, perhaps *hemlocks* (pl. XXIII E).

By the third quarter of the fourteenth

century the combination of supporters with shields of arms surmounted by crested

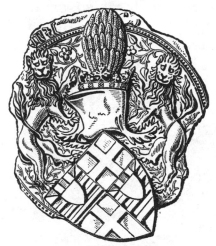

Fig. 117. Seal of Edmund Mortimer earl of March and Ulster, 1400, with rampant leopard supporters.

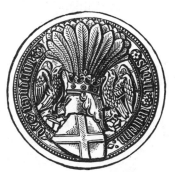

Fig. 118. Seal of Sir William Windsor, 1381, with eagle supporters.

helms had become fully established, and
henceforth the number of beautiful and
instructive examples is so great that it is
unnecessary to do more than illustrate a
typical series (figs. 117–121). It will be

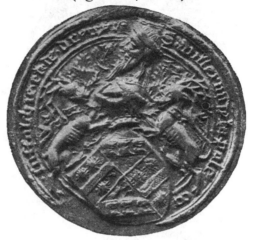

Fig. 119. Seal of William de la Pole duke
of Suffolk, 1448.

seen from these that in seals the majority
of the supporters are upholding the heavy
helm and its crest, and not the shield that
hangs below it ; probably on account of the
nature of the design. The supporters, too,
usually form pairs, and it goes without say-
ing that every variety of creature is made to
serve. Sometimes they are composed of
badges, like the falcons on crooked billets

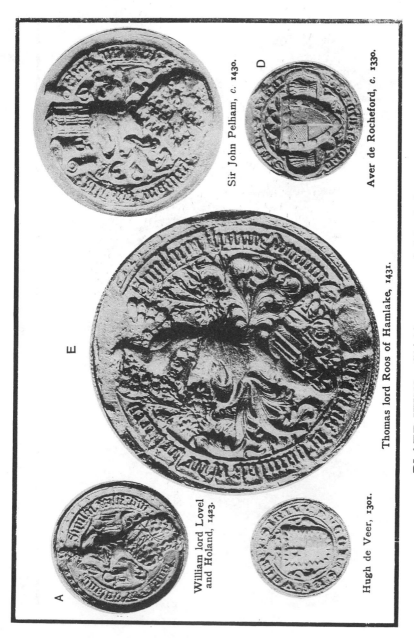

D

Sir John Pelham, c. 1430.

Aver de Rocheford, c. 1330.

E

Thomas lord Roos of Hamlake, 1431.

A

William lord Lovel and Holand, 1423.

Hugh de Veer, 1301.

PLATE XXIII.—Shields accompanied by badges.

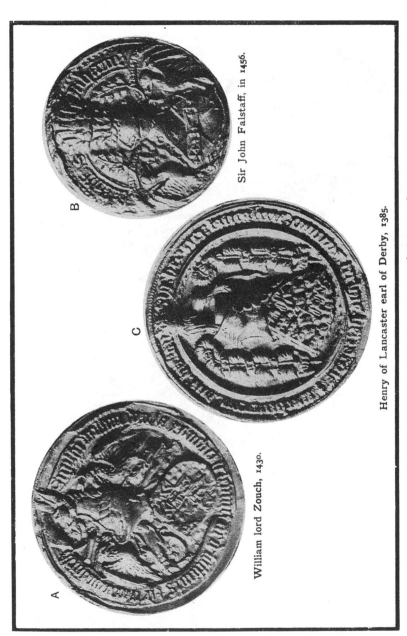

B

Sir John Falstaff, in 1456.

C

Henry of Lancaster earl of Derby, 1385.

William lord Zouch, 1430.

A

PLATE XXIV.—Shields accompanied by badges.

used by William lord Zouch (pl. XXIV A),
or the similar birds with 'words' coupled
with oak leaves and the letter t that appear

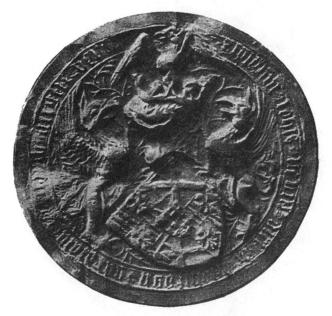

Fig. 120. Seal of John Nevill lord Montagu,
1461.

on a seal of Sir John Falstaff used in 1456
(pl. XXIV B). William lord Botraux, in a
seal used in 1426, has his armorial ensigns
flanked by two buttresses (Fr. *botreaux*);
while John lord Talbot and Furnival (1406)
has two *talbots* (fig. 122), and George duke

203

Supporters of Clarence (1463) the black bulls of Clare (fig. 123).

Where the supporters differ it is usually

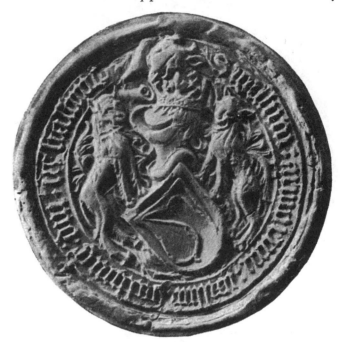

Fig 121. Seal of William lord Hastings, *c* 1461.

the case that they represent more than one dignity. Thus on one of his seals (fig. 124) Richard Beauchamp earl of Warwick (1401) used as such for supporters two muzzled bears hugging ragged staves, but on a later seal

204

(1421) as earl of Warwick and of Albe-
marle the supporters are a bear and a griffin
(fig. 125). So, too, his successor in the title
of earl of Warwick, Richard Nevill, on a fine

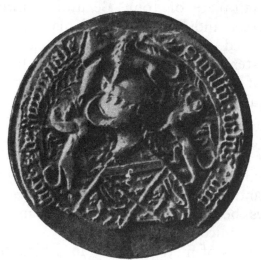

FIG. 122. Seal of John lord Talbot and
Furnival, 1406.

seal (*c.* 1451–2) has two muzzled bears for
supporters, but on a later seal (*c.* 1460) as
earl of Warwick and Salisbury his supporters
are a Warwick bear and a Montagu griffin
(fig. 69). Edmund Beaufort duke of
Somerset on his seal for the town of Bayeux
(*c.* 1445) (fig. 126) has on one side his own
eagle supporter, and on the other a spotted
dog-like beast with a crown about his neck ;

205

and Richard duke of York and earl of March on his seal as governor of France and Normandy in 1436 has for supporters the York falcon and the white lion of March. On the stall-plate of John Beaufort duke of Somerset and earl of Kendal his arms are supported by a Somerset crowned eagle and a mysterious beast called a yale,* behind each of which stands an ostrich feather with the quill gobony of blue and silver.

It is not necessary here to cite the various supporters borne by the Kings of England, but it may suffice to point out that since the union of the crowns of England and Scotland one of the royal supporters has always been a lion for England and the other a unicorn for Scotland.

In seals of married ladies in which their arms are accompanied by supporters, one often represents the husband and the other the lady's family.

Thus Joan Holand, daughter of Thomas earl of Kent, and wife of Edmund of Langley duke of York, has (after 1393) her

* For a full account of the yale or eale see papers in the *Archæological Journal*, lxviii, 173–199. The adoption of the beast by the duke of Somerset has not yet been explained, but it may be for his earldom of Kendal and partly be a rebus (Kend-eale).

206

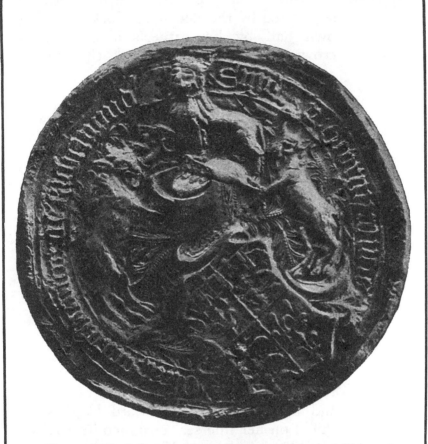

Fig. 123. Seal of George duke of Clarence and lord of Richmond, 1462, with black bulls of Clare supporting his crested helm.

husband's half of her impaled shield supported by the falcon of York, and her own half by her father's hind with its crown collar. Cecily Nevill, the wife of

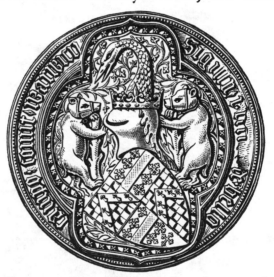

Fig. 124. Seal of Richard Beauchamp earl of Warwick, 1401.

Richard duke of York and earl of March, and mother of King Edward IV, has the shield on her fine seal ensigned by a falcon of York and supported by a stag with crown-collar and chain and by a lion of March (fig. 127). The even more splendid seal of Elizabeth Wydville, queen-consort of King Edward IV, shows as her supporters the

208

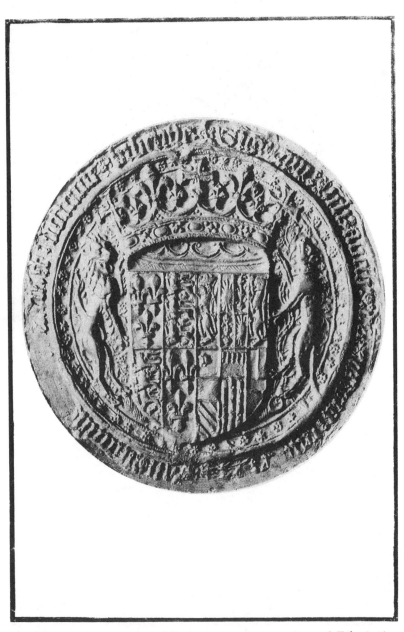

PLATE XXV.—Arms with crown and supporters of Elizabeth
Wydville, queen of Edward IV.

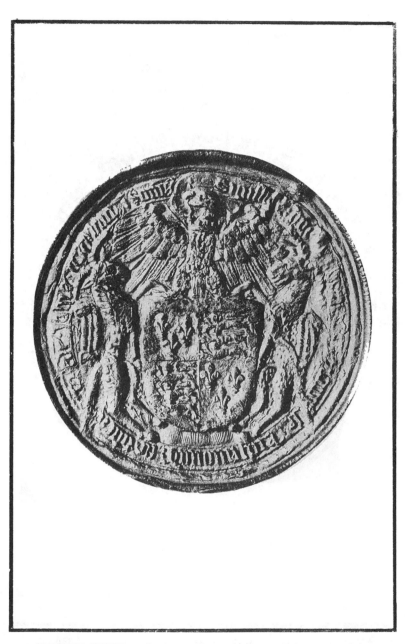

PLATE XXVI.—Arms, supporters, and badges of the
Lady Margaret Beaufort, 1455.

lion of March and a lean spotted beast not Supporters unlike an otter, collared and chained (pl. xxv). The lady Margaret Beaufort, on the

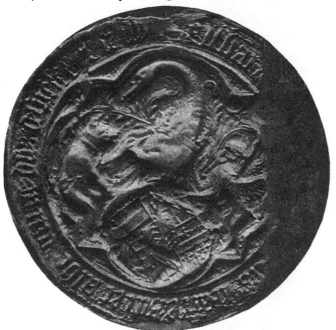

Fig. 125. Seal of Richard Beauchamp earl of Warwick and of Albemarle and lord Despenser, 1421.

other hand, ensigns on both her seals her paternal arms of Beaufort with the Somerset eagle and uses for her supporters a pair of yales (pls. xxvi, xxx).

It is of course all-important that sup-

porters should be shown standing upon something solid, and not on so precarious a footing as the edge of a motto or forked

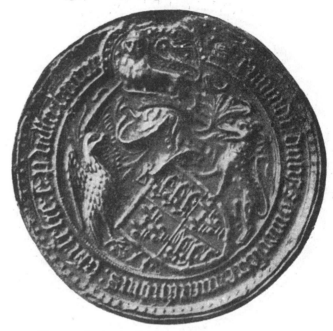

Fig. 126. Seal of Edmund duke of Somerset for the town of Bayeux, *c*. 1445.

scroll. One of the beautiful armorial groups with the supporters of King Henry VII in King's college chapel at Cambridge (fig. 128) shows how effectively and yet unobtrusively this may be done. In the splendid panel at New Hall in Essex with

210

the crowned arms, etc. of King Henry
VIII his dragon and greyhound supporters
stand in a bush of roses and pomegranates
(fig. 189) ; and in the well-known glass at
Ockwells the supporters have fields full
of flowers to stand on.

Besides the more or less regular use of
supporters just described, there are a
number of curious and irregular ways of
supporting shields. These deserve special
attention, not only from their value in
showing how delightfully heraldry used to
be played with, but as precedents for similar
variety of treatment at the present day,
when supporters so-called often do not
support anything. Over the doorway, for
example, of the National Portrait Gallery
in London the 'supporters' of the royal
arms are merely a pair of cowering beasts
at the base of the shield.

Quite an early instance of playful treat-
ment is furnished by the seal of Roger
Leybourne (*ob.* 1284). This has a small
banner standing behind the shield, which
is hung on a tree with side branches ; one
of these supports the crested helm, and the
other ends in a bunch of leaves (pl. XI A).

Thomas lord Holand and Wake (*c.*
1353) has within a traceried panel a tree

211

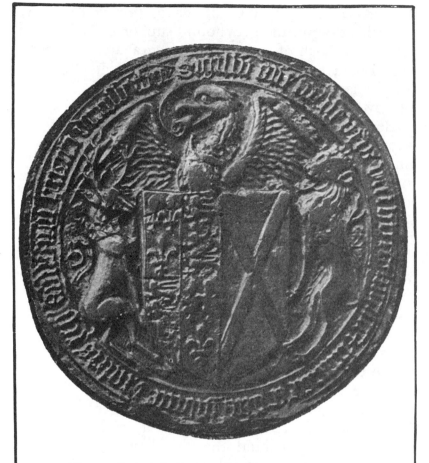

Fig. 127 Seal of Cecily Nevill, wife of Richard duke of York and mother of King Edward IV, 1461.

standing in a rabbit warren and supporting
his crowned helm with its huge bush of
feathers Hanging on either side are two

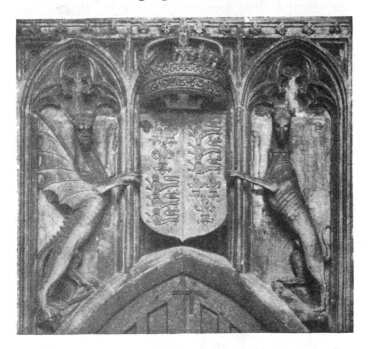

Fig. 128. Arms and supporters, a dragon and
a greyhound, of King Henry VII in King's
college chapel at Cambridge.

shields, one with beautiful diapering of his
lordship of Wake, the other (originally) of
his lordship of Holand (pl. xxvii a).
 Thomas of Woodstock duke of

213

Gloucester, son of Edward III, used from about 1385 a lovely seal with the stock of a tree standing within a paling and surrounded by water on which float two chained Bohun swans, for his wife Eleanor Bohun ; from the tree hangs a large shield of the duke's arms, with his crested helm above, and from two side branches are suspended diapered shields of the earldom of Hereford (*azure two bends, one gold, the other silver*), also in reference to his Bohun marriage.

Margaret daughter of Richard Beauchamp earl of Warwick, and wife of John Talbot earl of Shrewsbury and Waterford, in her fine shield (after 1433) suspends by their straps her father's shield and the impaled shield of her husband and herself from the ragged staff of her father's house (pl. xxvii b).

Thomas Holand earl of Kent used in 1398 a seal bearing his badge of a white hind with a crown for a collar, reclining under a tree, and with the shield of his arms hanging round its neck (pl. xviii b).

In the fourteenth century seal of the mayoralty of Calais a boar has a cloak tied about his neck and flying upwards bannerwise to display the arms of the town, which

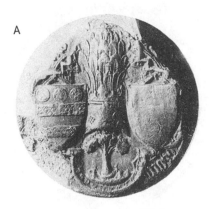

A

Thomas lord Holand and Wake, c. 1350.

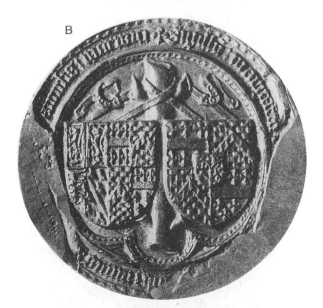

B

Margaret Beauchamp, wife of John Talbot
earl of Shrewsbury, after 1433.

PLATE XXVII.—Methods of arranging shields.

A

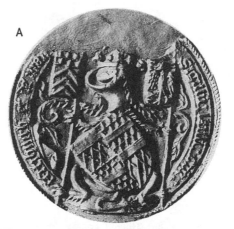

William lord FitzHugh (1429) and of Marmion.

B

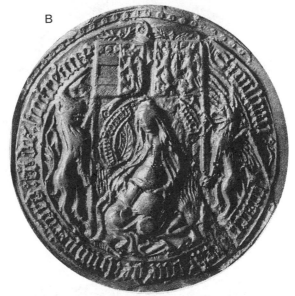

Margaret lady Hungerford and Botreaux, 1462.

PLATE XXVIII.—Examples of banners of arms.

were *barry wavy with a crowned* (?) *leopard*
rampant (fig. 129). A similar treatment
occurs on the half-florin of King Edward
III, which has for device a crowned sitting
leopard with a cloak about his neck with the
royal arms.

On one of his seals as regent of France

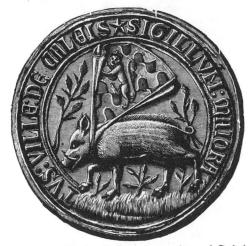

Fig. 129. Seal of the mayoralty of Calais.

(1422-35) John duke of Bedford has an
eagle standing with one leg upon his badge,
the root of a tree, and holding in its other
claw a shield of his arms.

William lord Fitz Hugh (1429) and of
Marmion shows on his seal his quartered
shield ensigned by his helm and crest,

215

which was apparently a lion's head. The rest of the beast is somewhat incongruously squatting behind the shield and has the paws thrust out on each side to grasp two banners of arms that complete the composition (pl. XXVIII A).

A similar pair of banners appears on the

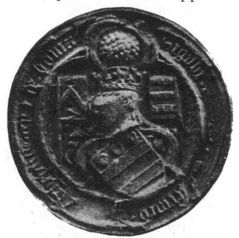

Fig. 130. Seal of Walter lord Hungerford
with banners of Heytesbury and Hussey
or Homet, c. 1420.

seal of Walter lord Hungerford, which has the shield 'supported' by two Hungerford sickles, and surmounted by the crested helm, with flanking banners of the arms of the lordships of Heytesbury and Hussey (fig. 130).

216

Banners also figure prominently on the charming seal of Margaret lady of Hungerford and Botreaux (1462) (pl. xxviii b). She was the daughter of William lord Botreaux and Margaret Beaumont, and wife of Sir Robert Hungerford, who died in 1459. The seal shows the lady in her widow's dress 'sitting upon her knees' in a garden, and reading from a book some words which are inscribed on a scroll about her head. Overshadowing her are two large banners of impaled arms : one of Hungerford and Botreaux, upheld by a lion ; the other of Botreaux and Beaumont, upheld by a griffin.

On many late thirteenth and early fourteenth century seals it was not uncommon to represent ladies holding up shields of arms. A delightful example that may be cited is that of Emmeline FitzGerald, and wife of Stephen Longespee, who is upholding her father's shield in her right and her husband's in her left hand. Below each shield is a leopard of England to show her husband's close relationship to the royal house, and on each side of her is a *long sword*. She died in 1331 (pl. xxix b).

A few cases occur where a man himself acts as the supporter of his arms. One

217

of the shields of Henry Percy earl of Northumberland (1377) shows him in armour, standing behind a large shield of Percy which he supports with his left hand. His right is upon the hilt of a sword with the belt wrapped about it, and against his left shoulder rests a banner with the Percy lion. The earl appears in similar fashion in another of his seals as lord of Cockermouth (1393). In this the shield is quarterly of Percy and Lucy, and is grasped as before by his left hand, while the right holds up a pennon charged with his badge of a crescent (pl. xxix A).

It must suffice to quote one last piece of playfulness, a seal of Richard duke of York and earl of March and Ulster (*ob.* 1460) as justice-in-eyre of the forests. This has his shield of arms suspended about the neck of a York falcon, and enclosed by the horns of a buck's head in base, in reference to his office. Upon the buck's horns are fixed two small hands for the duke's earldom of Ulster (pl. xxix c).

218

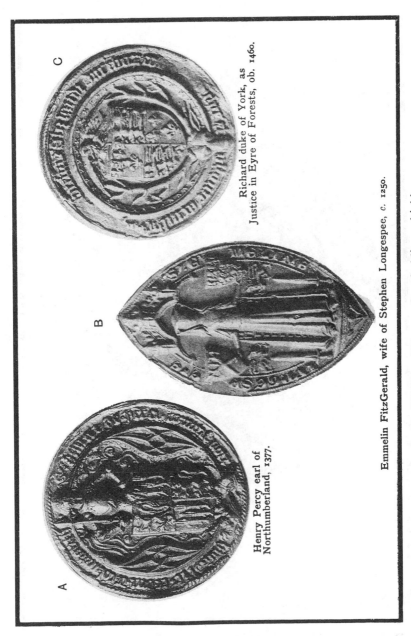

A

Henry Percy earl of
Northumberland, 1377.

B

Emmelin FitzGerald, wife of Stephen Longespee, c. 1250.

C

Richard duke of York, as
Justice in Eyre of Forests, ob. 1460.

PLATE XXIX.—Ways of upholding shields.

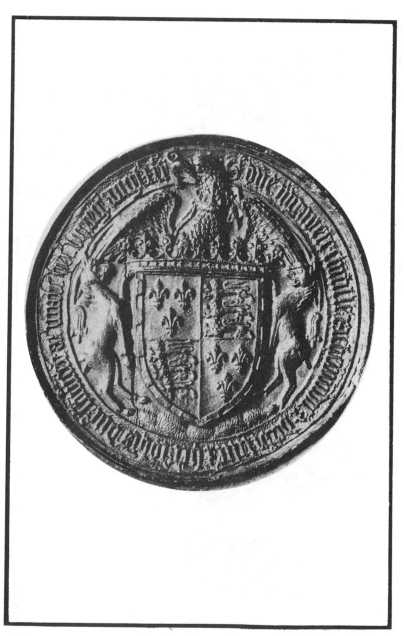

PLATE XXX.—Crowned shield with supporters and badges
of the Lady Margaret Beaufort, 1485.

CHAPTER IX

BANNERS OF ARMS

The Royal Banner of Arms ; the Banner of
the Arms of the City of London ; Shapes of
Banners ; Sizes of certain Banners ; Upright
versus Long Banners ; Advantages of the
upright form ; Banners with Achievements of
Arms ; Modern Use of Banners.

REPRESENTATIONS of banners constantly
occur in medieval pictures (fig. 131) ; and,
as has been shown above, they are not
infrequent upon seals.

Everyone is familiar with the banner of the
royal arms that betokens the presence of the
King, and with our splendid national banner
known as the Union Jack. The banner with
the arms of the city that is flown above the
Mansion House when the lord mayor is in
residence is familiar to Londoners, and the
citizens of Rochester are equally accustomed
to see the banner of their city flying on
Sundays and holidays from the great tower
of their castle. Let a banner once be re-
garded in the light of a rectangular shield

219

and its fitness to contain armorial bearings immediately becomes apparent. The King's banner is now always miscalled 'the royal

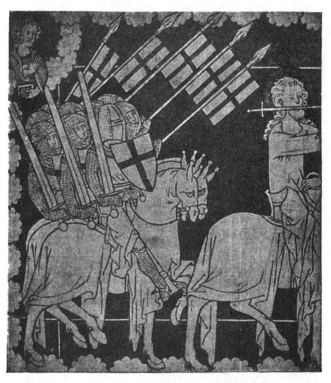

FIG. 131. Knights with banners, from an illumination in Royal MS. 19 B xv in the British Museum.

standard,' even in official language, though heraldically it is not a standard at all, but simply a banner.

220

Medieval banners at first were oblong in shape, and set upright with a longer side next the staff. In the late thirteenth century pictures formerly in the painted

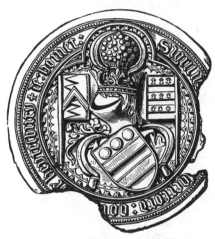

FIG. 132. Seal of Walter lord Hungerford with banners.

chamber in the palace of Westminster the banners borne by the knights were more than twice as tall as they were broad. The same proportion survives even in the famous pictorial pageant of Richard Beauchamp earl of Warwick, drawn about 1493;* but the majority of the banners therein shown have a height one and

* Brit. Mus. Cott. MS. Julius E. **IV.**

three-quarter times the width, which is
better for the display of heraldry. This is
also the proportion of the banners on
William lord Hungerford's seal (fig. 132),
but the banners with impaled arms on lady

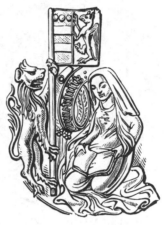

Fig. 133. Part of the seal of Margaret lady
Hungerford, with impaled banner held up
by a lion.

Hungerford's seal are nearly square (fig.
133). On the monument in Westminster
abbey church of Lewis lord Bourchier (*ob.*
1431) the large quartered banners at the
ends, upheld by lions and eagles, are slightly
less than a square and a half in area, and
admirably proportioned for displaying arms
(fig. 134). The banner of King Edward IV,

222

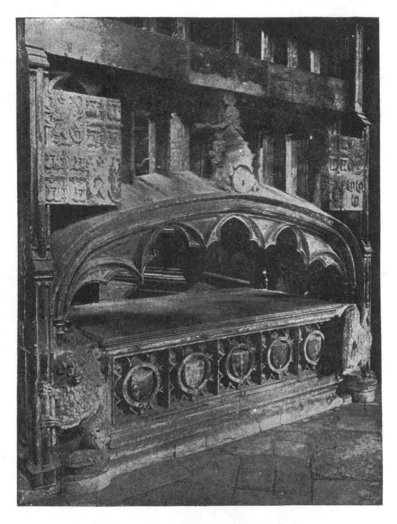

Fig. 134. Tomb of Lewis Robsart lord Bourchier, K.G. (*ob.* 1431), in West-
minster abbey church, with banners of arms upheld by supporters

'which also hung over his grave' in St. George's chapel in Windsor castle, is described as of 'Taffaty, and thereon painted quarterly France and England; it had in breadth three foot four inches, besides a Fringe of about an inch broad, and in depth five foot and four inches, besides the Fringe.'* Ashmole, in his description of the banners hung above the stalls of the Knights of the Garter, states (in 1672) that 'the fashion of the Soveraign's and all the Knight-Companions Banners are square; but it doth no where appear to us, of what size their Banners anciently were; yet in Queen Elizabeth's Reign, we find them two yards and a quarter long, and a yard and three quarters broad, beside the Fringe (which is made of Gold or Silver and Silk, of the colours in the Wreath) and thereon are wrought or beaten upon Taffaty-Sarcenet, double-Sarcenet, or rich Taffaty, with fine Gold and Colours, on both sides, the paternal Coat of the Knights Companion, together with his Quarterings, or so many of them as he please to make use of, wherein Garter is to take care that

* Elias Ashmole, *The Institution, Laws and Ceremonies of the most Noble Order of the Garter* (London, 1672), 149.

they be warrantly marshalled. . . . These Banners of Arms are fixed to the end of long Staves, painted in Oyl, formerly with the Colours of the Wreath, but now Red.'*

The remark here as to the quarterings, in view of the comments upon them in an earlier page of this book, is interesting, but it is more important to note that both the banner of King Edward IV, and those of the Knights of the Garter in Queen Elizabeth's time, were of similar proportions to those on the Bourchier monument.

The fact is that the heraldic draughtsmen of even this late period were fully as aware as their predecessors of the difficulty of drawing arms in a banner that exceeded the width of a square, and they also appreciated the greater advantage of an area that was narrower than that figure.

The longer form of banner may be tolerated for so simple a combination as the Union Jack, or even for such of its component parts as the cross of St. Andrew or the saltire of St. Patrick, but it is rarely possible so to arrange heraldry upon it as

* *Ibid.* 335, 336.

225

to look well, and even the cross of St. George looks better upright thus

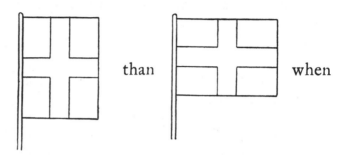

than when

extended unduly horizontally.

In the King's banner as at present borne it is practically impossible to draw the arms artistically, or with a proper balancing relation of field and charge (fig. 135). The leopards of England may be so outrageously lengthened and attenuated as nearly to fill the quarters allotted to them, but it is impracticable to display properly the upright form of the ramping lion of Scotland or to expand horizontally the Irish harp. In the banner, too, of the lord mayor of London as used on the Mansion House to-day, the sword of St. Paul in the quarter can only be drawn of the comparative size of Sir William Walworth's dagger, which it is in consequence so absurdly mistaken to be.

226

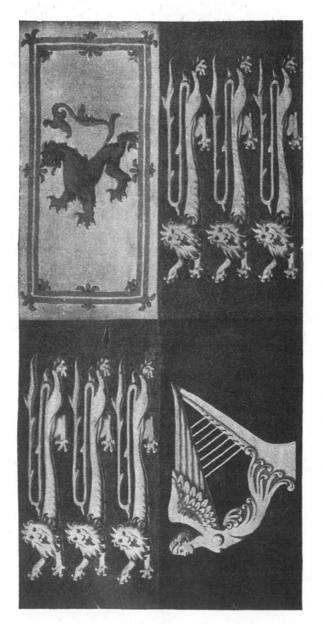

Fig. 135. The King's banner or 'royal standard' as now borne.

Were, however, the King's arms (see frontispiece) and those of his city of London placed on upright oblong or even square banners, all difficulties of drawing them would be avoided, and from appearing to be glaring examples of mean modern heraldry they would forthwith become fine pieces of artistic decoration.

A close approximation to the better way of displaying the King's arms is illustrated by the lately adopted banners of Queen Mary and Queen Alexandra, both of which show the Sovereign's arms impaling those of his consort. The King's arms are thus restricted to half the usual length of the present 'royal standard,' that is, to a square, and so can be drawn with less waste space on either side of the charges.

Whatever be their shape, banners, like shields, ought as a rule to be covered completely with the heraldry, like the banners of the Knights of the Garter at Windsor (which, though modern, are quite good in this respect) and those of more recent institution of the Order of St. Michael and St. George in St. Paul's cathedral church.

Examples are not lacking, even in the fifteenth century, of banners charged with regular heraldic achievements instead of

228

arms, and quite an interesting series may be found among the Windsor stall-plates. Two small oblong plates of Sir Peter Courtenay and Henry lord FitzHugh are practically complete banners of their arms, but Walter lord Hungerford (after 1426) displays his arms, with helm, crest, and mantling, upon a dull black banner with fringed gold border attached to a writhen gilded staff (fig. 136). Richard Nevill earl of Salisbury (*c.* 1436) (fig. 137), John earl of Shrewsbury (*c.* 1453), John lord Tiptoft (*c.* 1461), and several others have their arms, etc. on plain gold-coloured fringed banners, but Richard lord Rivers (*c.* 1450), Thomas lord Stanley (*c.* 1459), and George duke of Clarence (*c.* 1461) have the field worked all over with decorative scroll-work. Sir John Grey of Ruthin (*c.* 1439) also displays his arms on an undoubted banner with black ground and gold fringe and staff (fig. 138), and William lord Fauconberg (*c.* 1440) on a banner with the field bendy of blue and silver, with a gold fringe and staff. It is not improbable that several other quad-rangular stall-plates with coloured grounds represent banners. Edmund of Langley duke of York has the field paly of three pieces of silver, green, and black ; John duke

229

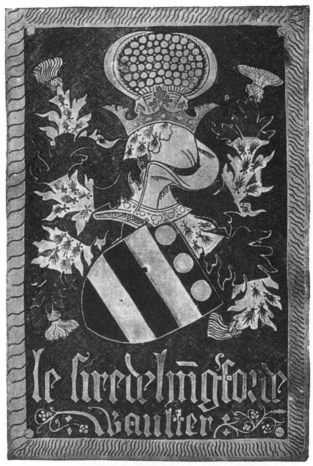

FIG. 136. Stall-plate, as a banner, of Walter
lord Hungerford, after 1426.

of Bedford (1422–3) has a ground party
blue and silver, and Thomas duke of
Exeter (*c.* 1422) a ground all black.

230

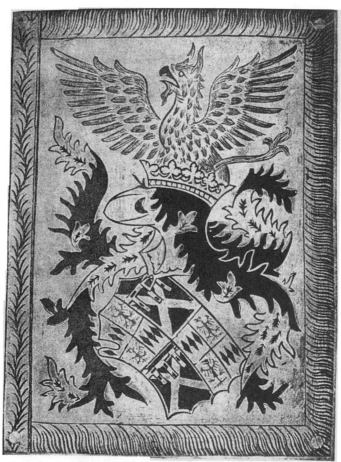

FIG. 137. Stall-plate, as a banner, of Richard
Nevill earl of Salisbury, c. 1436.

John duke of Somerset (c. 1440) has
the field of his plate bendy of silver, red,

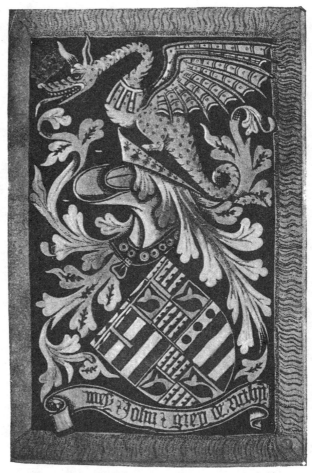

FIG. 138. Stall-plate, as a banner, of Sir
John Grey of Ruthin, *c.* 1439.

and green, with a gilded border of scrolled
leaves; and Walter lord Mountjoy (*c.* 1472)

232

disposes the same three colours in vertical stripes.

Two similar displays of heraldic achievements are to be found in a manuscript at the Heralds' College.* In one of these the arms, etc. of Sir Richard Nanfant (*ob.* 1506–7) are painted upon a quadrangular field party of blue and green. In the other the impaled shield of Sir Richard and his dame, upheld by an angel, is painted upon a ground having the upper three-fourths red and the fourth part pale pink.†

In modern practice there is no conceivable reason why banners for the display of arms should not be more widely adopted; not only as banners proper, to fly upon a staff, but in decorative art, such as painting, sculpture, and embroidery. Both the Royal Society and the Society of Antiquaries regularly notify their existence in Burlington House by displaying banners of their arms over their apartments, and their example is one that might be followed by other corporations entitled to bear arms. On the use of banners by individuals it is unnecessary to enter after the useful series

* MS. M 3.

† *Illustrated Catalogue of the Heraldic Exhibition, Burlington House,* 1894 (London, 1896), pl. xxviii.

of examples and usages thereof already
noted.

The curious flags known as standards,
which were in use during the fifteenth and
sixteenth centuries, seem to have been
borne simply for display in pageants or at
funerals. For decorative purposes they

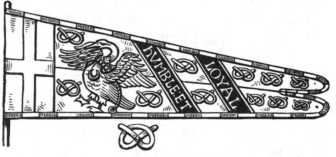

Fig. 139. Standard of Sir Henry Stafford, K.G.
c. 1475.

are most effective, and as they were anciently
borne by men of every degree down to
and including esquires, they might with
much advantage from the artistic standpoint
again be devised and brought into use.

A standard (fig. 139) was a long narrow
flag with the lower edge horizontal, and the
upper gradually descending from the staff
to the extremity, which was split into two
rounded ends. A compartment next the
staff always contained the arms of St. George.

234

The rest of the ground not infrequently was formed of two, three, or four horizontal stripes of the livery colours of the owner, and divided into three sections by two slanting bands with his word, reason, or motto. Upon the section next to the St. George's cross was generally displayed the principal beast or other device of the bearer and in later times the crest on a torse, while the other sections and the field in general were powdered with badges or rebuses. The whole was fringed of the livery colours.

The series illustrated in the volume in the De Walden Library on "Banners, Standards, and Badges from a Tudor Manuscript in the College of Arms" will supply ample evidence of the playful composition of ancient standards, and hints as to the way in which they may be invented nowadays.

Pennons were small and narrow flags of varying length, sometimes pointed, sometimes swallow-tailed at the end, fixed below the point of a lance or spear and carried by the owner as his personal ensign (fig. 140). That held by Sir John d'Abernoun in his well-known brass (*c.* 1277) at Stoke d'Abernoun is short and pointed and fringed, and

235

bears his arms (*azure a cheveron gold*). A
contemporary illustration of a large and
more fluttering form of pennon is to be

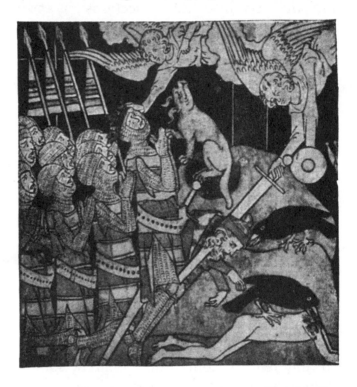

FIG. 140. Knights with pennons, from an illumination
in Royal MS. 19 B xv in the British Museum.

seen in fig. 141. An example of a pennon
charged with a badge, in the shape of the
Percy crescent, occurs on the seal of Henry

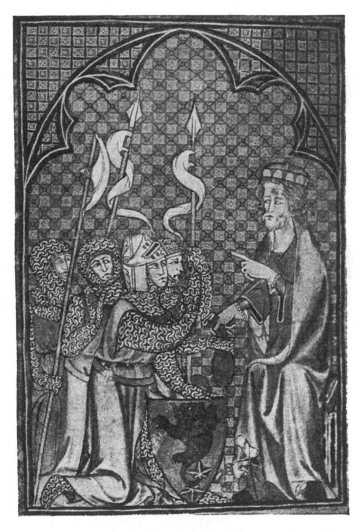

Fig. 141. Armed Knights carrying pennons, temp. Edward I,
from an illumination in Arundel MS. 83 f. 132.

Percy earl of Northumberland, who is
shown with it in his hand (pl. xxix A).

In the fifteenth and sixteenth centuries
it was not unusual to set up on gables,
pinnacles, and other high places figures of
animals holding banners as vanes or orna-
ments. Heraldic beasts as finials began to
be used even in the thirteenth century,
and an example so early as 1237 is noted
on the Pipe Roll of 22 Henry III, when a
charge occurs 'for making and setting up
a certain lion of stone upon the gable of
the King's hall '* within the castle of
Windsor. Examples of the fourteenth
century are hard to find, but in the
fifteenth century and first half of the
sixteenth they are common enough. In
most of these later examples the creatures
sit up and support shields with arms or
badges ; some, like the fine groups at
Mapperton in Dorset, once held vanes
as well.

Early vanes from their tendency to
decay are rare. In 1352–3 14s. were
spent 'upon a vane of copper painted
with the king's arms, bought to be put
upon the top of the hall of the king's

* 'Et in quodam leone de petra faciendo et
erigendo super gabulum in eadem aula.'

238

college ' * in Windsor castle ; and a delightful example, also of copper, pierced with the arms of Sir William Etchingham, its builder (*ob.* 1389), still surmounts the steeple of Etchingham church in Sussex (fig. 142). A simple specimen of an iron vane may yet be seen on Cowdray House in the same county. The octagonal steeple of Fotheringay church, Northants, built at the cost of Richard duke of York *c.* 1435, is surmounted by a fine representation in copper of his badge, the falcon within a fetterlock.

The employment of a creature to hold up a banner of arms was already no novelty in the fifteenth century, and examples have been noted above of those on the tomb of Lewis lord Bourchier (*ob.* 1431) and on the seal of Margaret lady Hungerford (*c.* 1460); to which may be added the banner-bearing lion on the seal (*c.* 1442) of Henry Percy, eldest son of Henry second earl of Northumberland. The conversion therefore of the sitting beast into a vane-holder came about quite naturally. A good instance of the end of the fifteenth century forms a charming finial to the well-

* 'Et in una vane de cupro picta de armis Regis empta ad ponendum super summitatem aule Collegij Regis ibidem, xiiij s.' Pipe Roll, 28 Edward III.

239

Banners of
Arms

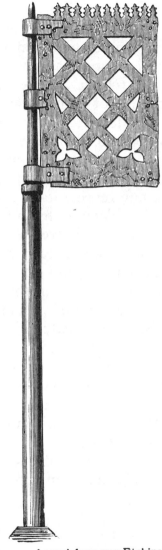

Fig. 142. Armorial vane on Etchingham
church, Sussex.

known kitchen at Stanton Harcourt in Oxfordshire, but the griffin which sits aloft there has, alas, no longer a vane to hold (fig. 143).

Quite an array of such vane-holders was set up early in the sixteenth century upon

Fig. 143. Vane formerly upon the finial of the kitchen roof at Stanton Harcourt, Oxon.

the pinnacles of the nave clerestory of St. George's chapel in Windsor castle, and the contract made in 1506 for completing the quire in like fashion provides for 'as well the vautte within furth as archebotens, crestys, corses, and the King's bestes stondyng on theym to bere the fanes on the outside of the said quere, and the

241

creasts, corses (and) beasts above on the
outsides of Maister John Shornes Chappell.'
The contract made in 1511 for finishing
the adjacent Lady chapel also includes
'making up crests, corses, and the King's
bestes stondyng on theym to bere furth
squychons with armes.' These beasts
holding their glittering vanes seem to have
been completed only so far as the great
chapel was concerned, and are plainly
shown in Hollar's engraving of the build-
ing ; but they were all taken down in 1682
by the advice of Sir Christopher Wren,
who suggested that pineapples be set up in
their stead !

Another mention of figures with vanes
occurs in the contract made in 1546 for
the building of the Coventry cross :

> And further to set on every principall
> pinnacle in the lowest story of the same
> new Crosse, the Ymage of a Beast or a
> foule, holding up a fane, and on everie
> principall pinnacle in the second story
> the image of a naked boy with a Targett,
> and holding a Fane.*

These beasts, fowls, and boys obviously

* T. Hearne, *Liber Niger*, ii. 620.

242

performed a double duty, like the creatures on Mapperton manor-house.

The exact nature of the 'King's bestes' at Windsor and elsewhere is illustrated by the accounts for the building of the great hall of Hampton Court in 1533–4. These include payments 'for the workyng and makyng of a lyon and a dragon in stone, standyng at the Gabull ends of the said hall'; 'for two pynnys of irne for stayes for the two bests of freston, standyng at the gabyll endes of the haull'; and 'for gylding and payntyng of two vanys, servyng the bests of freston stondyng at the endes uppon the haull, oon of the Kynges armys, the other of the Quenys, wrowghte wyth fyne golde and in owyle.' Further payments are 'for makyng of 29 of the Kynges bestes to stand upon the new batilments of the Kynges New Hall, and uppon the femerell of the said Hall' and 'for 16 vanys for the bestes standyng upon the battylment of the hall.' Also 'for the payntyng of 6 great lyons, standyng abowght the bartyllment, of tymber worke, uppon the Kynges New Hall, theyre vaynys gylte with fyne golde and in oyle,' and for the painting 'of 4 great dragons & of 6 grewhounds servyng the same barttylment.'

243

There are also payments to a 'Karver,
for karvyng and coutting of 2 grewhondes,
oon lybert, servyng to stande uppon the
typpis of the vycys abowght the Kynges
new haull,' and to a 'paynter, for gyldyng
and payntyng of 2 grewhondes, oon
lybert, syttyng upon basys baryng vanys,
uppon the typys at the haull endes'; like-
wise 'for gyldyng and payntyng of 24
vanys with the Kynges armes and the
Quenes badges.'*

The free use of external colouring should
be noted.

The use of the King's beasts as heraldic
adjuncts was not confined at Hampton
Court to the building only, but they were
made to do duty, in an equally delight-
ful manner, as garden decorations. Thus
the payments already quoted include
charges

for makyng and entaylling of 38 of the
Kynges and the quenys Beestes, in free-
ston, barying shyldes wythe the Kynges
armes and the Quenys; that ys to say,
fowre dragownes, seyx lyones, fyve
grewhoundes, fyve harttes, foure Inny-

* Ernest Law, *The History of Hampton Court Palace*
(London 1903), i. 346–8.

244

Fig. 144. Part of King Henry VIII's garden at
Hampton Court, from a contemporary picture.

cornes, servyng to stand abowght the
ponddes in the pond yerd ;
for cuttyng and intayling of a lyon and
grey-hound in freestoon, that is to say,
the lyon barying a vane with the Kynges
armes, &c. servyng to stand uppon the
bases of freeston abought the ponds ;
for pynnes servyng the pyllers of freestoon
that the beastes standyth uppon abowght
the ponds in the pond yerd ;
for payntyng of 30 stoon bests standyng
uppon bases abowght the pondes in the
pond yerd, for workmanship, oyle, and
collers. Also
for payntyng off 180 postes wyth white and
grene * and in oyle . . . standyng in the
Kynges new garden ;
also for lyke payntyng of 96 powncheones
wyth white and grene, and in oyle,
wrought wyth fyne antyke uppon both
the sydes beryng up the rayles in the
sayd Garden ;
also for lyke payntyng of 960 yerdes in
leyngthe of Rayle.†

The quaint aspect of such an heraldic
garden has been preserved to us in the

* White and green were the livery colours of
King Henry VIII.

† Law, *op. cit.* i. 370, 371.

Fig. 145. Part of King Henry VIII's garden at Hampton Court, from a contemporary picture.

large picture at Hampton Court itself of
King Henry VIII and his family. This
has at either end archways in which stand
Will Somers the King's jester and Jane the
fool, and behind them are delightful peeps
of the garden, with its low brick borders
carrying green and white railings, and its
gay flower beds from which rise tall painted
posts surmounted by the King's beasts
holding up their glittering vanes (figs. 144,
145).

Before finally leaving the subject of
banners, a few remarks may be offered
touching our beautiful national banner
which we call the Union Jack.

This charming and interesting com-
position is not only, in a large number of
cases when it is flown, displayed upside
down, but in a still greater number of
instances it is made quite incorrectly.

The first Union Jack, that in use from
1606 to 1801, combining as it did only
the cross of St. George for England and
the saltire of St. Andrew for Scotland,
presented little difficulty, since there was
practically no excuse for not drawing the
St. Andrew's cross straight through from
corner to corner. But the present Union
Jack is a much more difficult banner to

248

draw, as well as to understand, and the
prevailing ignorance of its history even
among so-called 'educated' people is
extraordinary.

The Union Jack consists actually of (i)
the banner of St. George with its white
field reduced to a narrow edging on all
sides of the red cross, to enable it to be
superposed, without breaking the heraldic
rule of colour upon colour, upon (ii) the
blue banner of St. Andrew with his white
cross ; but since the Union with Ireland
there has been combined with these (iii)
the banner of St. Patrick, which has a red
saltire upon a white field. This combina-
tion, in order to meet Scottish suscepti-
bilities, has been effected in a very peculiar
but ingenious way, first by treating the
Irish banner like that of England, and
reducing its white field to a narrow edging
about the saltire, and then by slitting this
down the middle of each arm, and joining
the pieces to the opposite sides of St.
Andrew's saltire similarly treated, yet so
that the Scottish pieces are uppermost next
the staff. It thus comes about that what-
ever be the shape of the flag, whether
square or oblong, two straight lines drawn
across it diagonally from corner to corner

249

should always equally divide the Scottish and Irish crosses, and if this cannot be done the flag is not correctly built up (pl. xxxi).

It also happens that unless the flag is exactly square the blue sections of the field must differ more or less in size. Ignorant flag-makers try to correct this, but only by dislocating in the middle the diagonal lines that ought always to be straight and continuous.

The right way up of a Union Jack is indicated by the Scottish, that is, the broader white, half of the diagonal members being always uppermost in the two pieces next the staff.

CHAPTER X

MARSHALLING OF ARMS

Arms of husband and wife ; Dimidiating ; Impaling ; Scutcheons of Pretence ; Impalement with Official Arms ; Arms of ladies ; Heraldic Drawing ; Mottoes ; Use and Misuse of the Garter ; Lettering and Mottoes.

In gathering up for practical consideration some of the points already discussed, as well as others that are suggested by them, something may first be said on the ways of combining the arms of husband and wife. This was done originally by simply setting them side by side, a plan which of course may still be followed whenever it is thought desirable.

For a short time during the latter part of the thirteenth and beginning of the fourteenth century the arms of husband and wife were combined in one shield by the curious device of halving or 'dimidiating' them, by joining the half of the one to the opposite half of the other, as in the arms of Aymer of Valence and Mary de Seynt Pol,

251

still borne (since 1347) by the lady's founda-
tion of Pembroke college at Cambridge.
Owing however to the many inconveniences
which this plan involved, it was soon ex-

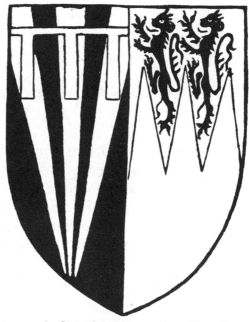

Fig. 146. Shield of Bryen impaling Bures,
from a brass in Acton church, Suffolk.

changed for the more simple way of
'impaling' or placing the entire arms of
both parties side by side in one shield
(fig. 146 and pls. viii c, xviii a, b), a
practice that has continued ever since,

252

except when the wife is an heiress. In that case the lady's arms are usually drawn upon a smaller shield and placed upon the middle of the husband's arms (pl. v A). This ugly and most inconvenient plan, though of considerable antiquity, might very well be amended by the more ancient way of quartering the arms together, as is still done by the children of the heiress. For rules for the combination of the arms of a husband who has married two or more wives, or the cumbrous regulations as to quartering, the student may, if he wishes, consult the various manuals of heraldry.

When a man is a member of any Order, such as the Garter or the Bath, only his own arms should be encircled by the insignia of the Order. Exceptions to this rule can of course be found, but it is otherwise a general one that ought strictly to be followed. Bishops are entitled to bear their personal arms only impaled with those of their bishopstool or cathedral church, and the same rule applies to deans, heads of colleges, and regius professors (like those at Cambridge) who have official arms. The chancellor of a University presumably may impale its arms with his own.

253

It has already been shown that the arms
of ladies, all through the medieval period,
were borne in precisely the same way as their
fathers' or their husbands', that is, upon
a shield, lozenge, or roundel, and that the
present inconvenient restriction to a lozenge
did not come into use much before the
middle of the sixteenth century, when
heraldry and heraldic art were already
on the down-grade. The present custom
seems to be for the arms of married ladies
to be borne upon shields, and of widows
and spinsters upon lozenges. From the
artistic standpoint it would certainly be
desirable, whenever it is thought advisable,
to revert to the freedom of pre-Elizabethan
times.

Enough has already been said as to the
elasticity of drawing shields, helms, crests,
and mantlings, and as to the proper use of
supporters, but a few words may be added
as to the proper way of drawing the various
creatures that are used in heraldry.

Since heraldry is a survival of what was
once a living thing, it is clear that if modern
work is to look well, animals and birds ought
to be drawn in a more or less conventional
manner (figs. 148, 149). Some, such as
elephants, dogs, falcons, etc. may be drawn

almost directly from nature; but others, espe-
cially lions, if so represented, would mani-
festly be unfit to consort with the leopards,
the wivers, the griffins, the two-headed
eagles, and other delightful creatures of

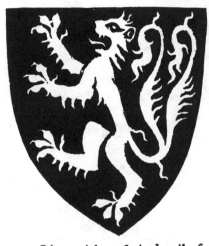

FIG. 147. Lion with a forked tail, from a
brass at Spilsby in Lincolnshire, 1391.

the early heralds which they borrowed from
the bestiaries. The conventional treatment
should not, however, be carried to excess,
nor should natural forms be too closely
copied. Here, as in other matters con-
edtnec with heraldry, a comparative study
of good ancient examples will soon show
what are the best types to follow.

255

It would be an advantage, too, if artists
would revert to the old ways of represent-

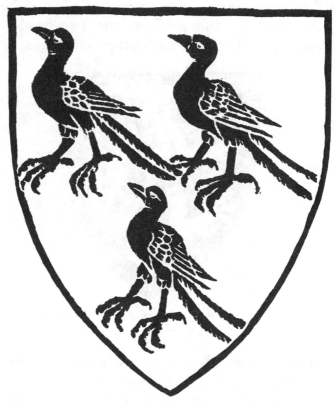

Fig. 148. Shield with three pheasants, from a
brass at Checkendon, Oxon, 1404.

ing the furs known as ermine and vair.
The ancient ermine tails did more or less
resemble the actual tail of an ermine, but

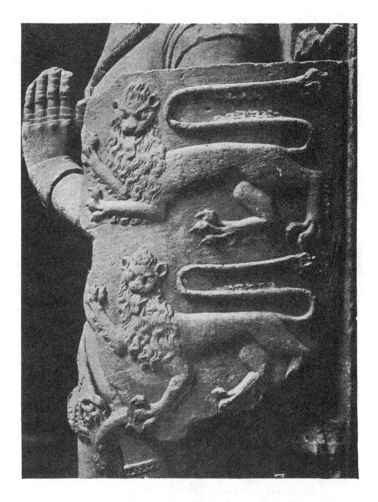

Fig. 149. Shield of the arms of Sir Humphrey Littlebury, from his effigy at Holbeach in Lincolnshire, *c.* 1360, with fine examples of heraldic leopards.

the modern object with its three dots above has no likeness to it whatever (fig. 150). So too with regard to vair, which represents

FIG. 150. Early and modern versions of ermine-tails.

the skins of grey squirrels, the modern treatment of it as rows of angular eighteenth

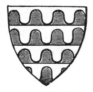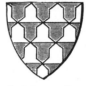

FIG. 151. Early and modern versions of vair.

century shields is far removed from the conventional forms of the real skins seen in the best old work (fig. 151).

It has already been pointed out that there are no strict rules as to the particular shades of colour allowable in heraldry, and

258

it is one of the surprises of the student to find what dull and cold tones were anciently used that yet look quite right. The apparently bright reds, for example, of the enamel in the early stall-plates at Windsor are actually brick-colour, and the apparent fine blues a cold grey ; but their combination with gilding and silvering makes all the difference in the ultimate beautiful rich effect.

One thing that ought to be most scrupulously avoided in all modern heraldic decoration is the indicating of the gilding and colouring by the pernicious 'dot-and-dash' system. This is all very well as a kind of shorthand in one's own notes or memoranda, but it is utterly destructive of artistic effect if applied in actual work. Ancient shields in relief were no doubt invariably painted, like those still to be seen behind the quire at Westminster ; but let any one try to imagine the fine series at York or St. Albans scored and pecked to indicate the colour and gilding. If the heraldic carvings are not to be painted, at any rate do not let their surfaces be disfigured. They may always be relieved by diapering.

The treatment of mottoes may not, at

first sight, seem to fall within the scope of
this work, but actually it is one of very
real importance. There is much to be said
for the theory that mottoes are derived
from the war cries of early times, and
hence their frequent association with the
crest worn upon the helm. Reference has
already been made to examples upon seals
and other authorities. The association of
a motto with a shield only was not common
anciently, and when it is so found it is
generally placed on a scroll, like the well-
known examples on the tomb of Edward
prince of Wales at Canterbury (fig. 85).
In later times, when shields began to be en-
circled by the Garter of the famous Order
(fig. 152), mottoes were often arranged
about the shield in a similar way.

There was however always this very
important and noteworthy difference and
distinction, that the buckled band now so
commonly used for mottoes was anciently
never allowed for any but the motto of
the Order of the Garter. Other mottoes
were written on a band which was fastened
in a different way, or merely disposed
Garter-wise round the shield.

The earliest known representation of the
Garter is on a singular lead or pewter medal-

lion (fig. 153) commemorative of Edward
prince of Wales, first Prince of the Order,
now in the British Museum. In this

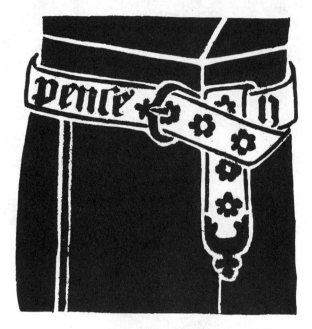

FIG. 152. The Garter, from the brass of Thomas
lord Camoys, K.G. at Trotton in Sussex.

the prince is kneeling bare-headed before
a personification of the Holy Trinity, with
his gloves on the ground before him, and
an angel standing behind him and holding
his crested helm. The whole is enclosed
by a buckled band inscribed 𝔥𝔬𝔫𝔶 𝔰𝔬𝔶𝔱 𝔨𝔢

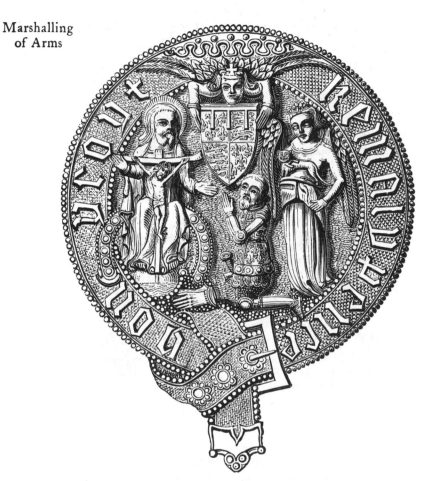

Fig. 153. Pewter medallion with Edward prince of
Wales, now in the British Museum.

𝔪𝔞𝔩 𝔶 𝔭𝔢𝔫𝔰𝔢, with a cloud overlapping
its upper margin, from which issues an

angel holding down the prince's shield of arms.

It has been customary from within a few years of the foundation of the Order in 1348 for the Knights-Companions to encircle their personal arms with the Garter.

In a wardrobe account of King Edward III, from 14th February 1349–50 to 30th September 1351, payments are entered for the making 'of two pencells of sindon *de Triple*, each having in the midst a Garter of blue sindon with a shield within the same Garter of the King's arms quartered, and beaten throughout the field with eagles of gold'; but representations of such a usage are hard to find. A good early example is afforded by the monumental brass at Trotton in Sussex of Thomas lord Camoys (*ob.* 1419) (fig. 154).

In illustration of the care above referred to of distinguishing the Garter motto from any other, two concrete examples may be cited : one on the brass at Constance of Robert Hallam bishop of Salisbury (*ob.* 1416), where the King's arms are encircled by the Garter, and the bishop's own arms by an open scroll with a scripture (fig. 155) ; the other on the west porch of the cathedral church of Norwich, where the arms of King

Henry VI have the Garter about them,
and the arms of the builder of the porch,
bishop William Alnwick (1426–36), are
surrounded by a scroll with his motto.

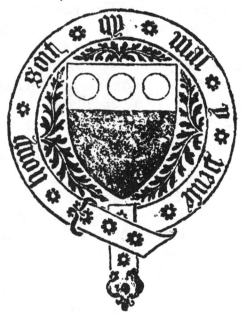

FIG. 154. Shield of arms (*a chief and three roundels
on the chief*) encircled by the Garter, from the
brass of Thomas lord Camoys (*ob.* 1419).

This distinction was carefully borne in
mind when the insignia of British Orders,
other than that of the Garter, were devised,
and in every case their mottoes are displayed
on plain and not buckled bands. In the

Albert Medal for Bravery, however, the encircling motto has been most improperly placed on a buckled band like the Garter, and the people who supply 'heraldic stationery' are notorious offenders in the same direction.

The lettering of a motto must of course

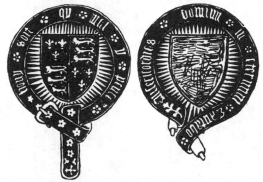

Fig. 155. Shields encircled by the Garter and a scroll, from the brass of Bishop Hallam (*ob.* 1416) at Constance.

depend upon the circumstances of its use. Nothing looks so well as the so-called 'old-English' or small black-letter, especially if the height of the words is as nearly as possible the same as the width of the band or scroll, and the capitals are not unduly prominent; but the form of capital known as Lombardic is always preferable to those of the black-letter alphabet. When

265

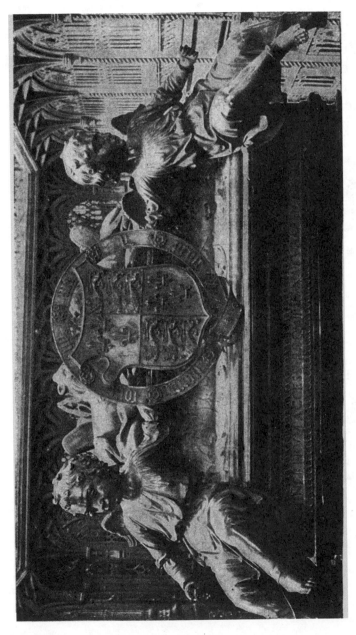

Fig. 156. Royal arms of King Henry VII within the Garter, of English work, from the King's tomb by Torregiano at Westminster.

capitals alone are used, fanciful types should
be avoided ; a good Roman form such as
is often found in Tudor inscriptions being

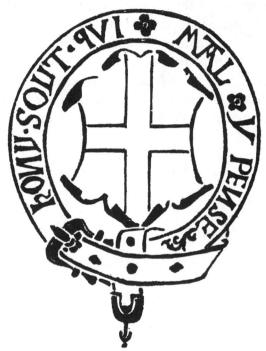

Fig. 157. Arms of St. George within the
Garter, from the brass of Sir Thomas
Bullen, K.G. earl of Wiltshire and
Ormond, 1538, at Hever in Kent.

far better. If the motto to be set about a
shield is a short one it can often be ex-
tended conveniently, if necessary, by a

judicious use of ornamental devices like roses or other flowers between the words. The ends of scrolls with mottoes have a more satisfactory appearance if shown partly curled up and partly pulled out spirally than if forked and waved, as may so often be seen nowadays. Scrolls always look better if not bordered or edged in any way, but this does not apply to the narrow bounding line that may be necessary in enamelled work.

CHAPTER XI

CROWNS, CORONETS, AND COLLARS

Crowns and Coronets ; Introduction of Coronets ; Coronets of Princes, Dukes, and Earls ; Bequests of Coronets ; Illustrations of Coronets and Crowns ; Collars and Chains ; Collars of Orders ; Lancastrian Collars of SS ; Yorkist Collars of Suns and Roses ; Tudor Collars of SS ; Other Livery Collars ; Waits' Collars ; Collars and Chains of Mayors, Mayoresses, and Sheriffs ; The Revival of Collars ; Inordinate Length of modern Collars.

AT the present day it is the habit of divers ladies of rank to surmount their hair, when occasion allows, with diamond tiaras of surpassing splendour. The ladies of olden time were not free from a similar weakness, but the diamond mines of South Africa being then unknown, and other gems too costly, they encouraged the goldsmiths to make them beautiful crowns and crestings, with which they adorned their heads and headgear. A reference to the accurate drawings and details published by Stothard in his *Monumental Effigies* will show not only

the high artistic excellence of these orna-
ments, but also how becoming they were
to the ladies who wore them. They varied
greatly in design, from the simple circlet

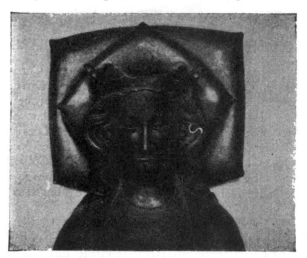

FIG. 158. Crowned effigy of Queen Eleanor at
Westminster.

of fleurons and trefoils of Queen Eleanor
of Castile (fig. 158) to the sumptuous piece
of jewellery beset with pearls and stones,
which is represented on the alabaster effigy
of Queen Joan at Canterbury (fig. 159)
and reflects so worthily the yet more
splendid crown of her husband, King
Henry IV (fig. 173).

270

Attention has already been drawn to the decorative use of crowns in heraldry, and

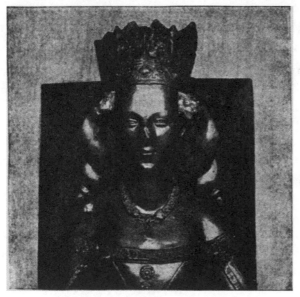

Fig. 159. Crowned effigy of Queen Joan at Canterbury.

a reference promised to the coronets of peers and peeresses.

Coronets, as they are now called, originated as early as 1343, when Edward duke of Cornwall and earl of Chester was created Prince of Wales, and invested by his father with a circlet (*sertum*) on his head, a gold ring on his finger, and a golden verge which

271

was placed in his hand. The circlet in question passed into the possession of his brother, Lionel duke of Clarence, who in 1388 left in his will 'a golden circlet with which my brother and lord was created prince' as well as 'that circlet with which I was created duke.' This latter event happened in 1362, at the same time that his brother John of Gaunt was created duke of Lancaster, when King Edward girded his son with a sword and put upon his head a fur cap and over it 'un cercle d'or et de peres,' a circlet of gold and precious stones. This investiture with a coronet was for some time restricted to dukes, but in 1385 King Richard II bestowed upon Richard earl of Oxford the new dignity of marquess of Dublin, and invested him with a sword and a circlet of gold.

The investing of an earl with a coronet does not seem to have become customary before the reign of Edward VI, but earls had worn coronets in virtue of their rank for a long time previously. In April 1444, when Henry Beauchamp earl of Warwick was created premier earl by Henry VI, the letters patent of his appointment empower him 'to wear a golden circlet upon his head and his heirs male to do the same on

feast days in all places where it is convenient as well in our presence as of others.' But the practice can perhaps be carried still further back, for Selden in his *Titles of Honour* (p. 680) quotes a receipt dated 1319 by William of Lavenham, treasurer of Aymer of Valence earl of Pembroke, of 'a gold crown of the said earl.'

By his will dated 1375 Richard FitzAlan earl of Arundel leaves to Richard his son 'my best crown (*ma melieure coroune*) charging him upon my blessing that he part not with it during his life, and that after his death he leave it to his heir in the same manner to descend perpetually from heir to heir to the lords of Arundel in remembrance of me and of my soul.' He also leaves to his daughter Joan 'my second-best crown' and to his daughter Alice 'my third crown,' under similar conditions. The earl's best crown may be that shown upon the alabaster effigy at Arundel of his grandson Thomas earl of Arundel, to whom it was bequeathed by his father (fig. 163). It has alternate leaves and pearled spikes, similar to, but richer and better in design than, the earls' coronets of to-day. Sir N. H. Nicolas suggests that earl Richard's second and third coronets were bequeathed to his daughters

273

because both were countesses ; Joan being wife to Humphrey Bohun earl of Hereford, and Alice to Thomas Holand earl of Kent. There are other bequests of coronets to

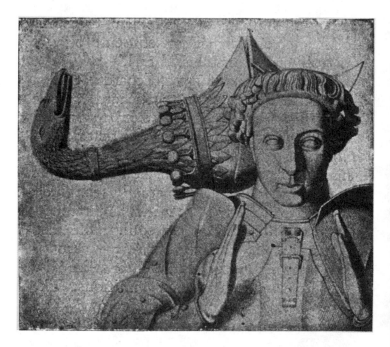

Fig. 160. Helm and crest, and bust, of Richard Beauchamp, earl of Warwick (*ob.* 1439,) from his gilt-latten effigy at Warwick.

ladies : Edmund Mortimer earl of March and Ulster left in 1380 to his daughter Philippa, afterwards wife to (1) John

274

Hastings earl of Pembroke, (2) Richard earl of Arundel, and (3) John lord St. John, 'a coronal of gold with stones and two hundred great pearls (*un coronal a'or ove verie et deuz cents grands perles*) and also a circlet with roses, with emeralds and rubies

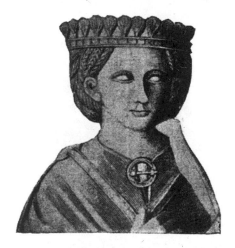

FIG. 161. Effigy of a lady (*c.* 1250) in Scarcliffe church, Derbyshire.

or Alexandria in the roses (*un cercle ove roses emeraudes et rubies d'alisaundre en les roses*).' Michael de la Pole earl of Suffolk also left in 1415 to his wife Katherine the diadem or coronet which had belonged to her father Hugh earl of Stafford, who died in 1386.

275

The swan's head crest of Richard Beau-
champ earl of Warwick (*ob*. 1439) on his
effigy at Warwick is encircled by a crown of
stalked pearls, not unlike those of an earl's
coronet of the present day (fig. 160).

Among Stothard's engravings are two of

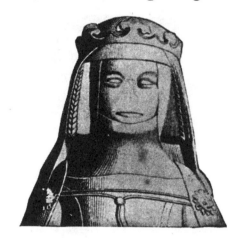

Fig. 162. Effigy of a lady in Staindrop
church, Durham.

effigies of quite early date of ladies wearing
crowns or coronets. One, at Scarcliffe in
Derbyshire (fig. 161), cannot be later than
about 1250, and the crown in this case is
composed of some twenty simple leaves set
upright upon the edge of a narrow band.
The other, at Staindrop in Durham, is about
a century later, and represents a widowed

276

lady, probably Margery, second wife of
John lord Nevill, wearing a crown of curled

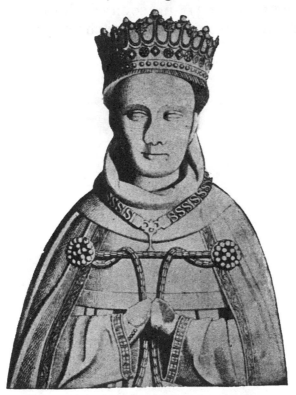

Fig. 163. Thomas earl of Arundel (*ob.* 1416),
from his alabaster effigy at Arundel.

leaves with points between (fig. 162). The
next illustration is of special interest since
it represents Thomas earl of Arundel (*ob.*

1416) wearing presumably the coronet mentioned above in his grandfather's bequest (fig. 163) ; his countess Beatrice has a slighter coronet of similar character. The

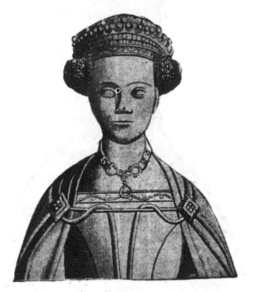

Fig. 164. Joan Beaufort, countess of Westmorland (*ob*. 1440), from her alabaster effigy in Staindrop church, Durham.

great alabaster tomb, also at Staindrop, of Ralph earl of Westmorland (*ob*. 1425) and his two countesses furnishes the next example. In this case the earl is in armour, but both ladies wear delicate coronets, formed of rows of points with triplets of

pearls and intervening single pearls, rising from narrow ornamental circlets (fig. 164).

The tomb of another earl of Arundel, William FitzAlan (*ob.* 1487), and of his

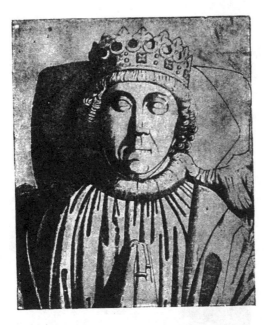

FIG. 165. William FitzAlan, earl of Arundel (*ob.* 1487), from his effigy at Arundel.

countess Joan, further illustrates the use of coronets. The earl's coronet is in this case composed of a continuous row of leaves with a jewelled band (fig. 165); the countess wears a similar coronet, but curiously

279

distorted behind, evidently because it was
thought to be more becoming when so worn
(fig. 166).

The monument in St. Peter's church,

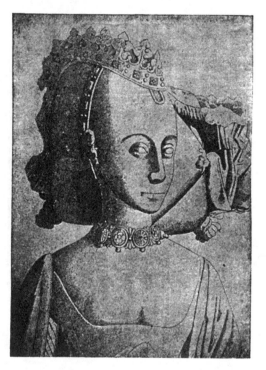

Fig. 166. Joan countess of Arundel, from
her effigy at Arundel.

in Sheffield, of George earl of Shrewsbury
(*ob.* 1538) and his two wives represents
him in armour, with the mantle and collar
280

of the Garter, and a coronet, now broken, about his head. His wives also have coronets, which are happily complete, and are composed of continuous series of twelve short points tipped with pearls. The earl's coronet seems to have had similar points, but with sixteen pearls instead of twelve.

The effigy *circa* 1500 at Whitchurch in Salop of that famous warrior, John Talbot earl of Shrewsbury, who was killed in 1453, also represents him in the mantle of the Garter over his armour and a coronet about his head. This is unfortunately badly broken, but seems to have resembled that on the Sheffield figures.

Besides these examples of coronets of earls and their countesses a few illustrations of those worn by dukes and duchesses may be cited.

It has been already noted that the shields on the monument of Humphrey duke of Gloucester (*ob.* 1446) at St. Albans are surmounted alternately by crested helms and by caps with coronets. These coronets have a richly jewelled circlet on which is set, instead of leaves, a series of what seem to be cups full of daisies, with small triplets of pearls between.

Another good coronet is to be seen

281

on the effigy of Thomas Holand duke of Exeter (*ob.* 1447) on the monument formerly in St. Katharine's hospital by the Tower, now in the chapel in Regent's

FIG. 167. John Holand duke of Exeter (*ob.* 1447), from his effigy at St. Katharine's hospital, Regent's Park.

Park. The duke's coronet here is quite narrow, and composed of some eighteen or twenty trefoils set close upon a band (fig. 167) ; but his two duchesses have coronets of triplets of pearls with intermediate single pearls, like those of the countesses of Westmorland at Staindrop (fig. 168).

282

The alabaster effigy at Ewelme of Alice, widow of William duke of Suffolk (*ob.* 1450), shows her in a beautiful coronet of fleurs-de-lis alternating with small clusters

FIG. 168. Head of a duchess of Exeter, from the monument at St. Katharine's hospital, Regent's Park.

of pearls (fig. 169), and similar coronets once adorned the effigies at Wingfield in Suffolk of her son John de la Pole duke of Suffolk (*ob.* 1491) and his wife Elizabeth.

The privilege of wearing coronets was not extended to viscounts until the reign of James I, and to barons until 1661.

The official patterns of coronets to which
peers and peeresses are now restricted have,
as may be seen from the examples above
cited, practically no relation to the older

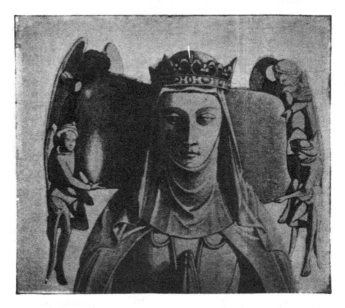

FIG. 169. Alice duchess of Suffolk (*ob.* 1475), from
her alabaster effigy in Ewelme church, Oxon.

forms, which exhibited the usual delightful
medieval elasticity of design.

The present coronets too are rendered
uglier than ever by the modern rule for-
bidding them to be jewelled in any way.
This was not formerly the case. Among

284

the stuff remaining in the palace of Westminster in 1553, and delivered to lady Jane Grey, was 'a coronet for a duke, set with five roses of diamonds, six small pointed diamonds, one table emerald, six great ballases, seven blue sapphires, and thirty-eight great pearls, with a cap of crimson velvet and a roll of powdered armyns about the same'; and a beautifully ornamented coronet of much earlier date than the painting is shown in a portrait of John marquess of Winchester, the defender of Basing House, who died in 1674.

It is the custom now for ladies of rank to wear their coronets only at coronations, and to display them on their note-paper, their spoons and forks, and on the panels of their carriages and motor-cars. Such coronets cannot however be considered artistic objects, even when depicted apart from the crimson velvet bonnets which they encircle, and there is no reason why ladies should not devise and wear coronet-like ornaments of their own invention.

A little research will show that crowns of every form and fashion have always been freely used in heraldic decoration, both by themselves and as ensigning letters or other devices, and so long as

285

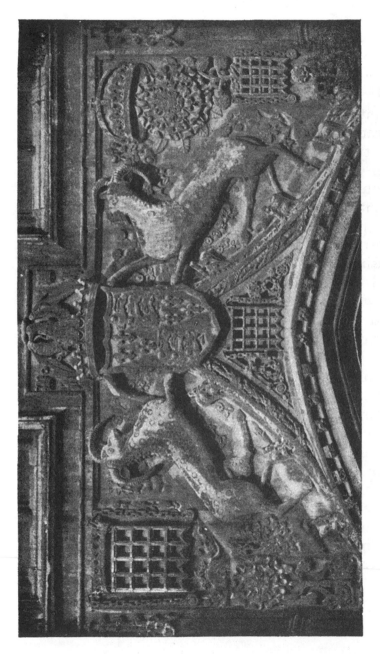

Fig. 170. Armorial ensigns and badges of the lady Margaret Beaufort, from the gatehouse of her foundation of Christ's College, Cambridge.

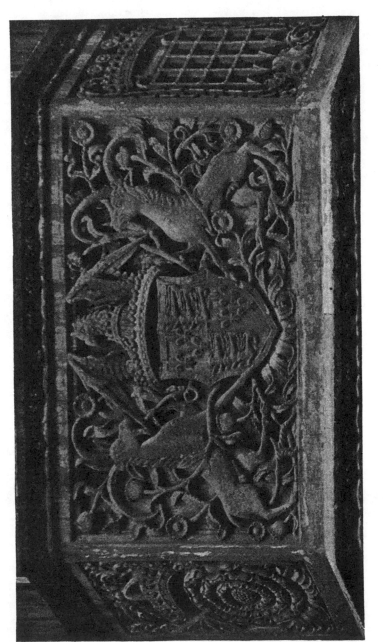

Fig. 171. Arms of the foundress, the lady Margaret Beaufort, with yale supporters, from the base of an oriel in Christ's College, Cambridge.

care be taken not to infringe what may be called official patterns, there are really no limits to a continuance of the ancient practice.

The lady Margaret Beaufort, countess of Richmond and mother of King Henry VII, has left us a delightful series of coronets. First, on a seal newly made for her on the accession of her son, her shield of arms is ensigned with a coronet or crown of roses and fleurs-de-lis placed alternately along the edge of a narrow band (pl. xxx). Shortly after 1505 the lady Margaret began to build Christ's College at Cambridge, and both the gatehouse (fig. 170) and the oriel of the master's lodge (fig. 171) are rich in heraldic decora-- tion. In this case both her arms and her portcullis badge are ensigned with coronets set with a continuous row of triplets of pearls.* In the lady Margaret's later foundation of St. John's College, her arms, etc. again are displayed upon the stately gatehouse ; in this case with a coronet of roses and fleurs-de-lis over the shield, as in her seal (fig. 172). Her portcullis badge, on the other hand, has over it a fine coronet

* On the gatehouse the coronet over the arms has been restored.

288

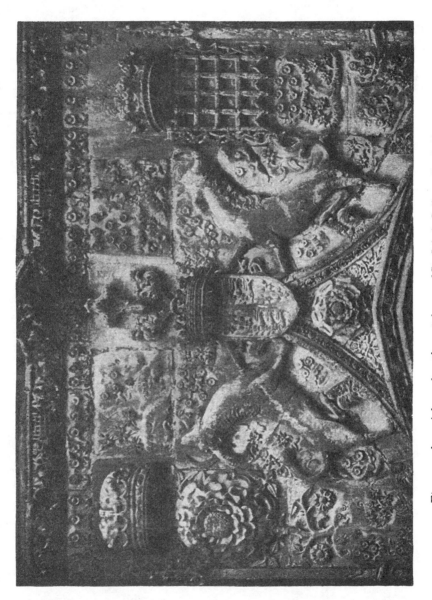

Fig. 172. Armorial panel on the gatehouse of St. John's College, Cambridge.

formed of clusters of roses, which recalls
the circlet of roses set with emeralds and
rubies of Alexandria mentioned earlier in
this chapter. It is quite easy to conjure
up visions of coronets or circlets formed of
lilies or marguerites, or of roses red and
white, or of any other suitable flower or
device, wrought in gold or gilded silver,
and either jewelled or bright with enamel.
And let designers take heart when so
recent and yet so picturesque an object as
the so-called 'naval crown' can be pro-
duced, with its cresting of sterns and square
sails of ships. This was used most effec-
tively some years ago as one of the decora-
tions encircling the Nelson Column in
London on Trafalgar Day.

It may be as well to point out that the
royal crown has been composed, from the
fifteenth century, of crosses alternating with
fleurs-de-lis, and since the coronation of
King Henry IV it has been distinguished
by being arched over cross-wise. The
splendid open crown shown on the effigy
of the king at Canterbury (fig. 173) is
not that wherewith he was crowned, but
another worn with the parliament robes
in which he is represented. Beautiful
examples of crowns of simpler type are

290

afforded by the effigies of King Henry III (fig. 174) and King Edward II (fig. 175). When the lady Elizabeth Wydville became the queen of Edward IV, she ensigned her

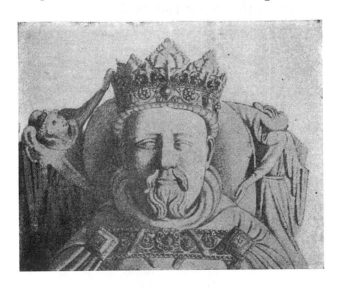

FIG. 173. King Henry IV, from his alabaster effigy in Canterbury cathedral church.

arms with a beautiful crown or coronet of alternate large crosses and fleurs-de-lis with smaller fleurs-de-lis between, rising from a richly jewelled band (pl. xxv), and a rich example of the crown of King Henry VIII so treated is to be seen on the great carved panel with his arms, etc. at New Hall in

291

Essex (fig. 189). Crosses and fleurs-de-
lis are now used only in the coronets of
those of royal blood.

From ornaments for the head it is easy
to pass to those for the neck.

FIG. 174. King Henry III, from his gilt-latten
effigy at Westminster.

The wearing about the neck of some-
thing which was considered decorative or
becoming has been customary with the fair
sex in every part of the world and in all
ages of its history, and necklaces of every
form, material, and fashion are as popular
to-day as ever. But less attention is now

292

paid to the decorative collars that once were
worn not only by women but by men.

It has always been a mark of distinction
or dignity to wear about the neck a chain

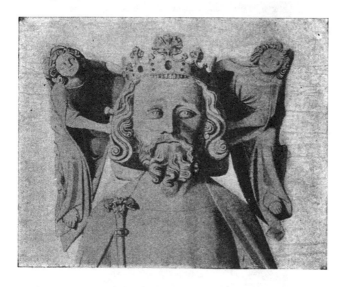

FIG. 175. King Edward II, from his alabaster effigy at
Gloucester.

or collar of gold, silver, or silver-gilt, either
as an ornament, or a decoration of honour,
or as a badge of partizanship ; and the
most noteworthy of these to-day are the
collars of the various orders of Knighthood,
such as the Garter (fig. 177), the Thistle,
and the Bath.

293

The history and characteristic features of
these are well known, and representations
of them abound ; moreover the wearing of

Fig. 176. Crowned initials of King Henry
VII, from his Lady chapel at Westminster.

them is confined to a few privileged persons.
It is therefore hardly necessary to discuss
them further in a work like the present.

The case is however different with
regard to the so-called livery collars, since
these may properly be regarded as models

294

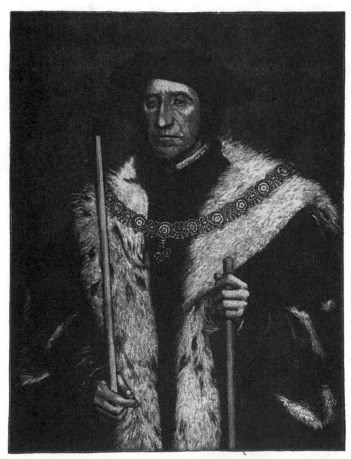

FIG. 177. Thomas Howard third duke of Norfolk
(1473(?)–1554) with the collar of the Order of the
Garter, from the picture by Holbein at Windsor castle.

for the formation and construction of such
similar collars as may freely be worn to-day.

295

The most notable of such decorations
during the medieval period was the collar
of SS which formed the distinctive cogni-
sance of the House of Lancaster (figs. 178,

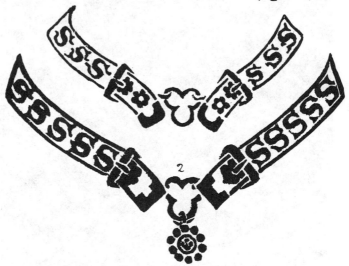

FIG. 178. Collars of SS.
1. From the brass of Lady Camoys, 1419, at Trotton
in Sussex.
2. From the brass of Sir William Calthorpe, 1420,
at Burnham Thorpe in Norfolk.

179). It was worn by persons of every
degree, from the King and Queen to the
knight and his esquire, and it was likewise
worn by their wives and even conferred on
civilians.

The collar of SS was apparently invented

by King Henry IV before his accession,
and quite a number of important entries
that throw light upon its history occur in
his household accounts while he was only
Henry of Lancaster earl of Derby.

In 1390–1 a gold signet was engraved

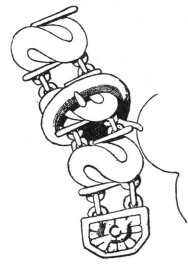

FIG. 179. Collar of SS from the effigy of
William lord Bardolf (*ob.* 1441) at Denning-
ton in Suffolk.

for him 'cum j plume et j coler,' of which
unhappily no impressions are known. In
1391–2 there was made for him a 'coler'
of gold 'with seventeen letters of S after
the manner of feathers with scrolls and

297

scriptures in the same with a swan in the tiret.' This recalls the badge upon one cf Henry's own seals as earl of Derby (1385) described above (p. 167), an ostrich plume entwined with a scroll and the scripture **souvereyne** (pl. xxiv c), and we know from other sources of Henry's favour towards the Bohun swan, which device he used in right of his first wife, the lady Mary Bohun. The collar of SS, moreover, on the effigy of John Gower the poet (*ob.* 1402) in Southwark cathedral church has a swan on the pendant of it, and no doubt represents the collar actually given to him by Henry of Lancaster in 1393–4. The initial letter, too, of the charter granted to the city of Gloucester by Henry as King in 1399, contains a crown encircled by a collar of SS ending in two lockets between which is a pendant charged with a swan. The earl's accounts for 1393–4 mention the purchase of the silver 'of a collar made with rolled esses and given to Robert Waterton because the lord had given the collar of the same Robert to another esquire.'

In 1396–7 a charge is entered 'for the weight of a collar made, together with esses, of flowers of **soveigne vous de**

298

moy* hanging and enamelled weighing eight ounces.'

What these flowers were is uncertain. Charges for making 'flores domini' occur in 1390–1 and other years, and in 1391–2 three hundred leaves (?flowers) *de souveine vous de moy* of silver-gilt were bought for one of the earl's robes.

In 1407 Henry of Lancaster as King ordered payment to be made to Christopher Tildesley, citizen and goldsmith of London, of the huge sum of £385 6s. 8d. 'for a collar of gold worked with this word **soveignez** and letters of S and X enamelled and garnished with nine large pearls, twelve large diamonds, eight balases, and eight sapphires, together with a great nouche in manner of a treangle with a great ruby set in it and garnished with four large pearls.'†

Most of these entries suggest that the mysterious SS stand for *Soveignez,* and possibly at one time this was the case, but

* In 1426 Sir John Bigod lord of Settrington left to his daughter a covered cup 'pounset cum sovenez de moy'; perhaps a gift to him from Henry of Lancaster. *Testamenta Eboracensia* (Surtees Soc. 4) i. 411.

† P.R.O. Issue Rolls (Pells) Mich. 8 Henry IV (1407).

Henry's seal as earl of Derby in 1385 containing the feathers with the scripture **souverepne** must not be overlooked. There is moreover, on a fragment which has fortunately survived in a tattered and burnt mass of fragments of a jewel account of Henry's reign in the Public Record Office, the important entry of a payment to Christopher Tildesley of 'a collar of gold made for the King with twenty-four letters of S pounced with **soverain**, and four bars, two pendants, and a tiret with a nouche garnished with a balas and six large pearls (the balas bought of the said Christopher for £10 and the price of the pearls at 40s., being £12) weighing 7 oz. Troy at 23s. 4d. £8 3s. 4d. Also a black tissue for the same collar 3s. 4d. and for the workmanship of it £4.'* The King's word **soverapne** also occurs many times, with the Queen's word **a temperance,** on the tester over their monument at Canterbury, which has likewise the shield of arms for the King, the King and Queen, and the Queen alone, encircled in each case with a collar of SS with golden eagles placed upon the tiret. Gold eagles also form stops between the repetitions of the word **soverapne.**

* Accounts, Exch. K.R. 404/18.

Another example of a collar of SS with an eagle as a pendant is to be seen on the monument of Oliver Groos, esquire (*ob.* 1439), in Sloley church, Norfolk (fig. 180).

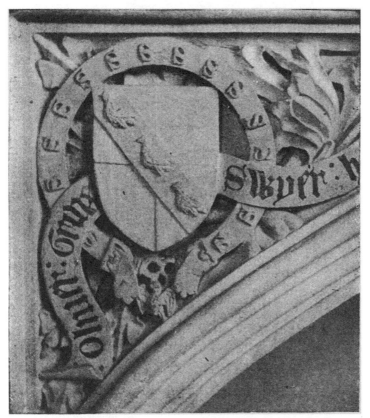

FIG. 180. Spandrel of the tomb of Oliver Groos, Esq. (*ob.* 1439), in Sloley church, Norfolk, with collar of SS.

Examples of effigies in stone or brass of men and women wearing the collar of SS are common throughout the Lancastrian period. The SS seem in most cases to be represented as sewn or worked upon a band of silk, velvet, or other stuff,* which usually ends in buckled lockets, linked by a trefoil-shaped tiret, from which is hung a small ring (fig. 181).

Several other interesting occurrences of the collar of SS may be noted. In one of the windows in the chapter house at Wells is a shield of the arms of Mortimer, and next to it a gold star within the horns of a crescent party blue and silver, encircled by a collar of SS also half blue and half white. As there are associated with these the arms of the King and of Thomas duke of Clarence (*ob.* 1421), they probably commemorate Edmund Mortimer earl of March, who died in 1425.

In 1449 a receipt given to the steward of Southampton by the prior of the Shene Charterhouse, which was founded by King Henry V, bears a seal with **iħs** within a collar of SS ; and in St. Mary's church at

* Notice of the theft of a collar of black silk dotted (*stipatum*) with silver letters of SS is entered on the Patent Roll of 7 Henry IV (1406), part ii. m. 29.

Bury St. Edmunds the ceiling over the Crowns,
tomb of John Baret, an ardent Lancastrian, Coronets,
and
Collars

1

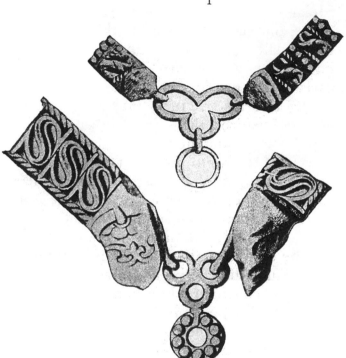

2

FIG. 181. Collars of SS from (1) the effigy of Queen
Joan at Canterbury, and (2) the effigy of Robert
lord Hungerford at Salisbury.

who died in 1480, is painted with collars
of SS surrounding his monogram.

303

There is also in a MS. in the British Museum,* written probably for John lord Lovel (*ob.* 1414), a painting of the arms of Holand quartering Lovel surrounded by a collar, one half of which is white and the other half blue, with gold letters of SS, having for a pendant a gold fetterlock, party inside of red and black.

On a brass *c.* 1475 at Muggington in Derbyshire the Beaufort portcullis appears as a pendant to the collar of SS.

With the rise to power of the Yorkists on the accession of Edward IV a rival collar to that of the Lancastrian livery came into vogue, composed of blazing suns and York roses disposed alternately (fig. 182). It may be seen in various forms on a number of monumental effigies and brasses, usually with the couchant white lion of the house of March as a pendant, but on the accession of Richard III the lion was replaced by his silver boar. On the wooden Nevill effigies at Brancepeth the earl has a collar of rayed suns with the boar pendant, while the countess has a collar of alternate suns and roses. Joan countess of Arundel, on her effigy at Arundel (fig. 166), shows another variation by interpolating the

* Harl. MS. 7026, f. 13.

FitzAlan oak leaves between the suns and the roses.

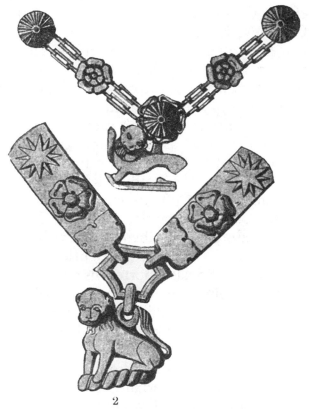

2

Fig. 182. Collars of suns and roses rom (1) the effigy of a knight of the Erdington family at Aston, Warwickshire, and (2) from the effigy of Sir Robert Harcourt, K.G. 1471, at Stanton Harcourt, Oxon.

305

After the accession of Henry VII the collar of SS was again revived, but with variations and different pendants. The effigy, for example, at Salisbury of Sir John Cheyney, K.G. (*ob.* 1489), has appended to his SS collar a large portcullis charged with a rose. A collar of gold weighing over 7 ounces is recorded to have been given in 1499 to adorn the image of the Holy Trinity in Norwich cathedral church, and is described as containing twenty-five letters of S, two tirets, two ' purcoles ' (portcullises), and one double R(?) with a red rose enamelled.* A similar collar, but all of gold, is shown in the portrait of Sir Thomas More, painted by Holbein in 1527 (fig. 183). On a brass *c.* 1510 at Little Bentley in Essex the collar of SS has a portcullis pendant, and on the Manners effigy (*c.* 1513) at Windsor and the Vernon effigy (1537) at Tong the pendant to the knight's collar is a large double rose.

The collars on the Salkeld effigies (1501) at Salkeld in Cumberland are composed of SS and four-leaved flowers alternately, and that worn by Sir George Forster (*ob.* 1526) on his tomb at Aldermaston in Berkshire is of SS laid sideways and alternating with

* Norwich Sacrist's Register, xi. f. 111.

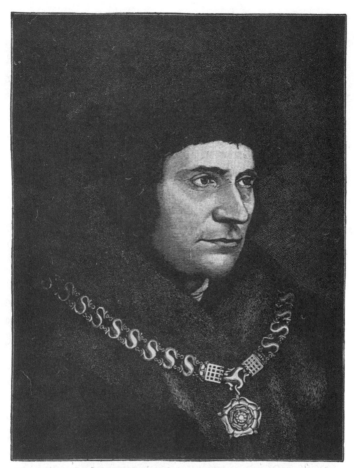

Fig. 183. Sir Thomas More wearing the collar of SS, from an original portrait painted by Holbein in 1527, belonging to the late Mr. Edward Huth.

knots, and has a portcullis and rose pendant. In 1545 Sir John Alen, sheriff in 1518 and

307

lord mayor in 1525 and 1535, bequeathed
for the use of the lord mayor of London,
and his successors for ever, his collar of
SS, knots, and roses of red and white
enamel ; and a cross of gold with precious
stones and pearls was given to be worn
with it in 1558. An effigy of a Lisle *c.*
1550 at Thruxton in Hants has a similar
collar of SS, knots, and roses, also with a
cross as a pendant. Sir John Alen's collar,
somewhat enlarged, and with a modern
'jewel' as a pendant, is still worn by the
lord mayor of London, and is the only
medieval collar of SS that has survived.

After the reign of King Henry VIII the
wearing of the collar of SS gradually
became restricted to judges and other
officials, and has so survived to the present
day, when it is still worn in England by
the lord chief justice, the kings-of-arms,
heralds, and pursuivants, and by the
serjeants-at-arms.

The lord chief justice's collar, like all
those formerly worn by the judges, is com-
posed of SS and knots ; the others of SS
only.

Beside the livery collars above mentioned,
others have been worn from time to time.

In the exquisitely painted diptych of
308

Richard II and his avowries, now at Wilton House, the King has about his neck a collar formed of golden broom-cods, and the gorgeous red mantle in which he is habited is covered all over with similar collars enclosing his favourite badge, the white hart. A collar of gold 'de Bromecoddes' with a sapphire and two pearls occurs in the great inventory taken on the death of King Henry V, and a collar formed of SS and broom-cods was also made for King Henry VI in July 1426.*

On his effigy at Ripon (*c.* 1390) Sir Thomas Markenfield displays a collar formed of park palings, which widen out in front to enclose a couchant hart (fig. 184). If this were not a personal collar, it may have been a livery of Henry of Lancaster as earl of Derby.

A brass of the same date of a knight, formerly at Mildenhall, showed him as wearing a collar apparently once composed of scrolls with scriptures, joining in front upon a large crown with a collared dog or other beast within it.

The brass at Wootton-under-Edge of Thomas lord Berkeley (*ob.* 1417) shows

* John Anstis, *The Register of the most noble Order of the Garter* (London, 1724), ii. 116 note.

him with a collar sown with mermaids, the cognisance of his house (fig. 185).

FIG. 184. Head of the effigy in Ripon minster of Sir Thomas Markenfield with livery collar of park-palings.

In his will dated 1430 William Stowe the elder, of Ripon, a retainer in the

310

household of the earl of Northumberland, bequeaths his silver livery *Anglice cressaunt* and his livery *Anglice coller* to the shrine of St. Wilfrid.* Possibly the 'cressaunt' was an object similar to that here figured (now belonging to the duke of

FIG. 185. Thomas lord Berkeley (*ob*. 1417) with a collar of mermaids, from his brass at Wootton-under-Edge, Gloucestershire.

Northumberland), and the collar like that formed of **p**'s and crescents enclosing **p**'s linked together which is engraved upon it (fig. 186).

* 'Item ego liberaturam meam argenteam Anglice cressaunt, et liberaturam meam Anglice coller. ad feretrum Sancte Wilfridi.' *Test. Ebor.* ii. 13.

311

The earlier collars, as has already been noted, were composed of devices sewn upon a band of stuff, but in later examples a more open treatment is found wherein the devices are linked together by short

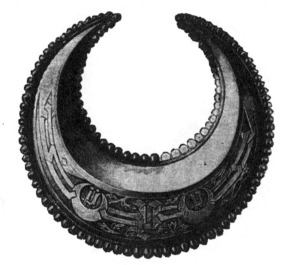

FIG. 186. Silver badge belonging to the
duke of Northumberland.

pieces of chain, as in the collar of SS shown in Sir Thomas More's portrait. The Yorkist collar of suns and roses on an effigy at Erdington is so treated, as is the collar of SS and flowers on the Salkeld effigies, which may perhaps be a personal and not a livery collar.

312

Collars of similar construction, but always fo silver, with pendent scutcheons of the town arms, were worn by the little bands of minstrels called waits, formerly in the employ of most towns of importance (fig. 187).

In London the six waits appointed in 1475 had silver collars of SS with scutcheons of the city arms. At Exeter the four waits' collars, dating from about 1500, still exist, and are formed of roundels with 𝔉's and 𝔅's alternately (fig. 187). Two beautiful waits' collars at Norwich (c. 1550) are composed of silver castles and gilded leopards alternately, like those in the appended shield (fig. 187). The waits' collars at Lynn were formed of scrolled leaves alternating with dragons' heads pierced with crosses, like those in the town arms, which are allusive of St. Margaret (fig. 187). At York the collars are formed wholly of little silver leopards, and at Beverley of eagles and beavers alternately. The waits' collars at Bristol date from the reign of Queen Mary, and are composed of pierced roundels containing alternately the letters CB. and a rose dimidiating a pomegranate.

The wearing of collars, or chains as they are called, by mayors, mayoresses, and

313

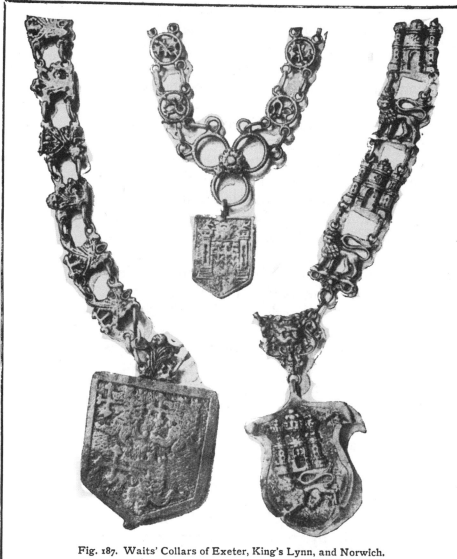

Fig. 187. Waits' Collars of Exeter, King's Lynn, and Norwich.

sheriffs is comparatively modern. It was formerly the custom for every person of any dignity to wear a chain, and it was only when chains began to go out of fashion that the wearing of them survived among persons of particular dignity such as mayors and sheriffs.

The collar of SS worn by the lord mayor of London is an exceptional example, and the only other early mayor's chain is that given to Kingston-on-Hull in 1564 and remade in 1570. A plain gold chain was bequeathed to the city of York in 1612, and 'a fayre chayne of gold double linked with a medall of massy gold' was given to the town of Guildford in 1673. In 1716 a gold chain for the mayor was given to the city of Norwich, but passed on for the use of the deputy mayor on a new chain being given in 1757. Yarmouth bought itself a chain in 1734, and seven other towns became possessed of mayors' chains towards the end of the eighteenth century. Down to 1850 some fifteen more mayors' chains came into existence, mostly of simple type, like the older chains, with one or more rows of plain or ornate links. Since 1850 practically every town that can boast of a corporation has likewise got a

chain for its mayor, and appalling creations many of them are, with rows of tablet links, and armorial pendants as large as saucers.

A simple gold chain to be worn by the sheriffs of Norwich was given in 1739, but those at Chester, Newcastle, Exeter, and other places are quite recent. In London it has been the custom for the friends and admirers of the sheriffs to present them with elaborate gold collars on their accession to office, but these are happily private property and not official insignia. The same description applies to them as to the recent mayors' chains.

Chains for mayoresses have not yet become general, but they are being multiplied yearly. The mayoress of Kingston-on-Hull had an official chain as early as 1604, but it was sold as being 'useless' in 1835. The lady mayoress of York has a chain of plain gold links given in 1670, which is regularly weighed on its delivery to and return by the wearer. All other mayoresses' chains are quite recent, and in most cases of the same fearsome design as those worn by their husbands.

The unfortunate mayors, mayoresses, and sheriffs are practically at the mercy of ignorant and inartistic tradesmen for the

designing and making of the collars they are called upon to wear officially, but that is no reason why people with more enlightened ideas should not invent, design, and wear collars or chains that are beautiful in themselves. The examples already quoted and the many illustrations of others that are accessible will show what comely ornaments the old heraldic collars were, and many a lady would look well in a collar to whom a necklace is most unbecoming. Flowers, letters, and devices of heraldic import can easily be embroidered in gold, or struck out of metal and enamelled, and then be sewn down on velvet or silk stuff, or linked together by fine chains.

But let every wearer of a chain or collar avoid the error of making it too long. The ancient collars were quite short, and therefore rested comfortably and easily upon the shoulders. Official collars have however grown to so preposterous a length that they have to be tied with bows of ribbons upon the shoulders to hinder them from slipping off the wearer altogether! The reason of this is curious and instructive. The old collars were, as aforesaid, of sensible dimensions, but the introduction

Crowns, Coronets, and Collars

317

of wigs in the seventeenth century necessi-
tated the collars being lengthened to be
worn outside them. Wigs had their day
and at last disappeared from general wear,
but the lengthened collars remain, and it
has not occurred to any one in authority
that they might now advantageously be
shortened. So the inconvenience goes on.

CHAPTER XII

HERALDIC EMBROIDERIES

The introduction of armorial insignia in embroidered Vestments : on Robes: on Beds, etc.

No one who has had occasion to examine any series of old wills and inventories, especially those of the fourteenth and fifteenth centuries, can fail to have noticed what a large part was played by heraldry in the household effects of our forefathers. In the vestments and other ornaments of the chapel, the hallings, bankers, and like furniture of the hall, the hangings and curtains of the beds and bedchambers, the gold and silver vessels and utensils of the table, or in carpets and cushions and footstools, shields of arms, badges, mottoes, and quasi-heraldic devices of all sorts were as common as blackberries in autumn.

And the evidence of illuminated pictures and monumental effigies is equally strong in showing that heraldry was quite as much in vogue for personal adornment.

As a matter of fact heraldry had its very

319

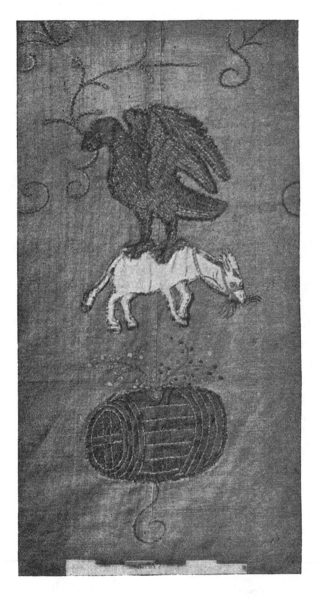

Fig. 188. Part of an embroidered altar frontal with a
rebus at Baunton in Gloucestershire; date, late fifteenth
century.

origin in a system of devices to be worn on
shields and banners and coats-of-arms
to distinguish the wearer in battle, and
from the coat-of-arms of the knight it was
but a step to the armorial gown or mantle
of his lady.

It would be somewhat tedious to extract
from the authorities just cited, especially
since they are easily accessible, every entry
relating to an heraldic ornament or piece
of furniture. But with regard to hangings
and embroideries the case is somewhat
different, inasmuch as numbers of ladies
are engaged nowadays in stitch-work of
every kind, amongst which heraldic em-
broidery ought certainly to have a place.

As might be expected, the inventories of
Church stuffs furnish us with some of the
earliest examples of heraldic embroideries,
and often in sufficiently precise terms to
enable us to realize what the things looked
like.

Thus an inventory taken in 1315 of the
ornaments at Christchurch, Canterbury,
enumerates such things as a chasuble and
five copes, the gift of Katharine Lovel,
sewn with arms of divers persons; a
white cope of the arms of the King of
Scotland ; a cope of Peter bishop of Exeter

321

(*ob.* 1291) of baudekyn 'with biparted shields' (an early example) ; a cope of John of Alderby bishop of Lincoln, and another of Thomas Burton bishop of Exeter, of green cloth embroidered with shields ; an albe with apparels of blue velvet embroidered with shields and fleurs-de-lis ; two albes sewn with shields and black letters, and a third of red samite embroidered with shields and popinjays ; an albe sewn with lozenges with the arms of the King of England and of Leybourne ; an albe sewn with shields and embroidered with letters ; an albe sewn with the arms of Northwood and Poynyngs in quadrangles ; and an albe, stole, and fanon sewn with divers arms in lozenges with purple frets. The same inventory mentions a vestment of Philip King of France, made, quite properly, of blue cloth with fleurs-de-lis ; and a number of vestments with orphreys of the arms of the King of England and of France.

The inventory of the vestry of Westminster Abbey taken in 1388 also contains some interesting heraldic ornaments, such as a frontal with the arms of England and France in red and blue velvet woven with golden leopards and fleurs-de-lis, from the

322

burial of King Edward III ; six murrey
carpets woven with the new arms of the
King of England and of the count of
Hainault (in other words, the quartered
shield adopted by Edward III in 1340,
and the arms of his queen, Philippa of
Hainault) ; four carpets of the arms of
the earl of Pembroke ; four carpets of red
colour woven with white shields having
three red fleurs-de-lis, of the gift of Richard
Twyford, whose arms they were ; five
black carpets having in the corners shields
of the arms of St. Peter and St. Edward ;
two green silk cloths sewn with the arms
of England, Spain, and Queen Eleanor ; a
bed with a border with the arms of the
King of Scotland ; three new copes of a
red colour of noble cloth of gold damask,
with orphreys of black velvet embroidered
with the letters T and A and swans of
pearl, the gift of Thomas duke of Gloucester,
whose wife was Eleanor Bohun, and her
family badge a white swan ; a cope of red
velvet with gold leopards and a border of
blue velvet woven with gold fleurs-de-lis,
formerly the lord John of Eltham's, whose
fine alabaster tomb in the abbey church has
the same arms on his shield.

A St. Paul's inventory of 1402 also

323

contains a few choice examples : a cope of
red velvet with gold lions, and orphreys of
the collars of the duke of Lancaster and a
stag lying in the middle of each collar ; a
suit of blue cloth of gold powdered with
gold crowns in each of which are fixed two
ostrich feathers ; six copes of red cloth of
gold with blue orphreys with golden-
hooded falcons and the arms of Queen
Anne of Bohemia ; three albes and amices
of linen cloth with orphreys of red velvet
powdered and worked with little angels
and the arms of England, given by Queen
Isabel ; three albes and amices with apparels
of red cloth of gold powdered with divers
white letters of S and with golden leopards,
given by John of Gaunt ; two great cushions
of silk cloth of blue colour with a white
cross throughout, and in each quarter of
the cross the golden head of a lion.

The secular documents carry on the
story.

Some quite noteworthy items may be
found in the account of the expenses of the
great wardrobe of King Edward III (1345–
48–9) : for making a bed of blue taffata
for the King powdered with garters con-
taining this word 𝔥𝔬𝔫𝔶 𝔰𝔬𝔦𝔱 𝔮 𝔪𝔞𝔩 𝔶
𝔭𝔢𝔫𝔰𝔢 ; for making a jupe of blue taffata for

324

the King's body with Garters and buckles and pendants of silver-gilt; for making 40 clouds for divers of the King's garments, embroidered with gold, silver, and silk, with an Œ in the middle of gold, garnished with stars throughout the field; for making six pennons for trumpets and clarions against Christmas Day of sindon beaten with the King's arms quarterly; for making of a bed of red worsted given to the lord King by Thomas de Colley powdered with silver bottles having tawny bands and curtains of sindon beaten with white bottles; for making a harness for the lord David King of Scotland of 'blu' velvet with a pale of red velvet and within the pale aforesaid a white rose; for making a harness of white bokeram for the King stencilled with silver, namely, a tunic and shield wrought with the King's word **hay hay the wythe swan; by godes soule J am thy man** and a crupper, etc. stencilled with silver; for making a doublet for the King of white linen cloth having about the sleeves and bottom a border of green long cloth wrought with clouds and vines of gold and with the King's word **it. is. as. it. is.**

In 1380 Edmund Mortimer earl of

March leaves 'our great bed of black satin embroidered with white lions (the badge of the house of March) and gold roses with scutcheons of the arms of Mortimer and Ulster'; and in 1385 Joan princess of Wales leaves to King Richard her son 'my new bed of red velvet embroidered with ostrich feathers and leopards' heads of gold with branches and leaves issuing from their mouths.'

In 1389 William Pakington archdeacon of Canterbury leaves 'my halling of red with a shield of the King's arms in the midst and with mine own arms in the corners'; and in 1391 Margaret, the wife of Sir William Aldeburgh, leaves (i) a red halling with a border of blue with the arms of Baliol and Aldeburgh, (ii) a red bed embroidered with a tree and recumbent lion and the arms of Aldeburgh and Tillzolf, and (iii) a green bed embroidered with griffins and the arms of Aldeburgh.

The inventory of Thomas of Woodstock duke of Gloucester, taken in 1397, also contains some interesting items : a white halling (or set of hangings for a hall) consisting of a dosser and four costers worked with the arms of King Edward (his father) and his sons with borders paly of red and

black powdered with Bohun swans and the arms of Hereford ; a great bed of gold, that is to say, a coverlet, tester, and selour of fine blue satin worked with gold Garters, and three curtains of tartryn beaten with Garters to match ; and a large bed of white satin embroidered in the midst with the arms of the duke of Gloucester, with his helm, in Cyprus gold.

A number of other items in the list are also more or less heraldic : a bed of black baudekyn powdered with white roses ; a large old bed of green tartryn embroidered with gold griffins ; twelve pieces of tapestry carpet, blue with white roses in the corners and divers arms ; a large bed of blue baudekyn embroidered with silver owls and gold fleurs-de-lis ; fifteen pieces of tapestry for two rooms of red worsted embroidered with blue Garters of worsted with helms and arms of divers sorts ; three curtains of white tartryn with green popinjays ; a green bed of double samite with a blue pale (stripe) of chamlet embroidered with a pot of gold filled with divers flowers of silver ; an old bed of blue worsted embroidered with a stag of yellow worsted ; a red bed of worsted embroidered with a crowned lion and two griffins and chaplets and roses ;

a bed of blue worsted embroidered with a white eagle ; a coverlet and tester of red worsted embroidered with a white lion couching under a tree ; a single gown of blue cloth of gold of Cyprus powdered with gold stags ; and a single gown of red cloth of gold of Cyprus with mermaids.

In 1381 William lord Latimer leaves 'an entire vestment or suit of red velvet embroidered with a cross of mine arms,' and in 1397 Sir Ralph Hastings bequeathed 'a vestment of red cloth of gold with orphreys before and behind ensigned with maunches and with colours of mine arms,' which were a red maunch or sleeve on a gold ground.

Among the chapel stuff of Henry Bowet archbishop of York, in 1423, were a sudary or veil of white cloth with the arms of the duke of Lancaster on the ends, and two costers or curtains of red embroidered with great white roses and the arms of St. Peter (the crossed keys).

In 1437 Helen Welles of York bequeathed a blue tester with a couched stag and the reason *Auxilium meum a Domino*.

In 1448 Thomas Morton, a canon of York, left a halling with two costers of green and red say paled with the arms

of archbishop Bowet ; and in 1449 the in-
ventory of Dan John Clerk, a York
chaplain, mentions two covers of red say
having the arms of Dan Richard Scrope
and the keys of St. Peter worked upon
them.

To the examples worked with letters
may be added a bed with a carpet of red
and green with crowned M's, left about
1440 by a Beverley mason, who also had
another bed with a carpet of blue and green
with Katharine wheels ; a vestment left in
1467, by Robert Est, a chantry priest in
York minster, of green worsted having
on the back two crowned letters, namely,
R and E ; and a bequest in 1520 by
Thomas duke of Norfolk of 'our great
hangede bedde palyd with cloth of golde
whyte damask and black velvet, and
browdered with these two letters T. A.,'
being the initials of himself and his wife.

There is of course nothing to hinder at
the present day the principles embodied in
the foregoing examples, which could easily
be extended *ad infinitum*, from being carried
out in the same delightful way ; and a small
exercise of ingenuity would soon devise a
like treatment of one's own arms, or the
use of a favourite device or flower, or the

setting out of the family word, reason, or
motto.

The medieval passion for striped, paned,
or checkered hangings might also be
revived with advantage, and the mention
in 1391 of 'a bed of white and murrey
unded' shows that waved lines were as
tolerable as straight.

CHAPTER XIII

TUDOR AND LATER HERALDRY

Decorative Heraldry of the Reign of Henry VIII ; The Decadent Change in the Quality of Heraldry ; Examples of Elaborated Arms ; Survival of Tradition in Heraldic Art ; Elizabethan Heraldry ; Heraldry in the Seventeenth Century and under the Commonwealth ; Post-Restoration Heraldry.

IN the foregoing chapters practically nothing has been said or any illustration given of heraldry later than the reign of Henry VIII, chiefly because little that is artistic can be found afterwards. There are however certain points about both Elizabethan and Stewart heraldry that are worthy of notice, especially when the old traditions have been followed.

In the second quarter of the sixteenth century decorative heraldry may be said to have reached its climax, and such examples as can be seen at Hengrave Hall, Hampton Court, Athelhampton House, Cowdray House, St. George's chapel in Windsor Castle, King's College chapel at Cambridge,

331

and Henry VII's Lady chapel at Westminster, or in the beautiful panel of
Henry VIII's arms at New Hall in Essex
(fig. 189), are quite the finest of their kind.
Then comes a falling off, and though sporadic cases in continuation of tradition may be
found, with the advent of the Renaissance
English heraldry underwent a complete
change.

One of the most notable differences
between the older and the later heraldry is
in the quality of the heraldry itself.

In the days when men devised arms for
themselves these were characterized by a
simplicity that held its own all through the
thirteenth and fourteenth centuries and well
down into the fifteenth century. But
following upon a privilege that had hitherto
been exercised by the King as a mark of
special honour, and in some rare cases even
by nobles, the heralds then began to assign
arms to such of the newly-rich who came
to the front after the Wars of the Roses
and were willing to pay for them. Henceforth the artistic aspect of heraldry entered
upon a continuous decadent course.

The beginning is visible in the extraordinary compositions devised and granted
to all sorts and conditions of men during

332

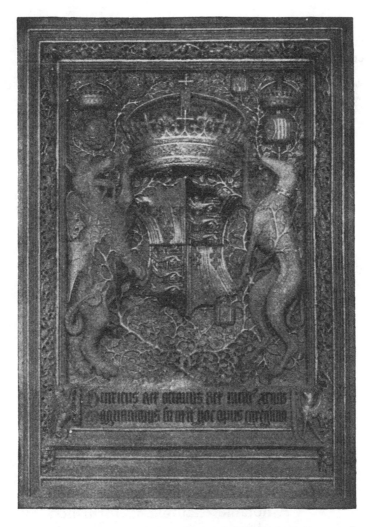

Fig. 189 Carved panel with the crowned arms, supporters, and badges of King Henry VIII at New Hall in Essex.

the reign of Henry VIII. Such arms as had been granted by Henry VI or Edward IV, or even by the kings-of-arms in the fifteenth century, still followed ancient

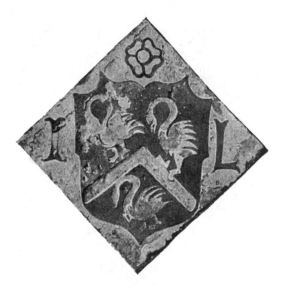

Fig. 190. Paving tile with arms and initials of John Lyte (*c.* 1535), from Marten church, Wilts.

precedent, but the Tudor members of the newly incorporated Heralds' College seem to have struck out a line for themselves.

A notable example is furnished by the arms devised for cardinal Thomas Wulcy. These, in token of his Suffolk origin, have

334

for basis the engrailed cross upon a sable field of the Uffords (to whom he was not related), charged with the leopards' heads of the de la Poles and a lion passant (perhaps for England); to which is added a gold chief, with a red Lancastrian rose, and two of the Cornish choughs from the posthumous arms of St. Thomas of Canterbury in allusion to his Christian name!

The arms granted by Christopher Barker, Garter, in 1536 to the city of Gloucester afford another example. They consist of the sword of state of the city, with the sword-bearer's cap on the point, set upright on a gold pale, and flanked on either side by a silver horseshoe and a triad of horsenails on a green field; there is also (as in Wulcy's arms) a chief party gold and purple, with the silver boar's head of Richard III (who granted a charter to the city) between the halves of a Lancastrian red rose and of a Yorkist white rose, each dimidiated with a golden sun!

A reference to Bedford's *Blazon of Episcopacy* will show that the arms of a considerable number of the bishops appointed during the reigns of Henry VIII and Edward VI were characterized by overcharged chiefs like those just described,

335

and these may be taken as typical of the
arms then being granted by the kings-of-
arms. The same passion for crowding the
shield is seen even in many of the less
elaborate arms that were occasionally
granted.

Things did not improve under Mary and
Elizabeth. Simple arms continued to be
issued from the College, but mixed with
such extravagant bursts as that of Laurence
Dalton, Norroy, who granted in January
1560–1 to the famous physician doctor
John Caius these arms :

> Golde semyd wth flowre gentle in the
> myddle of the cheyfe, sengrene resting
> uppon the heades of ij serpentes in pale,
> their tayles knytte to gether, all in proper
> color, resting uppon a square marble stone
> vert, betwene theire brestes a boke sable,
> garnyshed gewles, buckles gold, and to
> his crest upon thelme a Dove argent,
> bekyd & membred gewles, holding in
> his beke by the stalke, flowre gentle in
> propre color, stalked verte, set on a
> wreth golde & gewles.

This precious composition is further de-
scribed in the grant as

336

betokening by the boke lerning : by the ij serpentes resting upon the square marble stone, wisdom with grace founded & stayed upon vertues stable stone : by sengrene & flower gentle, immortality yt never shall fade, etc.

The way in which matters went from bad to worse is shown by the case of the Company of 'Barbours & Chirurgeons' of London, to whom had been granted in 1561

paly argent and vert, on a pale gules a lyon passant gardant golde betweene two Spatters argent on eche a double rose gules and argent crowned golde.

The united genius of Garter, Clarenceux, and Norroy 'improved' these arms in 1569 into :

Quarterly the first sables a Cheveron betweene three flewmes argent : the second quarter per pale argent and vert on a Spatter of the first, a double Rose gules and argent crowned golde : the third quarter as the seconde and the fourth as the first : Over all on a Crosse gules a lyon passant gardant golde.

Such compositions as these could not but

fail to bring heraldry into contempt, and men soon ceased to revel in and play with it in the same delightful way as before. Here and there, as in Sir Thomas Tresham's market house at Rothwell, or in Sir Henry Stafford's great mansion of Kirby Hall, tradition has been held fast, and play is made upon the former with the Tresham trefoils, and in the latter with Stafford knots and with crests treated as badges in quite the old style. At Kirby Hall, despite its date (1572-5), and at Cadhay in Devon, sitting figures of beasts with shields of arms were set upon the gables, and at Kirby upon the pinnacles that surmounted the pilasters about the court. A good panel with the arms and badge apparently of Sir John Guldeford (*ob.* 1565) is to be seen in East Guldeford church, Sussex (fig. 191).

A remarkably fine specimen of Elizabethan heraldic decoration is also to be seen in the great chamber of Gilling castle, Yorks, as finished by Sir William Fairfax about 1585. Here the beautiful inlaid wall-panelling is surmounted by a frieze nearly four feet deep, painted with hunting scenes and a series of large trees, upon which are hung according to wapentakes the shields of arms of Yorkshire gentlefolk.

338

The chimney piece displays the armorial ensigns of the builder, with those of his Queen above, and four other shields, and

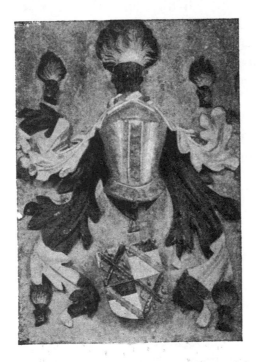

Fig. 191. Arms, with crested helm and badge (a blazing ragged-staff) of, apparently, Sir John Guldeford of Benenden (*ob.* 1565) in East Guldeford church, Sussex.

between the frettings of the plaster ceiling are the Fairfax lions and goats, and the Stapleton talbot. The rich effect of the

whole is completed by the contemporary
heraldic glazing with which the windows
happily are filled.

But in Elizabethan buildings generally,
heraldry made but a poor show. Sup-
porters and other creatures had descended
from the gables to stand or squat upon
gateposts, and occasionally a square panel
filled with heraldry was inset above a
doorway or a porch; or the family crest,
divorced from its helm, was carved upon
the spandrels of the entrance. But the
former glory had disappeared, and shields
of arms were often replaced by initials and
dates of owners and builders, presumably
because they were 'non-armigerous per-
sons.'

Within doors matters were somewhat
better. Such gorgeous rooms as the great
chamber at Gilling were quite exceptional,
and heraldic display was usually confined
to the elaborately carved overmantels of
the chimneys, which served as a frame for
the family arms and crested helm with
grand flourishing of mantlings. These
were often repeated upon the cast-iron fire-
backs. The art of the plasterer was ex-
tended to the inclusion of crests and other
devices among the ornaments of the

340

moulded ceilings, and the glazier continued to fill the windows with beautiful coloured shields of alliances. Occasionally too the family arms were woven into carpets or table covers ; or embroidered by the ladies of the house on the hangings of the state bed, within charming wreaths of flowers copied from those in the garden (fig. 192).

The monuments of the dead continue as before to be adorned with heraldry, but in a different way, and for the beautiful simple arms and devices of the medieval memorial began to be substituted the concentrated shield of the family quarterings, with crest and mantled helm, and such supporters as the College of Arms allowed or approved.

Despite the inevitable consequent formality, there is often much that is good about the treatment of Elizabethan and Jacobean heraldry, and it would not be easy, even at an earlier date, to beat the delightful lions upon the shields on the Lennox tomb at Westminster (fig. 194), or to fill up more satisfactorily a shield like that above the monument of Sir Ralph Pecksall (fig. 195). The effective way in which the shield itself is treated in this case is also praiseworthy, and both shields are models of heraldic carving in low relief.

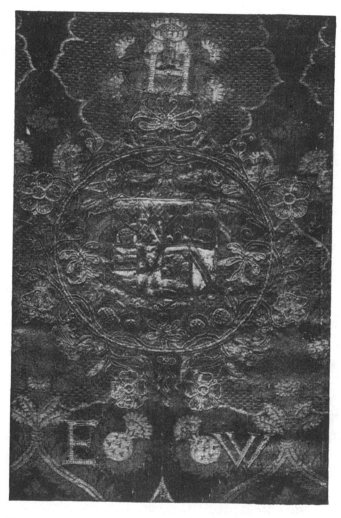

Fig. 192. Part of a bed-hanging embroidered with the arms of Henry and Elizabeth Wentworth, *c.* 1560, formerly in the possession of Sir A. W. Franks, K.C.B.

The Lennox and Pecksall shields are likewise indicative of another characteristic change, the desire to illustrate ancient descent by the multiplication of quarterings. The disastrous consequences of this practice, even in the fourteenth and

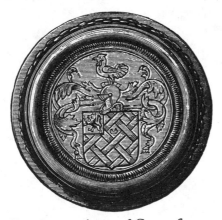

FIG. 193. Arms of Cotes, from a mazer print of 1585–6.

fifteenth centuries, have already been pointed out, but in the reign of Elizabeth it was carved to such an excess as to produce at times a mere patchwork of carved or painted quarters, in which the beauty of the heraldry was entirely lost. In the great hall of Fawsley House, Northants, there hangs a coloured achievement of the Knightley family containing actually 334

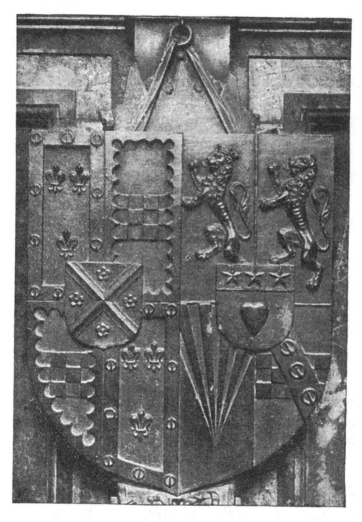

Fig. 194. Shield from the tomb of Margaret countess of Lennox
(*ob.* 1578) in Westminster abbey church.

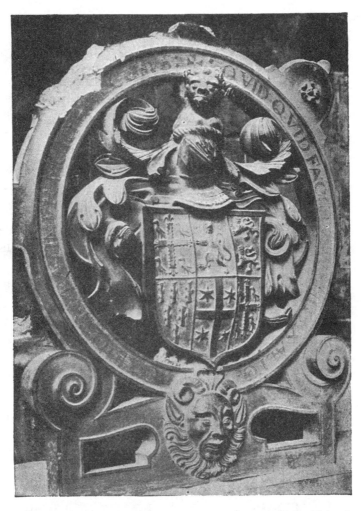

Fig 195. Achievement of arms from the monument of Sir Richard Pecksall (*ob*. 1571) in Westminster abbey church.

quarterings, which have been rightly described by Mr. J. A. Gotch as '330 too many for decorative effect.'

The heraldry of the seventeenth century is in general but a duller version of that of the later sixteenth century, with a tendency to become more commonplace as time goes on.

Under the Commonwealth every vestige of regality was ordered to be put down and done away ; a very large number of representations of the royal arms were defaced and destroyed ; and the leopards of England were for a time 'driven into the wilderness' along with the lion of Scotland. It was nevertheless thought desirable that the United Kingdom should still have arms, and on THE GREAT SEALE OF ENGLAND/ IN THE FIRST YEARE OF FREEDOM BY GOD'S BLESSING RESTORED, that is, 1648, the cross of St. George appears for England, and a harp for Ireland. The royal crown was at the same time superseded, on all maces and other symbols of kingly power, by another which curiously reproduces all its elements. It had a circlet inscribed THE FREEDOM OF ENGLAND BY GOD'S BLESSING RESTORED, with the date, and for the cresting of crosses and fleurs-de-lis there was

346

substituted an intertwined cable enclosing small cartouches with the cross of St. George and the Irish harp. The new crown was also arched over, with four graceful incurved members like ostrich feathers, but wrought with oak leaves and acorns. These supported a pyramidal group of four handsome cartouches with the cross and harp surrounded by an acorn, instead of the orb and cross.* Perfect examples of this singular republican crown still surmount the two maces of the town of Weymouth.

On the obverse of the new great seal of the Commonwealth, designed and engraved by Simon and first used in 1655, the field is filled with an heraldic achievement of some interest (fig. 196). This includes a shield with the cross of St. George in the first and fourth quarters, St. Andrew's cross in the second quarter, and the Irish harp in the third quarter, with the lion of Cromwell on a scutcheon of pretence. This shield of the State's arms is supported by a lion with a royal crown on his head, and by a dragon,

* A curious variant of this crown, with a jewelled instead of an inscribed band, heads a drawing of the city arms of the date 1651 in the Dormant Book of the corporation of Carlisle.

347

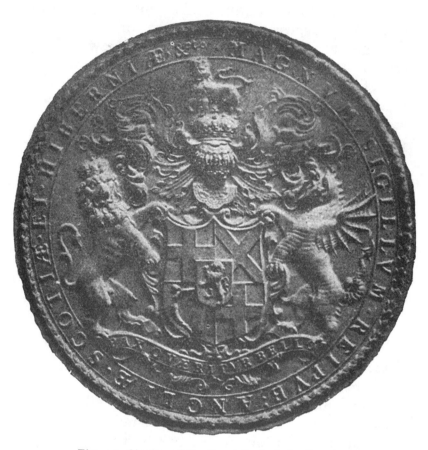

Fig. 196. Obverse of the Great Seal of the Republic
of England, Scotland, and Ireland, 1655.

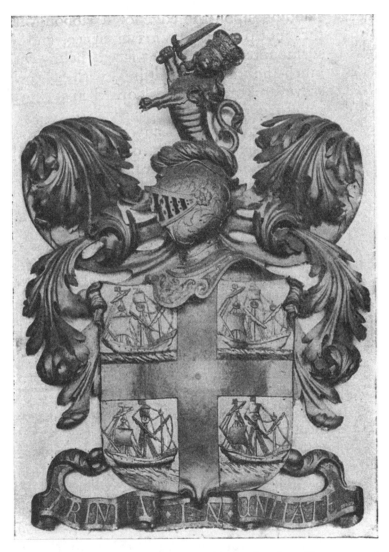

Fig. 197. Arms, etc. of the Trinity House, London. From a wood
carving c. 1670 in the Victoria and Albert Museum.

standing upon the edge of a ribbon with the motto PAX QVÆRITVR BELLO, and is surmounted by a front-faced helm with much flourished mantling, with a royal crown and the crowned leopard crest above, set athwart the helm.

The seal furnishes an excellent illustration of the heraldic art of the period, but it is singular that under a Nonconformist domination the arms selected for England and Scotland should consist of the crosses of their patron saints. It is also interesting to note that the expunged arms of England and Scotland had evidently been regarded rightly as personal to the murdered King. A further curious point is the reappearance on the seal of the royal crown of England above the helm and on the leopard crest and the lion supporter.

On the reverse of the seal just noted the State's new arms are repeated on a cartouche behind the equestrian figure of the Protector.

Of the heraldry of the Restoration and later it is hardly necessary to make mention, so lifeless and dull is the generality of it. A good specimen *c.* 1670 with the arms of the Trinity House (fig. 197), and a later one (fig. 198) with the arms,

etc. of the Trevor family, are to be Tudor and
seen in the Victoria and Albert Museum. later
Reference is due, too, to one other notable Heraldry

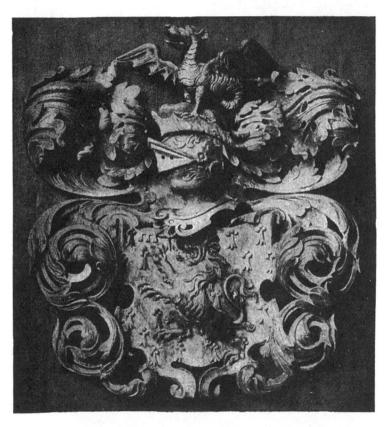

FIG. 198. Limewood carving with the arms and crest of the
Trevor family, *c.* 1700, in the Victoria and Albert
Museum.

351

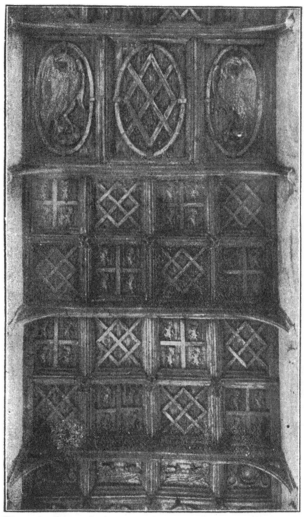

Fig. 199. Part of the carved oak ceiling of the chapel
formerly the hall, of Auckland castle, Durham, with the
arms of bishop John Cosin, date 1662-4.

example. This is the beautiful panelled ceiling set up over the chapel (formerly the great hall) of Auckland castle, by doctor John Cosin bishop of Durham (fig. 199). It was in making from 1662 to 1664, by a local carpenter, and consists for the most part of a series of square panels containing alternately the cross and four lions that form the arms of the bishopric of Durham, and the fret forming the arms of Cosin. In the middle bay the bishop's arms are given in an oval, and flanked by similar ovals with the eagle of St. John in allusion to his name. No earlier wooden ceiling could be finer in conception, and the effect of the whole was originally enhanced by colour and gilding, but this was most unhappily removed by order of bishop Barrington (1791–1826).

With so notable a late survival of medieval tradition this book may fitly end.

CHRONOLOGICAL SERIES OF ILLUSTRATIONS

THE following series of illustrations is an attempt to gather up into chronological order such of the more typical examples in this book as serve to show the development and various applications of heraldic art from the thirteenth to the eighteenth century. The series could, of course, have been extended indefinitely, but the present collection is probably sufficient for its purpose.

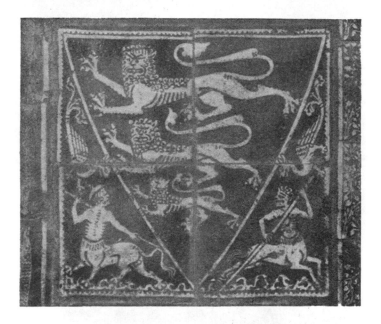

c. 1255

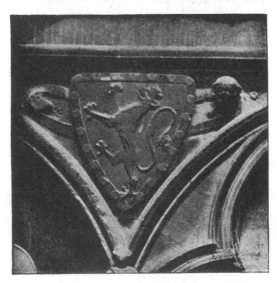

c. 1259

Tiles *c.* 1255 from the chapter-house and shield
c. 1259 from the quire aisle of Westminster
abbey

355

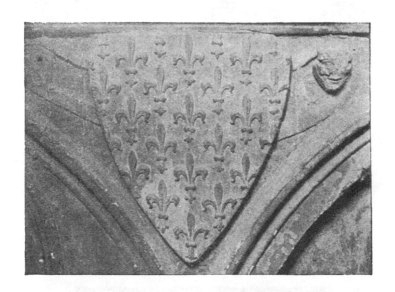

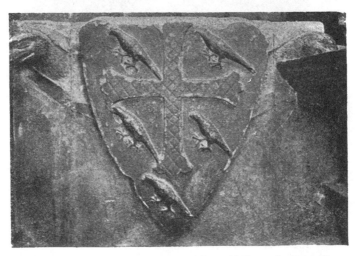

Shields *c*. 1259 from the quire aisles of Westminster abbey church

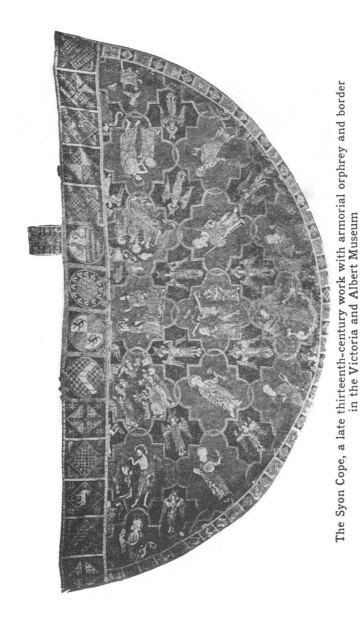

The Syon Cope, a late thirteenth-century work with armorial orphrey and border in the Victoria and Albert Museum

357

Quartered shield of Queen Eleanor of Castile, from her tomb
at Westminster, 1291

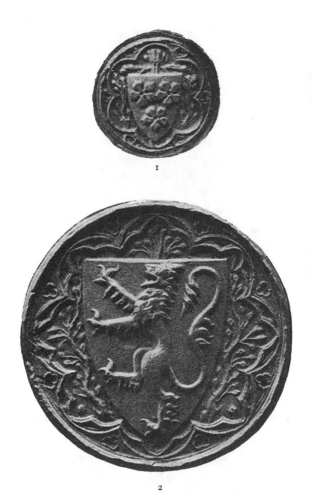

1

2

Seals from the Barons' Letter of 1301 of (1) Hugh
Bardolf and (2) Henry Percy

359

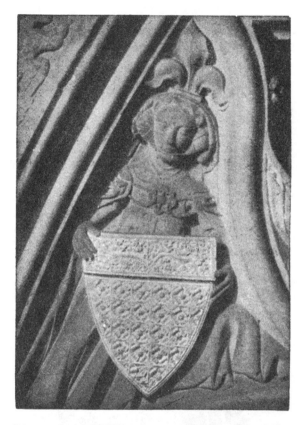

Diapered shield from the monument of the lady
Eleanor Percy (*ob.* 1337) in Beverley Minster

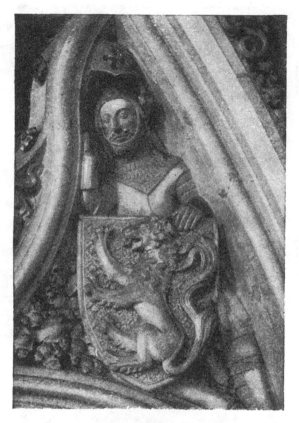

Diapered shield from the monument of the lady
Eleanor Percy (*ob.* 1337) in Beverley Minster

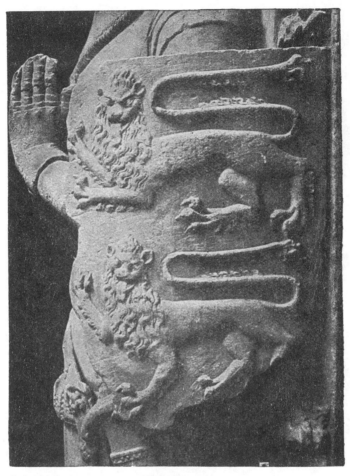

Shield of the arms of Sir Humphrey Littlebury, from his
effigy at Holbeach in Lincolnshire; *c.* 1360

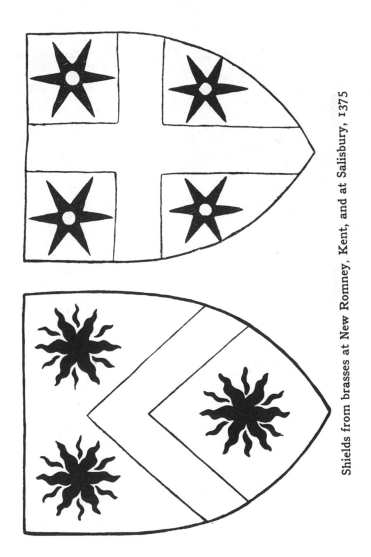

Shields from brasses at New Romney, Kent, and at Salisbury, 1375

363

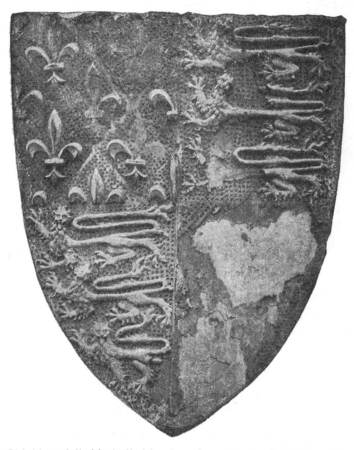

Shield modelled in boiled leather, from the tomb of Edward
prince of Wales, *ob.* 1376, at Canterbury

364

Shield and crested helm with simple mantling from a
brass at Southacre, Norfolk, 1384

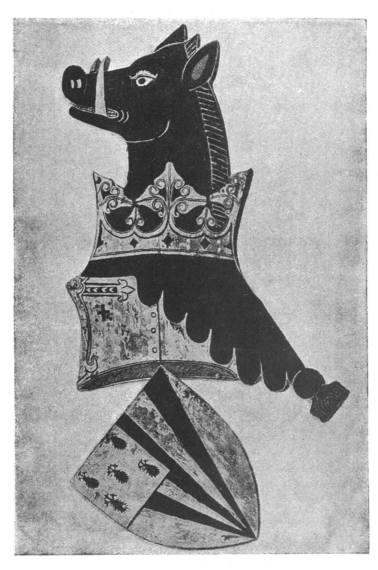

Stall-plate of Ralph lord Bassett, 1390, showing simple form of mantling

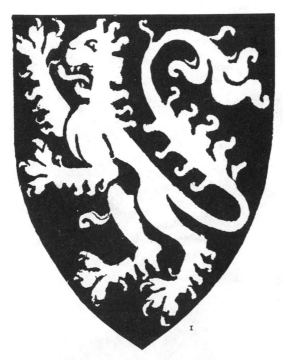

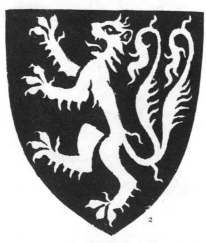

Shields with lions from (1) Felbrigge, Norfolk,
c. 1380, and (2) from Spilsby, Lincs, 1391

367

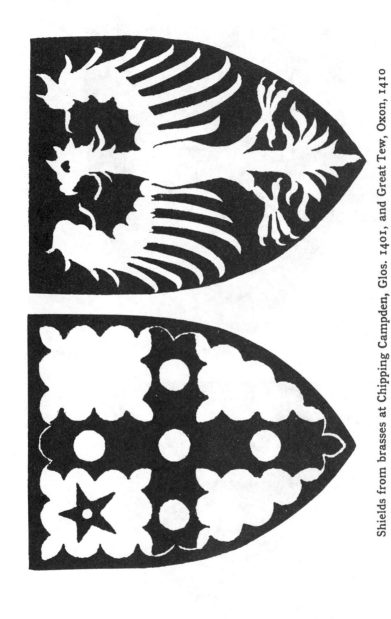

Shields from brasses at Chipping Campden, Glos. 1401, and Great Tew, Oxon, 1410

368

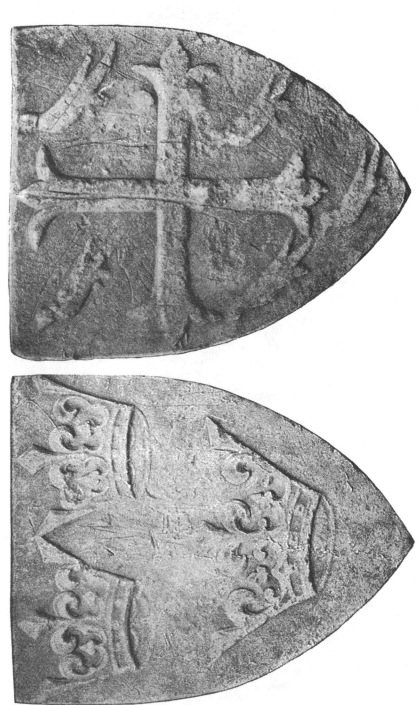

Arms of St. Edmund the King and St. Edward the Confessor, from the tomb of Edmund duke of York, *ob.* 1402, at King's Langley

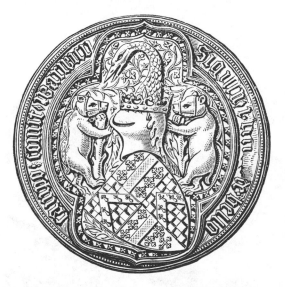

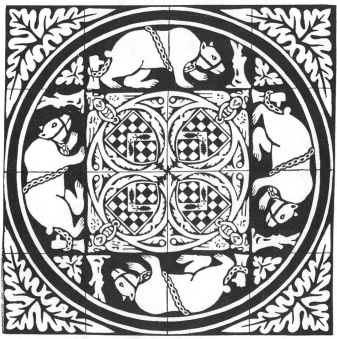

Seal of Richard Beauchamp earl of Warwick, in 1403, and early fifteenth-century heraldic tiles from Tewkesbury abbey church

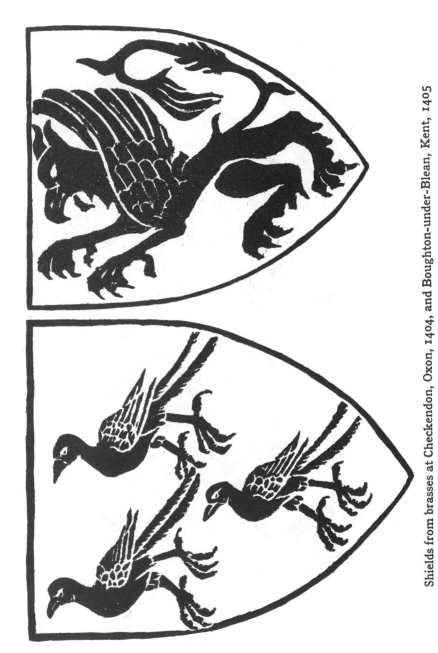

Shields from brasses at Checkendon, Oxon, 1404, and Boughton-under-Blean, Kent, 1405

371

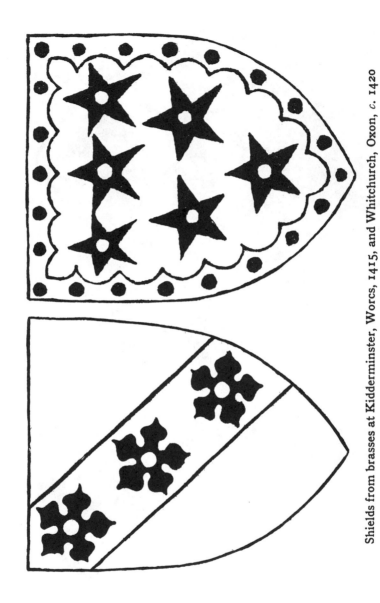

Shields from brasses at Kidderminster, Worcs, 1415, and Whitchurch, Oxon, c. 1420

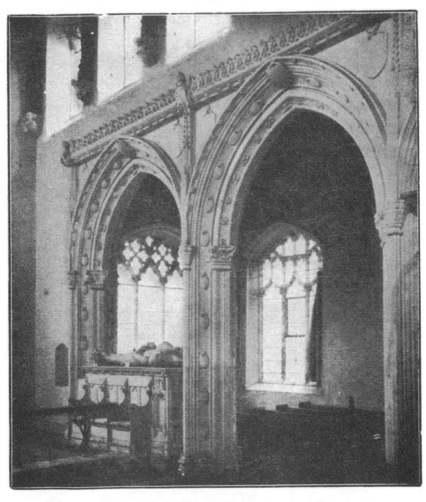

Part of the chancel arcade in Wingfield church, Suffolk, with badges of
Michael de la Pole earl of Suffolk, *ob.* 1415, and his wife Katherine
Stafford

373

Stall-plate of Walter lord Hungerford, after 1426

374

Stall-plate of Humphrey duke of Buckingham as
Earl of Stafford, *c.* 1429

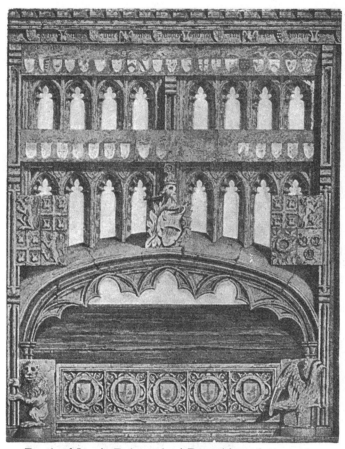

Tomb of Lewis Robsart lord Bourchier, *ob.* 1431, in
Westminster abbey church

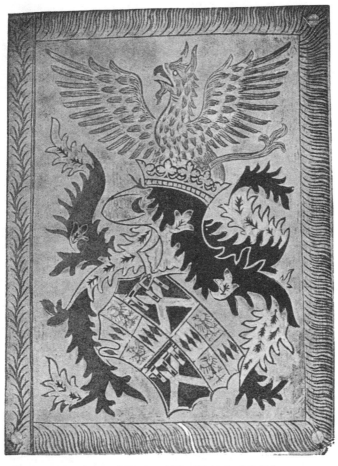

Banner stall-plate of Richard Nevill earl of Salisbury, *c.* 1436

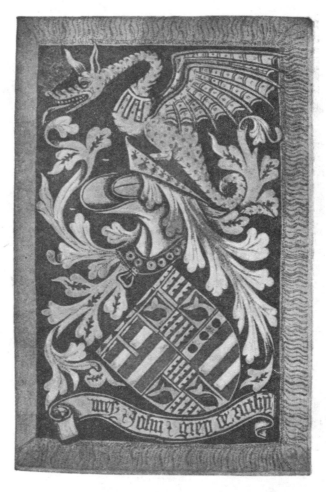

Banner stall-plate of Sir John Grey of Ruthin, *c.* 1439

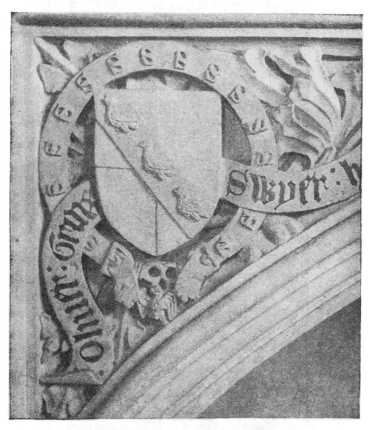

Spandrel of the tomb of Oliver Groos, Esq., *ob.* 1439, in
Sloley church, Norfolk

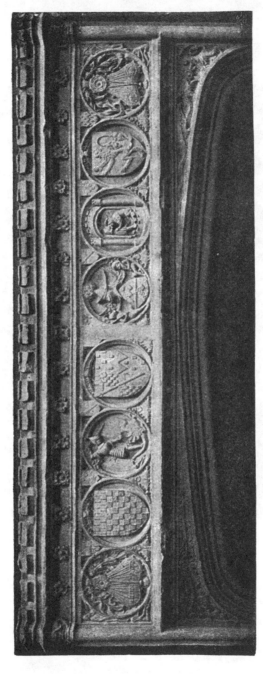

Chimney-piece in Tattershall castle, Lincs, built by Ralph lord Cromwell between 1433 and 1455

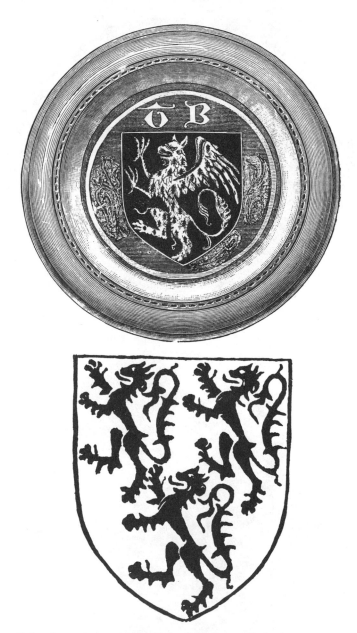

Print from a mazer at All Souls college, Oxford, *c.* 1450, and shield from a brass at Stanford Dingley, Berks, 1444

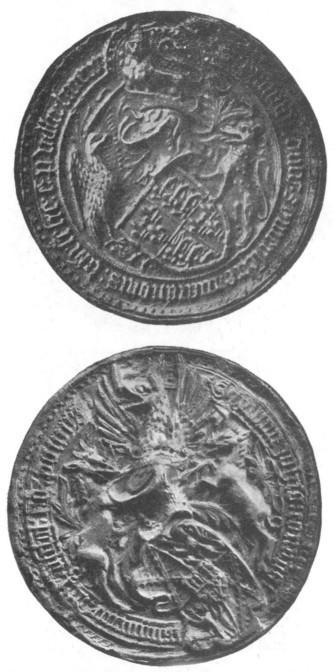

Seals of Edmund duke of Somerset, *c.* 1445, and John
Tiptoft earl of Worcester, 1449

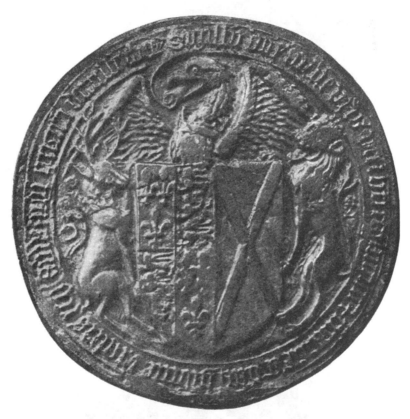

Seal of Cecily Nevill, wife of Richard duke of York and mother
of King Edward IV, 1461

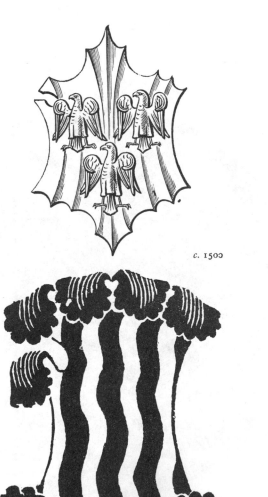

c. 1500

c. 1476

Shields from the chantry chapel of Thomas
Ramryge abbot of St. Albans, *c.* 1500, and
from a brass at Stoke Poges, Bucks, 1476

384

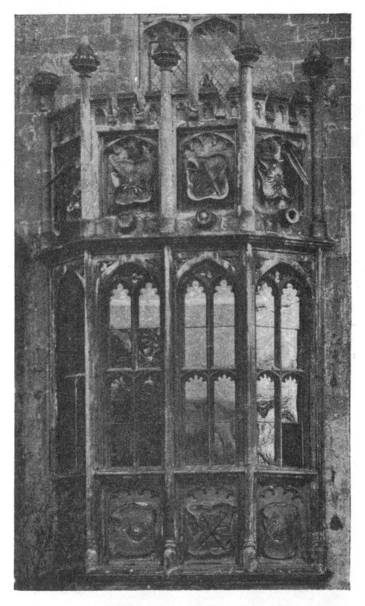

Oriel window in the Deanery at Wells, with badges of King
Edward IV and rebuses of Dean Gunthorpe, *c.* 1475-80

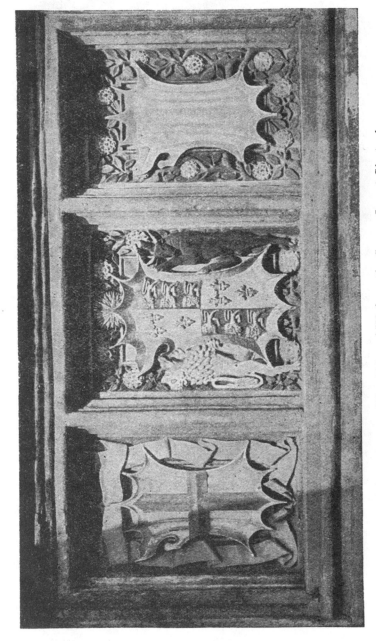

Armorial panel, *temp*. King Edward IV, from the George Inn at Glastonbury

387

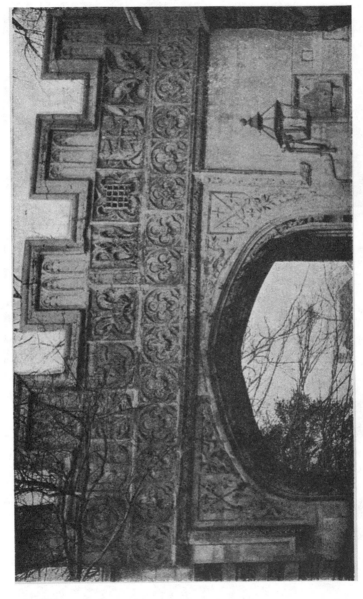

Gateway to the Deanery at Peterborough with arms and badges of King Henry VII and others, built by Robert Kirkton, abbot 1497-1526

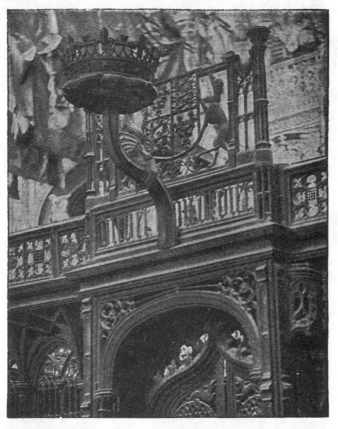

Heraldic candle-holder, etc. from the bronze grate about
the tomb of King Henry VII at Westminster

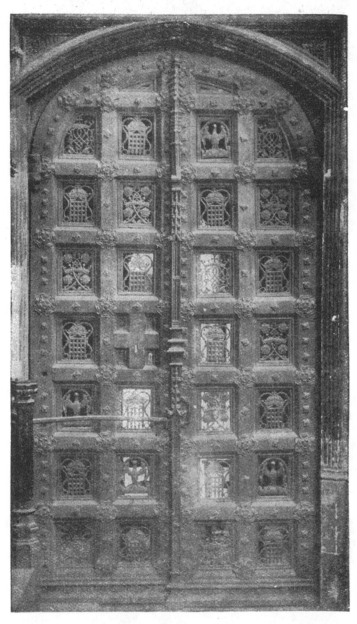

Bronze door with York and Beaufort badges from Henry VII's
chapel at Westminster

Crowned initials of King Henry VII from his chapel at Westminster, and crowned portcullis and rose from King's college chapel at Cambridge

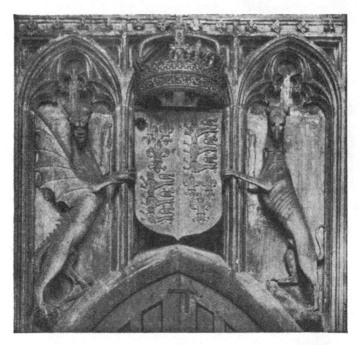

Crowned arms and supporters of King Henry VII in
King's college chapel at Cambridge

392

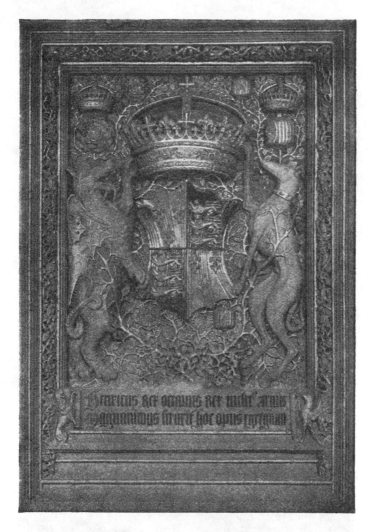

Carved panel with the crowned arms, supporters, and badges
of King Henry VIII at New Hall, Essex

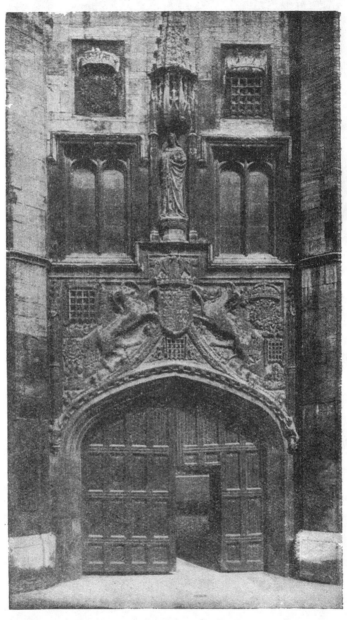

Gatehouse of Christ's college at Cambridge, built by the
lady Margaret Beaufort after 1505

394

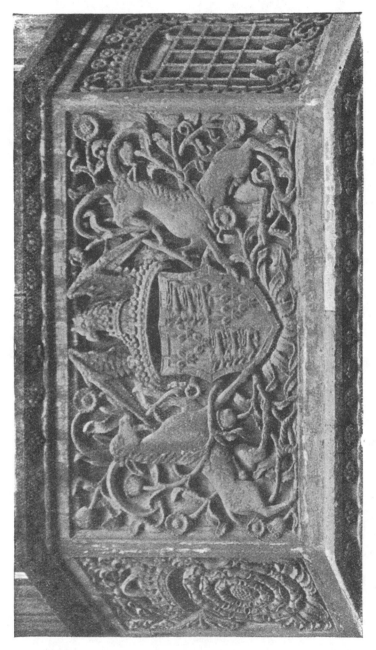

Base of an oriel on the master's lodge at Christ's college in Cambridge with the armorial ensigns of the lady Margaret Beaufort, foundress, *c.* 1505

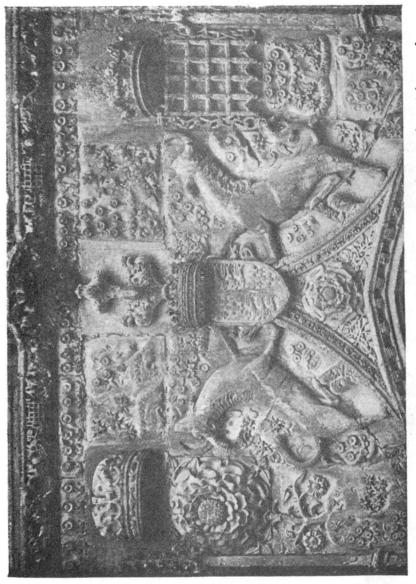

Armorial panel with the arms, etc. of the lady Margaret Beaufort, on the gatehouse of
St. John's college in Cambridge

396

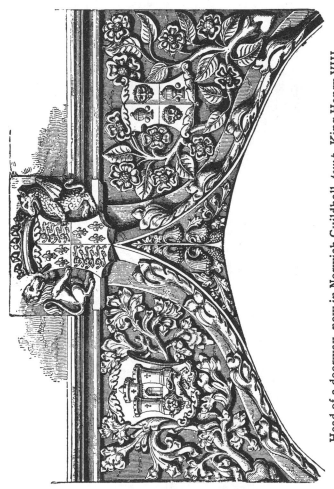

Head of a doorway, now in Norwich Guildhall, *temp.* King Henry VIII

397

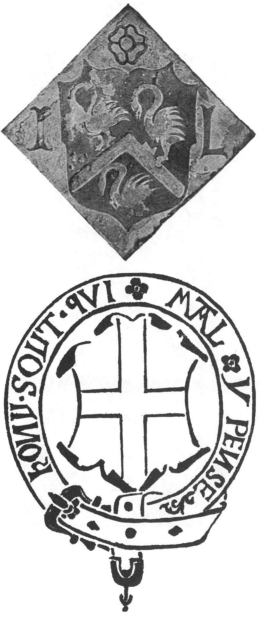

Paving tile, *c.* 1535, from Marten church,
Wilts; and shield of St. George in the Garter
from the brass of Thomas earl of Wiltshire
and Ormond, 1538, at Hever in Kent

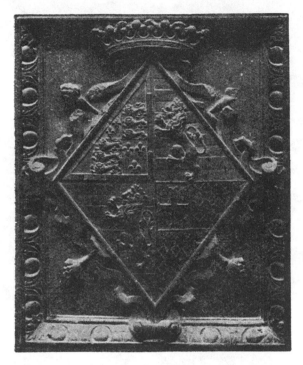

Lozenge of arms from the monument at
Westminster of Frances Brandon duchess
of Suffolk, *ob.* 1559

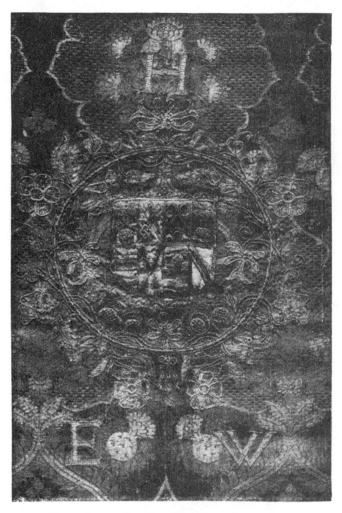

Part of an embroidered bed-hanging, *c.* 1560

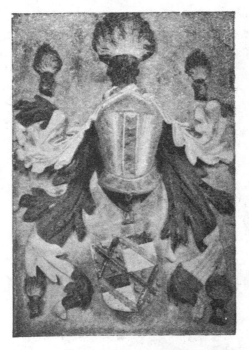

Arms with crested helm and badge of
(apparently) Sir John Guldeford of
Benenden, *ob.* 1565, in East Guldeford
church, Sussex

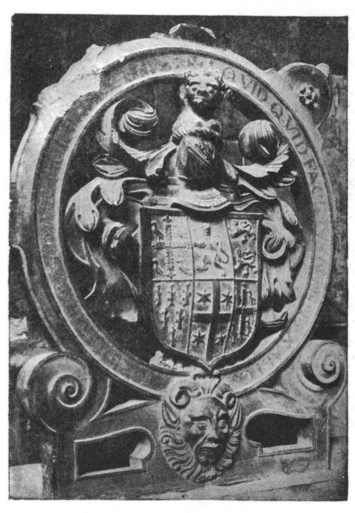

Armorial ensigns from the monument of Sir Richard Pecksall,
ob. 1571, in Westminster abbey church

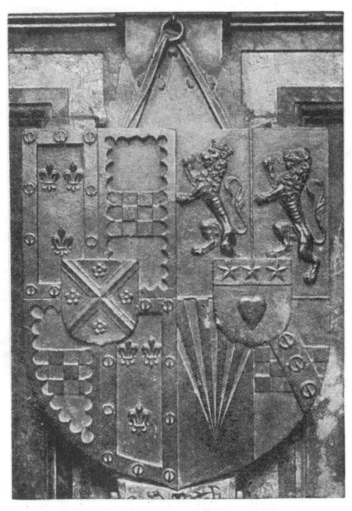

Shield from the tomb of Margaret countess of Lennox,
ob. 1578, in Westminster abbey church

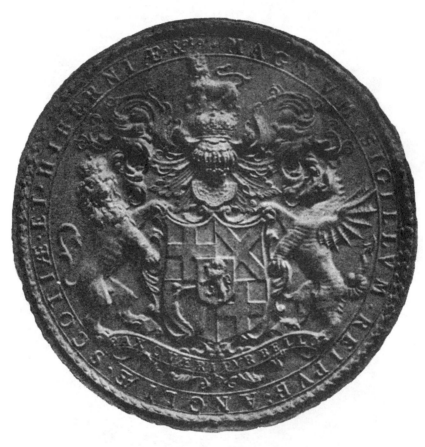

Obverse of the Great Seal of the Republic of England, Scotland, and Ireland, 1655

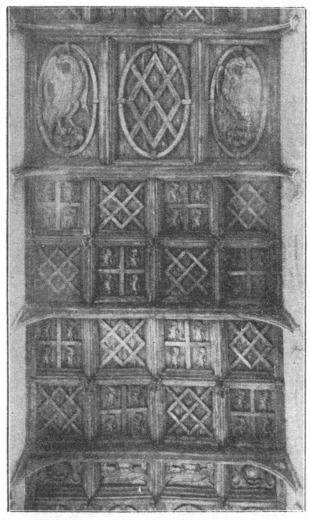

Part of the carved oak ceiling of the chapel of
Auckland castle, Durham, with the arms of bishop
John Cosin. Date, 1662-4

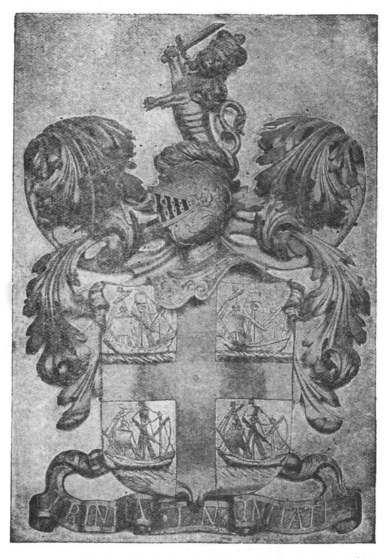

Arms, etc. of the Trinity House, London. From a wood-carving
c. 1670 in the Victoria and Albert Museum

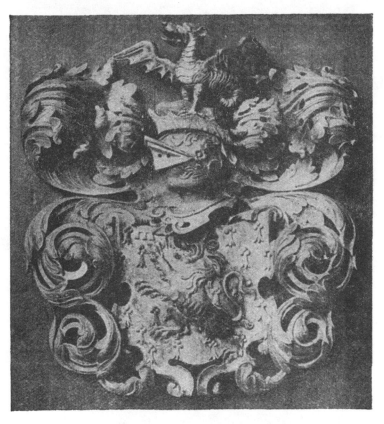

Limewood carving with the arms and crest of the Trevor
family, *c.* 1700, in the Victoria and Albert Museum

INDEX

409

410

412

414

416

418

419

420

A CATALOG OF SELECTED
DOVER BOOKS
IN ALL FIELDS OF INTEREST

A CATALOG OF SELECTED DOVER
BOOKS IN ALL FIELDS OF INTEREST

CONCERNING THE SPIRITUAL IN ART, Wassily Kandinsky. Pioneering work by father of abstract art. Thoughts on color theory, nature of art. Analysis of earlier masters. 12 illustrations. 80pp. of text. 5⅜ x 8½. 23411-8 Pa. $4.95

ANIMALS: 1,419 Copyright-Free Illustrations of Mammals, Birds, Fish, Insects, etc., Jim Harter (ed.). Clear wood engravings present, in extremely lifelike poses, over 1,000 species of animals. One of the most extensive pictorial sourcebooks of its kind. Captions. Index. 284pp. 9 x 12. 23766-4 Pa. $14.95

CELTIC ART: The Methods of Construction, George Bain. Simple geometric techniques for making Celtic interlacements, spirals, Kells-type initials, animals, humans, etc. Over 500 illustrations. 160pp. 9 x 12. (USO) 22923-8 Pa. $9.95

AN ATLAS OF ANATOMY FOR ARTISTS, Fritz Schider. Most thorough reference work on art anatomy in the world. Hundreds of illustrations, including selections from works by Vesalius, Leonardo, Goya, Ingres, Michelangelo, others. 593 illustrations. 192pp. 7⅛ x 10¼. 20241-0 Pa. $9.95

CELTIC HAND STROKE-BY-STROKE (Irish Half-Uncial from "The Book of Kells"): An Arthur Baker Calligraphy Manual, Arthur Baker. Complete guide to creating each letter of the alphabet in distinctive Celtic manner. Covers hand position, strokes, pens, inks, paper, more. Illustrated. 48pp. 8¼ x 11. 24336-2 Pa. $3.95

EASY ORIGAMI, John Montroll. Charming collection of 32 projects (hat, cup, pelican, piano, swan, many more) specially designed for the novice origami hobbyist. Clearly illustrated easy-to-follow instructions insure that even beginning papercrafters will achieve successful results. 48pp. 8¼ x 11. 27298-2 Pa. $3.50

THE COMPLETE BOOK OF BIRDHOUSE CONSTRUCTION FOR WOODWORKERS, Scott D. Campbell. Detailed instructions, illustrations, tables. Also data on bird habitat and instinct patterns. Bibliography. 3 tables. 63 illustrations in 15 figures. 48pp. 5¼ x 8½. 24407-5 Pa. $2.50

BLOOMINGDALE'S ILLUSTRATED 1886 CATALOG: Fashions, Dry Goods and Housewares, Bloomingdale Brothers. Famed merchants' extremely rare catalog depicting about 1,700 products: clothing, housewares, firearms, dry goods, jewelry, more. Invaluable for dating, identifying vintage items. Also, copyright-free graphics for artists, designers. Co-published with Henry Ford Museum & Greenfield Village. 160pp. 8¼ x 11. 25780-0 Pa. $10.95

HISTORIC COSTUME IN PICTURES, Braun & Schneider. Over 1,450 costumed figures in clearly detailed engravings–from dawn of civilization to end of 19th century. Captions. Many folk costumes. 256pp. 8⅜ x 11¾. 23150-X Pa. $12.95

CATALOG OF DOVER BOOKS

STICKLEY CRAFTSMAN FURNITURE CATALOGS, Gustav Stickley and L. & J. G. Stickley. Beautiful, functional furniture in two authentic catalogs from 1910. 594 illustrations, including 277 photos, show settles, rockers, armchairs, reclining chairs, bookcases, desks, tables. 183pp. 6½ x 9¼. 23838-5 Pa. $11.95

AMERICAN LOCOMOTIVES IN HISTORIC PHOTOGRAPHS: 1858 to 1949, Ron Ziel (ed.). A rare collection of 126 meticulously detailed official photographs, called "builder portraits," of American locomotives that majestically chronicle the rise of steam locomotive power in America. Introduction. Detailed captions. xi + 129pp. 9 x 12. 27393-8 Pa. $13.95

AMERICA'S LIGHTHOUSES: An Illustrated History, Francis Ross Holland, Jr. Delightfully written, profusely illustrated fact-filled survey of over 200 American lighthouses since 1716. History, anecdotes, technological advances, more. 240pp. 8 x 10¾.
 25576-X Pa. $12.95

TOWARDS A NEW ARCHITECTURE, Le Corbusier. Pioneering manifesto by founder of "International School." Technical and aesthetic theories, views of industry, economics, relation of form to function, "mass-production split" and much more. Profusely illustrated. 320pp. 6⅛ x 9¼. (USO) 25023-7 Pa. $9.95

HOW THE OTHER HALF LIVES, Jacob Riis. Famous journalistic record, exposing poverty and degradation of New York slums around 1900, by major social reformer. 100 striking and influential photographs. 233pp. 10 x 7⅞.
 22012-5 Pa. $11.95

FRUIT KEY AND TWIG KEY TO TREES AND SHRUBS, William M. Harlow. One of the handiest and most widely used identification aids. Fruit key covers 120 deciduous and evergreen species; twig key 160 deciduous species. Easily used. Over 300 photographs. 126pp. 5⅜ x 8½. 20511-8 Pa. $3.95

COMMON BIRD SONGS, Dr. Donald J. Borror. Songs of 60 most common U.S. birds: robins, sparrows, cardinals, bluejays, finches, more–arranged in order of increasing complexity. Up to 9 variations of songs of each species.
 Cassette and manual 99911-4 $8.95

ORCHIDS AS HOUSE PLANTS, Rebecca Tyson Northen. Grow cattleyas and many other kinds of orchids–in a window, in a case, or under artificial light. 63 illustrations. 148pp. 5⅜ x 8½. 23261-1 Pa. $5.95

MONSTER MAZES, Dave Phillips. Masterful mazes at four levels of difficulty. Avoid deadly perils and evil creatures to find magical treasures. Solutions for all 32 exciting illustrated puzzles. 48pp. 8¼ x 11. 26005-4 Pa. $2.95

MOZART'S DON GIOVANNI (DOVER OPERA LIBRETTO SERIES), Wolfgang Amadeus Mozart. Introduced and translated by Ellen H. Bleiler. Standard Italian libretto, with complete English translation. Convenient and thoroughly portable–an ideal companion for reading along with a recording or the performance itself. Introduction. List of characters. Plot summary. 121pp. 5¼ x 8½.
 24944-1 Pa. $3.95

TECHNICAL MANUAL AND DICTIONARY OF CLASSICAL BALLET, Gail Grant. Defines, explains, comments on steps, movements, poses and concepts. 15-page pictorial section. Basic book for student, viewer. 127pp. 5⅜ x 8½.
 21843-0 Pa. $4.95

CATALOG OF DOVER BOOKS

BRASS INSTRUMENTS: Their History and Development, Anthony Baines. Authoritative, updated survey of the evolution of trumpets, trombones, bugles, cornets, French horns, tubas and other brass wind instruments. Over 140 illustrations and 48 music examples. Corrected and updated by author. New preface. Bibliography. 320pp. 5⅜ x 8½. 27574-4 Pa. $9.95

HOLLYWOOD GLAMOR PORTRAITS, John Kobal (ed.). 145 photos from 1926-49. Harlow, Gable, Bogart, Bacall; 94 stars in all. Full background on photographers, technical aspects. 160pp. 8⅜ x 11¼. 23352-9 Pa. $12.95

MAX AND MORITZ, Wilhelm Busch. Great humor classic in both German and English. Also 10 other works: "Cat and Mouse," "Plisch and Plumm," etc. 216pp. 5⅜ x 8½. 20181-3 Pa. $6.95

THE RAVEN AND OTHER FAVORITE POEMS, Edgar Allan Poe. Over 40 of the author's most memorable poems: "The Bells," "Ulalume," "Israfel," "To Helen," "The Conqueror Worm," "Eldorado," "Annabel Lee," many more. Alphabetic lists of titles and first lines. 64pp. 5⅜₆ x 8¼. 26685-0 Pa. $1.00

PERSONAL MEMOIRS OF U. S. GRANT, Ulysses Simpson Grant. Intelligent, deeply moving firsthand account of Civil War campaigns, considered by many the finest military memoirs ever written. Includes letters, historic photographs, maps and more. 528pp. 6⅛ x 9¼. 28587-1 Pa. $12.95

AMULETS AND SUPERSTITIONS, E. A. Wallis Budge. Comprehensive discourse on origin, powers of amulets in many ancient cultures: Arab, Persian Babylonian, Assyrian, Egyptian, Gnostic, Hebrew, Phoenician, Syriac, etc. Covers cross, swastika, crucifix, seals, rings, stones, etc. 584pp. 5⅜ x 8½. 23573-4 Pa. $12.95

RUSSIAN STORIES/PYCCKNE PACCKA3bl: A Dual-Language Book, edited by Gleb Struve. Twelve tales by such masters as Chekhov, Tolstoy, Dostoevsky, Pushkin, others. Excellent word-for-word English translations on facing pages, plus teaching and study aids, Russian/English vocabulary, biographical/critical introductions, more. 416pp. 5⅜ x 8½. 26244-8 Pa. $9.95

PHILADELPHIA THEN AND NOW: 60 Sites Photographed in the Past and Present, Kenneth Finkel and Susan Oyama. Rare photographs of City Hall, Logan Square, Independence Hall, Betsy Ross House, other landmarks juxtaposed with contemporary views. Captures changing face of historic city. Introduction. Captions. 128pp. 8¼ x 11. 25790-8 Pa. $9.95

AIA ARCHITECTURAL GUIDE TO NASSAU AND SUFFOLK COUNTIES, LONG ISLAND, The American Institute of Architects, Long Island Chapter, and the Society for the Preservation of Long Island Antiquities. Comprehensive, well-researched and generously illustrated volume brings to life over three centuries of Long Island's great architectural heritage. More than 240 photographs with authoritative, extensively detailed captions. 176pp. 8¼ x 11. 26946-9 Pa. $14.95

NORTH AMERICAN INDIAN LIFE: Customs and Traditions of 23 Tribes, Elsie Clews Parsons (ed.). 27 fictionalized essays by noted anthropologists examine religion, customs, government, additional facets of life among the Winnebago, Crow, Zuni, Eskimo, other tribes. 480pp. 6⅛ x 9¼. 27377-6 Pa. $10.95

CATALOG OF DOVER BOOKS

FRANK LLOYD WRIGHT'S HOLLYHOCK HOUSE, Donald Hoffmann. Lavishly illustrated, carefully documented study of one of Wright's most controversial residential designs. Over 120 photographs, floor plans, elevations, etc. Detailed perceptive text by noted Wright scholar. Index. 128pp. 9¼ x 10¾. 27133-1 Pa. $11.95

THE MALE AND FEMALE FIGURE IN MOTION: 60 Classic Photographic Sequences, Eadweard Muybridge. 60 true-action photographs of men and women walking, running, climbing, bending, turning, etc., reproduced from rare 19th-century masterpiece. vi + 121pp. 9 x 12. 24745-7 Pa. $10.95

1001 QUESTIONS ANSWERED ABOUT THE SEASHORE, N. J. Berrill and Jacquelyn Berrill. Queries answered about dolphins, sea snails, sponges, starfish, fishes, shore birds, many others. Covers appearance, breeding, growth, feeding, much more. 305pp. 5¼ x 8¼. 23366-9 Pa. $8.95

GUIDE TO OWL WATCHING IN NORTH AMERICA, Donald S. Heintzelman. Superb guide offers complete data and descriptions of 19 species: barn owl, screech owl, snowy owl, many more. Expert coverage of owl-watching equipment, conservation, migrations and invasions, etc. Guide to observing sites. 84 illustrations. xiii + 193pp. 5⅜ x 8½. 27344-X Pa. $8.95

MEDICINAL AND OTHER USES OF NORTH AMERICAN PLANTS: A Historical Survey with Special Reference to the Eastern Indian Tribes, Charlotte Erichsen-Brown. Chronological historical citations document 500 years of usage of plants, trees, shrubs native to eastern Canada, northeastern U.S. Also complete identifying information. 343 illustrations. 544pp. 6½ x 9¼. 25951-X Pa. $12.95

STORYBOOK MAZES, Dave Phillips. 23 stories and mazes on two-page spreads: Wizard of Oz, Treasure Island, Robin Hood, etc. Solutions. 64pp. 8¼ x 11. 23628-5 Pa. $2.95

NEGRO FOLK MUSIC, U.S.A., Harold Courlander. Noted folklorist's scholarly yet readable analysis of rich and varied musical tradition. Includes authentic versions of over 40 folk songs. Valuable bibliography and discography. xi + 324pp. 5⅜ x 8½. 27350-4 Pa. $9.95

MOVIE-STAR PORTRAITS OF THE FORTIES, John Kobal (ed.). 163 glamor, studio photos of 106 stars of the 1940s: Rita Hayworth, Ava Gardner, Marlon Brando, Clark Gable, many more. 176pp. 8⅜ x 11¼. 23546-7 Pa. $12.95

BENCHLEY LOST AND FOUND, Robert Benchley. Finest humor from early 30s, about pet peeves, child psychologists, post office and others. Mostly unavailable elsewhere. 73 illustrations by Peter Arno and others. 183pp. 5⅜ x 8½. 22410-4 Pa. $6.95

YEKL and THE IMPORTED BRIDEGROOM AND OTHER STORIES OF YIDDISH NEW YORK, Abraham Cahan. Film Hester Street based on Yekl (1896). Novel, other stories among first about Jewish immigrants on N.Y.'s East Side. 240pp. 5⅜ x 8½. 22427-9 Pa. $6.95

SELECTED POEMS, Walt Whitman. Generous sampling from *Leaves of Grass*. Twenty-four poems include "I Hear America Singing," "Song of the Open Road," "I Sing the Body Electric," "When Lilacs Last in the Dooryard Bloom'd," "O Captain! My Captain!"—all reprinted from an authoritative edition. Lists of titles and first lines. 128pp. 5³⁄₁₆ x 8¼. 26878-0 Pa. $1.00

THE BEST TALES OF HOFFMANN, E. T. A. Hoffmann. 10 of Hoffmann's most important stories: "Nutcracker and the King of Mice," "The Golden Flowerpot," etc. 458pp. 5⅜ x 8½. 21793-0 Pa. $9.95

FROM FETISH TO GOD IN ANCIENT EGYPT, E. A. Wallis Budge. Rich detailed survey of Egyptian conception of "God" and gods, magic, cult of animals, Osiris, more. Also, superb English translations of hymns and legends. 240 illustrations. 545pp. 5⅜ x 8½. 25803-3 Pa. $13.95

FRENCH STORIES/CONTES FRANÇAIS: A Dual-Language Book, Wallace Fowlie. Ten stories by French masters, Voltaire to Camus: "Micromegas" by Voltaire; "The Atheist's Mass" by Balzac; "Minuet" by de Maupassant; "The Guest" by Camus, six more. Excellent English translations on facing pages. Also French-English vocabulary list, exercises, more. 352pp. 5⅜ x 8½. 26443-2 Pa. $9.95

CHICAGO AT THE TURN OF THE CENTURY IN PHOTOGRAPHS: 122 Historic Views from the Collections of the Chicago Historical Society, Larry A. Viskochil. Rare large-format prints offer detailed views of City Hall, State Street, the Loop, Hull House, Union Station, many other landmarks, circa 1904-1913. Introduction. Captions. Maps. 144pp. 9⅜ x 12¼. 24656-6 Pa. $12.95

OLD BROOKLYN IN EARLY PHOTOGRAPHS, 1865-1929, William Lee Younger. Luna Park, Gravesend race track, construction of Grand Army Plaza, moving of Hotel Brighton, etc. 157 previously unpublished photographs. 165pp. 8⅞ x 11¾. 23587-4 Pa. $13.95

THE MYTHS OF THE NORTH AMERICAN INDIANS, Lewis Spence. Rich anthology of the myths and legends of the Algonquins, Iroquois, Pawnees and Sioux, prefaced by an extensive historical and ethnological commentary. 36 illustrations. 480pp. 5⅜ x 8½. 25967-6 Pa. $10.95

AN ENCYCLOPEDIA OF BATTLES: Accounts of Over 1,560 Battles from 1479 B.C. to the Present, David Eggenberger. Essential details of every major battle in recorded history from the first battle of Megiddo in 1479 B.C. to Grenada in 1984. List of Battle Maps. New Appendix covering the years 1967-1984. Index. 99 illustrations. 544pp. 6½ x 9¼. 24913-1 Pa. $16.95

SAILING ALONE AROUND THE WORLD, Captain Joshua Slocum. First man to sail around the world, alone, in small boat. One of great feats of seamanship told in delightful manner. 67 illustrations. 294pp. 5⅜ x 8½. 20326-3 Pa. $6.95

ANARCHISM AND OTHER ESSAYS, Emma Goldman. Powerful, penetrating, prophetic essays on direct action, role of minorities, prison reform, puritan hypocrisy, violence, etc. 271pp. 5⅜ x 8½. 22484-8 Pa. $7.95

MYTHS OF THE HINDUS AND BUDDHISTS, Ananda K. Coomaraswamy and Sister Nivedita. Great stories of the epics; deeds of Krishna, Shiva, taken from puranas, Vedas, folk tales; etc. 32 illustrations. 400pp. 5⅜ x 8½. 21759-0 Pa. $12.95

BEYOND PSYCHOLOGY, Otto Rank. Fear of death, desire of immortality, nature of sexuality, social organization, creativity, according to Rankian system. 291pp. 5⅜ x 8½. 20485-5 Pa. $8.95

A THEOLOGICO-POLITICAL TREATISE, Benedict Spinoza. Also contains unfinished Political Treatise. Great classic on religious liberty, theory of government on common consent. R. Elwes translation. Total of 421pp. 5⅜ x 8½. 20249-6 Pa. $9.95

CATALOG OF DOVER BOOKS

MY BONDAGE AND MY FREEDOM, Frederick Douglass. Born a slave, Douglass became outspoken force in antislavery movement. The best of Douglass' autobiographies. Graphic description of slave life. 464pp. 5⅜ x 8½. 22457-0 Pa. $8.95

FOLLOWING THE EQUATOR: A Journey Around the World, Mark Twain. Fascinating humorous account of 1897 voyage to Hawaii, Australia, India, New Zealand, etc. Ironic, bemused reports on peoples, customs, climate, flora and fauna, politics, much more. 197 illustrations. 720pp. 5⅜ x 8½. 26113-1 Pa. $15.95

THE PEOPLE CALLED SHAKERS, Edward D. Andrews. Definitive study of Shakers: origins, beliefs, practices, dances, social organization, furniture and crafts, etc. 33 illustrations. 351pp. 5⅜ x 8½. 21081-2 Pa. $8.95

THE MYTHS OF GREECE AND ROME, H. A. Guerber. A classic of mythology, generously illustrated, long prized for its simple, graphic, accurate retelling of the principal myths of Greece and Rome, and for its commentary on their origins and significance. With 64 illustrations by Michelangelo, Raphael, Titian, Rubens, Canova, Bernini and others. 480pp. 5⅜ x 8½. 27584-1 Pa. $9.95

PSYCHOLOGY OF MUSIC, Carl E. Seashore. Classic work discusses music as a medium from psychological viewpoint. Clear treatment of physical acoustics, auditory apparatus, sound perception, development of musical skills, nature of musical feeling, host of other topics. 88 figures. 408pp. 5⅜ x 8½. 21851-1 Pa. $11.95

THE PHILOSOPHY OF HISTORY, Georg W. Hegel. Great classic of Western thought develops concept that history is not chance but rational process, the evolution of freedom. 457pp. 5⅜ x 8½. 20112-0 Pa. $9.95

THE BOOK OF TEA, Kakuzo Okakura. Minor classic of the Orient: entertaining, charming explanation, interpretation of traditional Japanese culture in terms of tea ceremony. 94pp. 5⅜ x 8½. 20070-1 Pa. $3.95

LIFE IN ANCIENT EGYPT, Adolf Erman. Fullest, most thorough, detailed older account with much not in more recent books, domestic life, religion, magic, medicine, commerce, much more. Many illustrations reproduce tomb paintings, carvings, hieroglyphs, etc. 597pp. 5⅜ x 8½. 22632-8 Pa. $12.95

SUNDIALS, Their Theory and Construction, Albert Waugh. Far and away the best, most thorough coverage of ideas, mathematics concerned, types, construction, adjusting anywhere. Simple, nontechnical treatment allows even children to build several of these dials. Over 100 illustrations. 230pp. 5⅜ x 8½. 22947-5 Pa. $8.95

DYNAMICS OF FLUIDS IN POROUS MEDIA, Jacob Bear. For advanced students of ground water hydrology, soil mechanics and physics, drainage and irrigation engineering, and more. 335 illustrations. Exercises, with answers. 784pp. 6⅛ x 9¼. 65675-6 Pa. $19.95

SONGS OF EXPERIENCE: Facsimile Reproduction with 26 Plates in Full Color, William Blake. 26 full-color plates from a rare 1826 edition. Includes "TheTyger," "London," "Holy Thursday," and other poems. Printed text of poems. 48pp. 5¼ x 7. 24636-1 Pa. $4.95

OLD-TIME VIGNETTES IN FULL COLOR, Carol Belanger Grafton (ed.). Over 390 charming, often sentimental illustrations, selected from archives of Victorian graphics—pretty women posing, children playing, food, flowers, kittens and puppies, smiling cherubs, birds and butterflies, much more. All copyright-free. 48pp. 9¼ x 12¼. 27269-9 Pa. $7.95

PERSPECTIVE FOR ARTISTS, Rex Vicat Cole. Depth, perspective of sky and sea, shadows, much more, not usually covered. 391 diagrams, 81 reproductions of drawings and paintings. 279pp. 5⅜ x 8½. 22487-2 Pa. $7.95

DRAWING THE LIVING FIGURE, Joseph Sheppard. Innovative approach to artistic anatomy focuses on specifics of surface anatomy, rather than muscles and bones. Over 170 drawings of live models in front, back and side views, and in widely varying poses. Accompanying diagrams. 177 illustrations. Introduction. Index. 144pp. 8⅜ x11¼. 26723-7 Pa. $8.95

GOTHIC AND OLD ENGLISH ALPHABETS: 100 Complete Fonts, Dan X. Solo. Add power, elegance to posters, signs, other graphics with 100 stunning copyright-free alphabets: Blackstone, Dolbey, Germania, 97 more—including many lower-case, numerals, punctuation marks. 104pp. 8⅛ x 11. 24695-7 Pa. $8.95

HOW TO DO BEADWORK, Mary White. Fundamental book on craft from simple projects to five-bead chains and woven works. 106 illustrations. 142pp. 5⅜ x 8.
20697-1 Pa. $4.95

THE BOOK OF WOOD CARVING, Charles Marshall Sayers. Finest book for beginners discusses fundamentals and offers 34 designs. "Absolutely first rate . . . well thought out and well executed."—E. J. Tangerman. 118pp. 7¾ x 10⅝.
23654-4 Pa. $6.95

ILLUSTRATED CATALOG OF CIVIL WAR MILITARY GOODS: Union Army Weapons, Insignia, Uniform Accessories, and Other Equipment, Schuyler, Hartley, and Graham. Rare, profusely illustrated 1846 catalog includes Union Army uniform and dress regulations, arms and ammunition, coats, insignia, flags, swords, rifles, etc. 226 illustrations. 160pp. 9 x 12. 24939-5 Pa. $10.95

WOMEN'S FASHIONS OF THE EARLY 1900s: An Unabridged Republication of "New York Fashions, 1909," National Cloak & Suit Co. Rare catalog of mail-order fashions documents women's and children's clothing styles shortly after the turn of the century. Captions offer full descriptions, prices. Invaluable resource for fashion, costume historians. Approximately 725 illustrations. 128pp. 8⅜ x 11¼.
27276-1 Pa. $11.95

THE 1912 AND 1915 GUSTAV STICKLEY FURNITURE CATALOGS, Gustav Stickley. With over 200 detailed illustrations and descriptions, these two catalogs are essential reading and reference materials and identification guides for Stickley furniture. Captions cite materials, dimensions and prices. 112pp. 6½ x 9¼.
26676-1 Pa. $9.95

EARLY AMERICAN LOCOMOTIVES, John H. White, Jr. Finest locomotive engravings from early 19th century: historical (1804–74), main-line (after 1870), special, foreign, etc. 147 plates. 142pp. 11⅜ x 8¼. 22772-3 Pa. $10.95

THE TALL SHIPS OF TODAY IN PHOTOGRAPHS, Frank O. Braynard. Lavishly illustrated tribute to nearly 100 majestic contemporary sailing vessels: Amerigo Vespucci, Clearwater, Constitution, Eagle, Mayflower, Sea Cloud, Victory, many more. Authoritative captions provide statistics, background on each ship. 190 black-and-white photographs and illustrations. Introduction. 128pp. 8⅞ x 11¾.
27163-3 Pa. $14.95

EARLY NINETEENTH-CENTURY CRAFTS AND TRADES, Peter Stockham (ed.). Extremely rare 1807 volume describes to youngsters the crafts and trades of the day: brickmaker, weaver, dressmaker, bookbinder, ropemaker, saddler, many more. Quaint prose, charming illustrations for each craft. 20 black-and-white line illustrations. 192pp. 4⅝ x 6. 27293-1 Pa. $4.95

VICTORIAN FASHIONS AND COSTUMES FROM HARPER'S BAZAR, 1867–1898, Stella Blum (ed.). Day costumes, evening wear, sports clothes, shoes, hats, other accessories in over 1,000 detailed engravings. 320pp. 9⅜ x 12¼. 22990-4 Pa. $15.95

GUSTAV STICKLEY, THE CRAFTSMAN, Mary Ann Smith. Superb study surveys broad scope of Stickley's achievement, especially in architecture. Design philosophy, rise and fall of the Craftsman empire, descriptions and floor plans for many Craftsman houses, more. 86 black-and-white halftones. 31 line illustrations. Introduction 208pp. 6½ x 9¼. 27210-9 Pa. $9.95

THE LONG ISLAND RAIL ROAD IN EARLY PHOTOGRAPHS, Ron Ziel. Over 220 rare photos, informative text document origin (1844) and development of rail service on Long Island. Vintage views of early trains, locomotives, stations, passengers, crews, much more. Captions. 8⅞ x 11¾. 26301-0 Pa. $13.95

THE BOOK OF OLD SHIPS: From Egyptian Galleys to Clipper Ships, Henry B. Culver. Superb, authoritative history of sailing vessels, with 80 magnificent line illustrations. Galley, bark, caravel, longship, whaler, many more. Detailed, informative text on each vessel by noted naval historian. Introduction. 256pp. 5⅜ x 8½. 27332-6 Pa. $7.95

TEN BOOKS ON ARCHITECTURE, Vitruvius. The most important book ever written on architecture. Early Roman aesthetics, technology, classical orders, site selection, all other aspects. Morgan translation. 331pp. 5⅜ x 8½. 20645-9 Pa. $8.95

THE HUMAN FIGURE IN MOTION, Eadweard Muybridge. More than 4,500 stopped-action photos, in action series, showing undraped men, women, children jumping, lying down, throwing, sitting, wrestling, carrying, etc. 390pp. 7⅞ x 10⅝. 20204-6 Clothbd. $27.95

TREES OF THE EASTERN AND CENTRAL UNITED STATES AND CANADA, William M. Harlow. Best one-volume guide to 140 trees. Full descriptions, woodlore, range, etc. Over 600 illustrations. Handy size. 288pp. 4½ x 6⅜. 20395-6 Pa. $6.95

SONGS OF WESTERN BIRDS, Dr. Donald J. Borror. Complete song and call repertoire of 60 western species, including flycatchers, juncoes, cactus wrens, many more—includes fully illustrated booklet. Cassette and manual 99913-0 $8.95

GROWING AND USING HERBS AND SPICES, Milo Miloradovich. Versatile handbook provides all the information needed for cultivation and use of all the herbs and spices available in North America. 4 illustrations. Index. Glossary. 236pp. 5⅜ x 8½. 25058-X Pa. $7.95

BIG BOOK OF MAZES AND LABYRINTHS, Walter Shepherd. 50 mazes and labyrinths in all—classical, solid, ripple, and more—in one great volume. Perfect inexpensive puzzler for clever youngsters. Full solutions. 112pp. 8⅛ x 11. 22951-3 Pa. $4.95

PIANO TUNING, J. Cree Fischer. Clearest, best book for beginner, amateur. Simple repairs, raising dropped notes, tuning by easy method of flattened fifths. No previous skills needed. 4 illustrations. 201pp. 5⅜ x 8½. 23267-0 Pa. $6.95

A SOURCE BOOK IN THEATRICAL HISTORY, A. M. Nagler. Contemporary observers on acting, directing, make-up, costuming, stage props, machinery, scene design, from Ancient Greece to Chekhov. 611pp. 5⅜ x 8½. 20515-0 Pa. $12.95

THE COMPLETE NONSENSE OF EDWARD LEAR, Edward Lear. All nonsense limericks, zany alphabets, Owl and Pussycat, songs, nonsense botany, etc., illustrated by Lear. Total of 320pp. 5⅜ x 8½. (USO) 20167-8 Pa. $7.95

VICTORIAN PARLOUR POETRY: An Annotated Anthology, Michael R. Turner. 117 gems by Longfellow, Tennyson, Browning, many lesser-known poets. "The Village Blacksmith," "Curfew Must Not Ring Tonight," "Only a Baby Small," dozens more, often difficult to find elsewhere. Index of poets, titles, first lines. xxiii + 325pp. 5⅜ x 8½. 27044-0 Pa. $8.95

DUBLINERS, James Joyce. Fifteen stories offer vivid, tightly focused observations of the lives of Dublin's poorer classes. At least one, "The Dead," is considered a masterpiece. Reprinted complete and unabridged from standard edition. 160pp. 5³⁄₁₆ x 8¼. 26870-5 Pa. $1.00

THE HAUNTED MONASTERY and THE CHINESE MAZE MURDERS, Robert van Gulik. Two full novels by van Gulik, set in 7th-century China, continue adventures of Judge Dee and his companions. An evil Taoist monastery, seemingly supernatural events; overgrown topiary maze hides strange crimes. 27 illustrations. 328pp. 5⅜ x 8½. 23502-5 Pa. $8.95

THE BOOK OF THE SACRED MAGIC OF ABRAMELIN THE MAGE, translated by S. MacGregor Mathers. Medieval manuscript of ceremonial magic. Basic document in Aleister Crowley, Golden Dawn groups. 268pp. 5⅜ x 8½. 23211-5 Pa. $9.95

NEW RUSSIAN-ENGLISH AND ENGLISH-RUSSIAN DICTIONARY, M. A. O'Brien. This is a remarkably handy Russian dictionary, containing a surprising amount of information, including over 70,000 entries. 366pp. 4½ x 6⅛. 20208-9 Pa. $9.95

HISTORIC HOMES OF THE AMERICAN PRESIDENTS, Second, Revised Edition, Irvin Haas. A traveler's guide to American Presidential homes, most open to the public, depicting and describing homes occupied by every American President from George Washington to George Bush. With visiting hours, admission charges, travel routes. 175 photographs. Index. 160pp. 8¼ x 11. 26751-2 Pa. $11.95

NEW YORK IN THE FORTIES, Andreas Feininger. 162 brilliant photographs by the well-known photographer, formerly with *Life* magazine. Commuters, shoppers, Times Square at night, much else from city at its peak. Captions by John von Hartz. 181pp. 9¼ x 10¾. 23585-8 Pa. $12.95

INDIAN SIGN LANGUAGE, William Tomkins. Over 525 signs developed by Sioux and other tribes. Written instructions and diagrams. Also 290 pictographs. 111pp. 6⅛ x 9¼. 22029-X Pa. $3.95

CATALOG OF DOVER BOOKS

ANATOMY: A Complete Guide for Artists, Joseph Sheppard. A master of figure drawing shows artists how to render human anatomy convincingly. Over 460 illustrations. 224pp. 8⅜ x 11¼. 27279-6 Pa. $11.95

MEDIEVAL CALLIGRAPHY: Its History and Technique, Marc Drogin. Spirited history, comprehensive instruction manual covers 13 styles (ca. 4th century thru 15th). Excellent photographs; directions for duplicating medieval techniques with modern tools. 224pp. 8⅜ x 11¼. 26142-5 Pa. $12.95

DRIED FLOWERS: How to Prepare Them, Sarah Whitlock and Martha Rankin. Complete instructions on how to use silica gel, meal and borax, perlite aggregate, sand and borax, glycerine and water to create attractive permanent flower arrangements. 12 illustrations. 32pp. 5⅜ x 8½. 21802-3 Pa. $1.00

EASY-TO-MAKE BIRD FEEDERS FOR WOODWORKERS, Scott D. Campbell. Detailed, simple-to-use guide for designing, constructing, caring for and using feeders. Text, illustrations for 12 classic and contemporary designs. 96pp. 5⅜ x 8½. 25847-5 Pa. $3.95

SCOTTISH WONDER TALES FROM MYTH AND LEGEND, Donald A. Mackenzie. 16 lively tales tell of giants rumbling down mountainsides, of a magic wand that turns stone pillars into warriors, of gods and goddesses, evil hags, powerful forces and more. 240pp. 5⅜ x 8½. 29677-6 Pa. $6.95

THE HISTORY OF UNDERCLOTHES, C. Willett Cunnington and Phyllis Cunnington. Fascinating, well-documented survey covering six centuries of English undergarments, enhanced with over 100 illustrations: 12th-century laced-up bodice, footed long drawers (1795), 19th-century bustles, 19th-century corsets for men, Victorian "bust improvers," much more. 272pp. 5⅜ x 8¼. 27124-2 Pa. $9.95

ARTS AND CRAFTS FURNITURE: The Complete Brooks Catalog of 1912, Brooks Manufacturing Co. Photos and detailed descriptions of more than 150 now very collectible furniture designs from the Arts and Crafts movement depict davenports, settees, buffets, desks, tables, chairs, bedsteads, dressers and more, all built of solid, quarter-sawed oak. Invaluable for students and enthusiasts of antiques, Americana and the decorative arts. 80pp. 6½ x 9¼. 27471-3 Pa. $8.95

HOW WE INVENTED THE AIRPLANE: An Illustrated History, Orville Wright. Fascinating firsthand account covers early experiments, construction of planes and motors, first flights, much more. Introduction and commentary by Fred C. Kelly. 76 photographs. 96pp. 8¼ x 11. 25662-6 Pa. $8.95

THE ARTS OF THE SAILOR: Knotting, Splicing and Ropework, Hervey Garrett Smith. Indispensable shipboard reference covers tools, basic knots and useful hitches; handsewing and canvas work, more. Over 100 illustrations. Delightful reading for sea lovers. 256pp. 5⅜ x 8½. 26440-8 Pa. $7.95

FRANK LLOYD WRIGHT'S FALLINGWATER: The House and Its History, Second, Revised Edition, Donald Hoffmann. A total revision–both in text and illustrations–of the standard document on Fallingwater, the boldest, most personal architectural statement of Wright's mature years, updated with valuable new material from the recently opened Frank Lloyd Wright Archives. "Fascinating"–*The New York Times*. 116 illustrations. 128pp. 9¼ x 10¾. 27430-6 Pa. $12.95

CATALOG OF DOVER BOOKS

PHOTOGRAPHIC SKETCHBOOK OF THE CIVIL WAR, Alexander Gardner. 100 photos taken on field during the Civil War. Famous shots of Manassas Harper's Ferry, Lincoln, Richmond, slave pens, etc. 244pp. 10⅝ x 8¼. 22731-6 Pa. $9.95

FIVE ACRES AND INDEPENDENCE, Maurice G. Kains. Great back-to-the-land classic explains basics of self-sufficient farming. The one book to get. 95 illustrations. 397pp. 5⅜ x 8½. 20974-1 Pa. $7.95

SONGS OF EASTERN BIRDS, Dr. Donald J. Borror. Songs and calls of 60 species most common to eastern U.S.: warblers, woodpeckers, flycatchers, thrushes, larks, many more in high-quality recording. Cassette and manual 99912-2 $9.95

A MODERN HERBAL, Margaret Grieve. Much the fullest, most exact, most useful compilation of herbal material. Gigantic alphabetical encyclopedia, from aconite to zedoary, gives botanical information, medical properties, folklore, economic uses, much else. Indispensable to serious reader. 161 illustrations. 888pp. 6½ x 9¼. 2-vol. set. (USO) Vol. I: 22798-7 Pa. $9.95
Vol. II: 22799-5 Pa. $9.95

HIDDEN TREASURE MAZE BOOK, Dave Phillips. Solve 34 challenging mazes accompanied by heroic tales of adventure. Evil dragons, people-eating plants, bloodthirsty giants, many more dangerous adversaries lurk at every twist and turn. 34 mazes, stories, solutions. 48pp. 8¼ x 11. 24566-7 Pa. $2.95

LETTERS OF W. A. MOZART, Wolfgang A. Mozart. Remarkable letters show bawdy wit, humor, imagination, musical insights, contemporary musical world; includes some letters from Leopold Mozart. 276pp. 5⅜ x 8½. 22859-2 Pa. $7.95

BASIC PRINCIPLES OF CLASSICAL BALLET, Agrippina Vaganova. Great Russian theoretician, teacher explains methods for teaching classical ballet. 118 illustrations. 175pp. 5⅜ x 8½. 22036-2 Pa. $5.95

THE JUMPING FROG, Mark Twain. Revenge edition. The original story of The Celebrated Jumping Frog of Calaveras County, a hapless French translation, and Twain's hilarious "retranslation" from the French. 12 illustrations. 66pp. 5⅜ x 8½. 22686-7 Pa. $3.95

BEST REMEMBERED POEMS, Martin Gardner (ed.). The 126 poems in this superb collection of 19th- and 20th-century British and American verse range from Shelley's "To a Skylark" to the impassioned "Renascence" of Edna St. Vincent Millay and to Edward Lear's whimsical "The Owl and the Pussycat." 224pp. 5⅜ x 8½. 27165-X Pa. $5.95

COMPLETE SONNETS, William Shakespeare. Over 150 exquisite poems deal with love, friendship, the tyranny of time, beauty's evanescence, death and other themes in language of remarkable power, precision and beauty. Glossary of archaic terms. 80pp. 5³⁄₁₆ x 8¼. 26686-9 Pa. $1.00

BODIES IN A BOOKSHOP, R. T. Campbell. Challenging mystery of blackmail and murder with ingenious plot and superbly drawn characters. In the best tradition of British suspense fiction. 192pp. 5⅜ x 8½. 24720-1 Pa. $6.95

CATALOG OF DOVER BOOKS

THE WIT AND HUMOR OF OSCAR WILDE, Alvin Redman (ed.). More than 1,000 ripostes, paradoxes, wisecracks: Work is the curse of the drinking classes; I can resist everything except temptation; etc. 258pp. 5⅜ x 8½. 20602-5 Pa. $5.95

SHAKESPEARE LEXICON AND QUOTATION DICTIONARY, Alexander Schmidt. Full definitions, locations, shades of meaning in every word in plays and poems. More than 50,000 exact quotations. 1,485pp. 6½ x 9¼. 2-vol. set.
Vol. 1: 22726-X Pa. $17.95
Vol. 2: 22727-8 Pa. $17.95

SELECTED POEMS, Emily Dickinson. Over 100 best-known, best-loved poems by one of America's foremost poets, reprinted from authoritative early editions. No comparable edition at this price. Index of first lines. 64pp. 5⁵⁄₁₆ x 8¼.
26466-1 Pa. $1.00

CELEBRATED CASES OF JUDGE DEE (DEE GOONG AN), translated by Robert van Gulik. Authentic 18th-century Chinese detective novel; Dee and associates solve three interlocked cases. Led to van Gulik's own stories with same characters. Extensive introduction. 9 illustrations. 237pp. 5⅜ x 8½. 23337-5 Pa. $7.95

THE MALLEUS MALEFICARUM OF KRAMER AND SPRENGER, translated by Montague Summers. Full text of most important witchhunter's "bible," used by both Catholics and Protestants. 278pp. 6⅝ x 10. 22802-9 Pa. $12.95

SPANISH STORIES/CUENTOS ESPAÑOLES: A Dual-Language Book, Angel Flores (ed.). Unique format offers 13 great stories in Spanish by Cervantes, Borges, others. Faithful English translations on facing pages. 352pp. 5⅜ x 8½.
25399-6 Pa. $8.95

THE CHICAGO WORLD'S FAIR OF 1893: A Photographic Record, Stanley Appelbaum (ed.). 128 rare photos show 200 buildings, Beaux-Arts architecture, Midway, original Ferris Wheel, Edison's kinetoscope, more. Architectural emphasis; full text. 116pp. 8¼ x 11. 23990-X Pa. $9.95

OLD QUEENS, N.Y., IN EARLY PHOTOGRAPHS, Vincent F. Seyfried and William Asadorian. Over 160 rare photographs of Maspeth, Jamaica, Jackson Heights, and other areas. Vintage views of DeWitt Clinton mansion, 1939 World's Fair and more. Captions. 192pp. 8⅞ x 11. 26358-4 Pa. $12.95

CAPTURED BY THE INDIANS: 15 Firsthand Accounts, 1750-1870, Frederick Drimmer. Astounding true historical accounts of grisly torture, bloody conflicts, relentless pursuits, miraculous escapes and more, by people who lived to tell the tale. 384pp. 5⅜ x 8½. 24901-8 Pa. $8.95

THE WORLD'S GREAT SPEECHES, Lewis Copeland and Lawrence W. Lamm (eds.). Vast collection of 278 speeches of Greeks to 1970. Powerful and effective models; unique look at history. 842pp. 5⅜ x 8½. 20468-5 Pa. $14.95

THE BOOK OF THE SWORD, Sir Richard F. Burton. Great Victorian scholar/adventurer's eloquent, erudite history of the "queen of weapons"–from prehistory to early Roman Empire. Evolution and development of early swords, variations (sabre, broadsword, cutlass, scimitar, etc.), much more. 336pp. 6⅛ x 9¼.
25434-8 Pa. $9.95

AUTOBIOGRAPHY: The Story of My Experiments with Truth, Mohandas K. Gandhi. Boyhood, legal studies, purification, the growth of the Satyagraha (nonviolent protest) movement. Critical, inspiring work of the man responsible for the freedom of India. 480pp. 5⅜ x 8½. (USO) 24593-4 Pa. $8.95

CELTIC MYTHS AND LEGENDS, T. W. Rolleston. Masterful retelling of Irish and Welsh stories and tales. Cuchulain, King Arthur, Deirdre, the Grail, many more. First paperback edition. 58 full-page illustrations. 512pp. 5⅜ x 8½. 26507-2 Pa. $9.95

THE PRINCIPLES OF PSYCHOLOGY, William James. Famous long course complete, unabridged. Stream of thought, time perception, memory, experimental methods; great work decades ahead of its time. 94 figures. 1,391pp. 5⅜ x 8½. 2-vol. set.
Vol. I: 20381-6 Pa. $13.95
Vol. II: 20382-4 Pa. $14.95

THE WORLD AS WILL AND REPRESENTATION, Arthur Schopenhauer. Definitive English translation of Schopenhauer's life work, correcting more than 1,000 errors, omissions in earlier translations. Translated by E. F. J. Payne. Total of 1,269pp. 5⅜ x 8½. 2-vol. set.
Vol. 1: 21761-2 Pa. $12.95
Vol. 2: 21762-0 Pa. $12.95

MAGIC AND MYSTERY IN TIBET, Madame Alexandra David-Neel. Experiences among lamas, magicians, sages, sorcerers, Bonpa wizards. A true psychic discovery. 32 illustrations. 321pp. 5⅜ x 8½. (USO) 22682-4 Pa. $9.95

THE EGYPTIAN BOOK OF THE DEAD, E. A. Wallis Budge. Complete reproduction of Ani's papyrus, finest ever found. Full hieroglyphic text, interlinear transliteration, word-for-word translation, smooth translation. 533pp. 6½ x 9¼.
21866-X Pa. $11.95

MATHEMATICS FOR THE NONMATHEMATICIAN, Morris Kline. Detailed, college-level treatment of mathematics in cultural and historical context, with numerous exercises. Recommended Reading Lists. Tables. Numerous figures. 641pp. 5⅜ x 8½.
24823-2 Pa. $11.95

THEORY OF WING SECTIONS: Including a Summary of Airfoil Data, Ira H. Abbott and A. E. von Doenhoff. Concise compilation of subsonic aerodynamic characteristics of NACA wing sections, plus description of theory. 350pp. of tables. 693pp. 5⅜ x 8½. 60586-8 Pa. $14.95

THE RIME OF THE ANCIENT MARINER, Gustave Doré, S. T. Coleridge. Doré's finest work; 34 plates capture moods, subtleties of poem. Flawless full-size reproductions printed on facing pages with authoritative text of poem. "Beautiful. Simply beautiful."—*Publisher's Weekly.* 77pp. 9¼ x 12. 22305-1 Pa. $7.95

NORTH AMERICAN INDIAN DESIGNS FOR ARTISTS AND CRAFTSPEOPLE, Eva Wilson. Over 360 authentic copyright-free designs adapted from Navajo blankets, Hopi pottery, Sioux buffalo hides, more. Geometrics, symbolic figures, plant and animal motifs, etc. 128pp. 8⅜ x 11. (EUK) 25341-4 Pa. $8.95

SCULPTURE: Principles and Practice, Louis Slobodkin. Step-by-step approach to clay, plaster, metals, stone; classical and modern. 253 drawings, photos. 255pp. 8⅛ x 11.
22960-2 Pa. $11.95

THE INFLUENCE OF SEA POWER UPON HISTORY, 1660–1783, A. T. Mahan. Influential classic of naval history and tactics still used as text in war colleges. First paperback edition. 4 maps. 24 battle plans. 640pp. 5⅜ x 8½. 25509-3 Pa. $14.95

THE STORY OF THE TITANIC AS TOLD BY ITS SURVIVORS, Jack Winocour (ed.). What it was really like. Panic, despair, shocking inefficiency, and a little heroism. More thrilling than any fictional account. 26 illustrations. 320pp. 5⅜ x 8½. 20610-6 Pa. $8.95

FAIRY AND FOLK TALES OF THE IRISH PEASANTRY, William Butler Yeats (ed.). Treasury of 64 tales from the twilight world of Celtic myth and legend: "The Soul Cages," "The Kildare Pooka," "King O'Toole and his Goose," many more. Introduction and Notes by W. B. Yeats. 352pp. 5⅜ x 8½. 26941-8 Pa. $8.95

BUDDHIST MAHAYANA TEXTS, E. B. Cowell and Others (eds.). Superb, accurate translations of basic documents in Mahayana Buddhism, highly important in history of religions. The Buddha-karita of Asvaghosha, Larger Sukhavativyuha, more. 448pp. 5⅜ x 8½. 25552-2 Pa. $12.95

ONE TWO THREE . . . INFINITY: Facts and Speculations of Science, George Gamow. Great physicist's fascinating, readable overview of contemporary science: number theory, relativity, fourth dimension, entropy, genes, atomic structure, much more. 128 illustrations. Index. 352pp. 5⅜ x 8½. 25664-2 Pa. $8.95

ENGINEERING IN HISTORY, Richard Shelton Kirby, et al. Broad, nontechnical survey of history's major technological advances: birth of Greek science, industrial revolution, electricity and applied science, 20th-century automation, much more. 181 illustrations. ". . . excellent . . ."–Isis. Bibliography. vii + 530pp. 5⅜ x 8¼. 26412-2 Pa. $14.95

DALÍ ON MODERN ART: The Cuckolds of Antiquated Modern Art, Salvador Dalí. Influential painter skewers modern art and its practitioners. Outrageous evaluations of Picasso, Cézanne, Turner, more. 15 renderings of paintings discussed. 44 calligraphic decorations by Dalí. 96pp. 5⅜ x 8½. (USO) 29220-7 Pa. $4.95

ANTIQUE PLAYING CARDS: A Pictorial History, Henry René D'Allemagne. Over 900 elaborate, decorative images from rare playing cards (14th–20th centuries): Bacchus, death, dancing dogs, hunting scenes, royal coats of arms, players cheating, much more. 96pp. 9¼ x 12¼. 29265-7 Pa. $12.95

MAKING FURNITURE MASTERPIECES: 30 Projects with Measured Drawings, Franklin H. Gottshall. Step-by-step instructions, illustrations for constructing handsome, useful pieces, among them a Sheraton desk, Chippendale chair, Spanish desk, Queen Anne table and a William and Mary dressing mirror. 224pp. 8⅛ x 11¼. 29338-6 Pa. $13.95

THE FOSSIL BOOK: A Record of Prehistoric Life, Patricia V. Rich et al. Profusely illustrated definitive guide covers everything from single-celled organisms and dinosaurs to birds and mammals and the interplay between climate and man. Over 1,500 illustrations. 760pp. 7½ x 10⅛. 29371-8 Pa. $29.95

Prices subject to change without notice.

Available at your book dealer or write for free catalog to Dept. GI, Dover Publications, Inc., 31 East 2nd St., Mineola, N.Y. 11501. Dover publishes more than 500 books each year on science, elementary and advanced mathematics, biology, music, art, literary history, social sciences and other areas.